POTTERY

for BEGINNERS

PROJECTS FOR BEAUTIFUL CERAMIC BOWLS,
MUGS, VASES *and* MORE

KARA LEIGH FORD

Creator of Kara Leigh Ford Ceramics

PAGE STREET
PUBLISHING CO.

PAGE STREET
PUBLISHING CO.

First published in 2021 by

Page Street Publishing Co.

27 Congress Street, Suite 105

Salem, MA 01970

www.pagestreetpublishing.com

Distributed by Macmillan, sales in Canada by The Canadian Manda Group.

25 24 23 22 3 4 5

ISBN-13: 978-1-64567-302-6

ISBN-10: 1-64567-302-2

Library of Congress Control Number: 2020948810

Cover and book design by Laura Benton for Page Street Publishing Co.

Photography by Kate Southall (copperandblossom.co.uk) and Kara Leigh Ford

Cone Charts provided with permission from The Edward Orton Jr. Ceramic Foundation

Printed and bound in the United States

To all the women who choose a different life— this one is for you.

"The direct engagement of hand and material—in this case, clay—gives birth to deep creativity and connects us to who we are as a species, as human beings. We become less about what we own and more about what we know and feel. A humane future is necessarily about knowing more and having less." —*Keith Luebke*

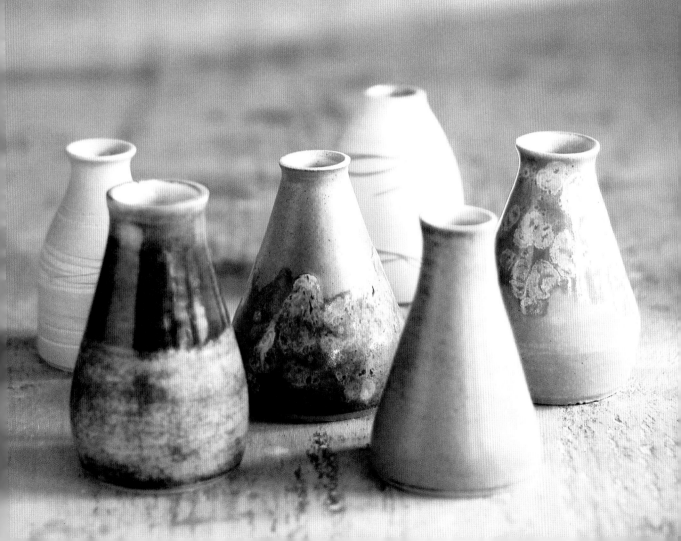

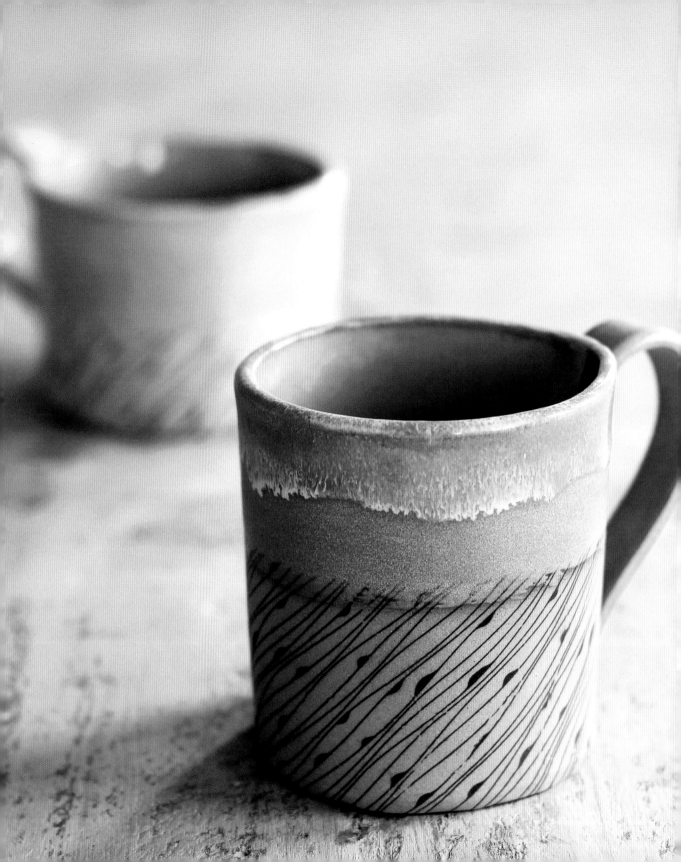

CONTENTS

FOREWORD

We are lucky to be living at a time when there is a great resurgence of interest in pottery, with many taking pottery classes and finding it relaxing and rewarding. After taking a few classes, the next step for some might be to buy tools and equipment and set up their own workspace, while others may prefer to keep pottery as a hobby. As well as refining pottery form and decoration, there is much to learn about glazing and firing, which is usually taken care of by technicians at evening classes. To learn and understand the process, you might need some guidance to help you take your interest to the next level.

I first met Kara Leigh Ford on social media, where I watched with interest as she grew her pottery business, building a studio in her garden near Bath in Somerset, developing her range of tableware and teaching others pottery. Kara trained in fine art and shows a great sense of design in her tableware range. She has put together a beautiful color palette of glazes—crystalline blues, greens and heather pinks—inspired by her walks on the South West Coast Path. I was delighted to meet Kara in person when she attended one of my glaze workshops in Dartington, Devon. She was friendly, warm and very enthusiastic about finding her own range of glazes. Her enthusiasm shines through in this book. I hope you will gain inspiration and enjoy making the projects.

This is a really useful book for beginners on how to make pottery by hand, with projects using both hand building and throwing on the wheel, illustrated throughout with beautiful photos of her process and finished work. The book is suitable for beginners who want to gain confidence with clay as well as makers who are looking for ideas for new projects. Kara has also written chapters on glazing, decorating and firing, showing how to achieve great results using stoneware clay and commercial glazes fired in an electric kiln.

—Linda Bloomfield

Potter and author of *Advanced Pottery* and
The Handbook of Glaze Recipes

INTRODUCTION

People often believe themselves to either be creative or not. I strongly believe everyone is creative. You don't need an artistic background to enjoy clay. There really is little reason you can't start pottery at any time in your life, on any budget. I'm thrilled to be your guide for the beginning of your journey into the wonderful world of ceramics.

This book is the perfect companion for anyone who fancies trying their hand at pottery. I give you all the basic background knowledge you need to start enjoying clay with ten step-by-step, detailed yet easy-to-follow hand building and throwing projects including mugs, plates, bowls, spoons, vases and lots more. I also provide you with beginner knowledge of glazing, with detailed instructions for eight different glazing and decorating techniques—all of which can be mixed and matched to create truly unique pottery pieces of your own.

This book is suitable for all novice potters who are looking to embark upon or expand their pottery education, providing a detailed yet fun kickoff point to start and grow your relationship with clay—I guarantee it will be a lifelong love affair. The projects in this book are designed specifically with gift-giving in mind. Presenting a loved one with an object steeped in love that you have taken time with, no matter how skillfully made, is a truly heartfelt gesture that spreads the joy of this wonderful craft even further.

The possibilities are endless—I encourage you to have fun, experiment and find your own style. All you need to start is curiosity and clay.

If you don't already know me, I'm Kara from Kara Leigh Ford Ceramics. I am a potter. I make pots, talk about pots and teach others how to make pots. I'm passionate about sharing this wonderful craft with the world. I'm mostly self-taught and began pottery as a hobby nearly 15 years ago. After finishing my degree in fine art, I was working a 9 to 5 office job and needed to do something creative to keep myself sane. I tried pottery for the first time at an evening class and fell in love. In 2015, I left my day job to follow my dream and set up my own pottery studio. I now teach others pottery in person and online via my Pottery Club. I sell my work on my website, and in shops and galleries all over the world. Through my large Instagram following, I share my love of clay with anyone who will listen.

I'm still close enough to the start of my pottery journey to remember clearly what it was like to be a beginner and how scary and overwhelming all the different pottery terms were. The difference between earthenware and stoneware, greenware and glazeware baffled me, as they might for you too. I don't aim to cover everything with this book, but I will try to demystify pottery for you and explain everything you need to know to simply get started, not taking anything for granted.

Get comfortable being a beginner. In the modern world, we all seem to want to learn everything there is to know instantly, but there is so much to learn in pottery that, even after 15 years of working with clay, the only thing I truly know for sure is that I'll never know everything. For me, that is all part of the joy of discovery. I look forward to continuing the learning process for the rest of my life. I always joke with my husband that I'm never going to retire from pottery because there are just too many things to learn. There are so many different ways of making things in pottery and no one way is the "right" way. Every potter has found their own little tricks, secret methods and techniques. In this book, I will share some of mine with you.

I designed this book to be an easy reference tool as well as a source of a lot of fun projects from which you can practice your newfound skills. I grouped all the making projects at the front and glazing projects near the back of the book because in pottery, it makes sense to make a batch of work which can be bisque fired (don't worry, I'll explain what bisque fired is later) together. You can then choose from the various glazing and decorating techniques, mixing and matching to adorn your pots and get them fired a second time together.

All the projects here create stand-alone pieces, but each one builds on the skills of the one preceding it, so it's recommended you start with the first project and move forward in order. I'll be sharing lots of useful tips and tricks along the way (look out for Pro Tips). Let's get started!

CURIOSITY AND CLAY

Getting to Know Clay

It's totally possible to learn pottery by teaching yourself. I went to a few evening classes but mostly learned via books (like this one), YouTube videos and hours and hours of practice. The clay itself really is the greatest teacher. Listen to what it is telling you. Be curious; if something goes wrong, try to understand why.

Working with clay is truly a lesson in acceptance of where you are.

Pottery is one of the most mindful activities you can do. When immersed in a pottery project you become totally engrossed, your mind fully occupied by the clay. Pottery can help you forget your day-to-day worries like nothing else.

MINDFUL CLAY EXERCISE

You might have never touched clay in your life, or if you have it was a very long time ago, possibly at school, so the memory is distant and fuzzy. While reading this introduction or soon after, I invite you to grab a handful of clay (any old clay) and just play with it in your hands, don't worry about the clay getting on the book. Get used to getting messy. When teaching my pottery students for the first time in my studio, I invite them, as I am inviting you now, to simply sit and handle the clay, not making anything but just feeling it between your fingers. Take a moment to get to know this new material.

1 . Spend 10 minutes just feeling the material, squishing it, manipulating it, using your fingertips, your palms, your knuckles.

2 . How does the clay feel? How does it smell? Some words and phrases people use to describe clay: satisfying, squishy, soft, damp, cool, sticky.

3 . Think deeply about how the clay feels. Feel the temperature, the consistency, the density and the weight.

4 . Take this moment to connect to your sense of touch. Close your eyes and mindfully ponder the material with your hands, your fingers, your skin.

5 . How does it respond to light pressure? To firm pressure? To the heat of your hand?

6 . Stretch it, tear it, pull it. What happens?

7 . Put some water on it. Notice how it gets slippery and glossy?

8 . Remember how great it felt to get messy when you were a kid.

In this book, I invite you to embrace the mess, free your inner child and let go of the need to be clean. The clay will get under your fingernails and coat your skin in a pale, fine dust. Some people don't like this at first—it goes against our modern instincts to be clean or have suitably moisturized hands—but getting messy and out of your comfort zone is all part of the joyful pottery experience. Most people will agree this is liberating as well as relaxing and meditative. Using your senses in a brand-new way is as mindful as it is enriching.

Getting to know clay like this will help you to understand its foibles and will be really useful later on when embarking on projects.

WHAT IS CLAY?

Clay is made of tiny particles; different mineral silicate rock finely ground and mixed with water via geological processes over many thousands of years. Clay is mined from the ground all over the world. Most of the time, it is refined into a powder and then rehydrated with water into workable clay and sold in bags. You can also buy powdered clay that you add your own water to.

A note on the environmental considerations of pottery:

Clay and glaze materials are mined and refined all over the globe. It is an abundant yet non-renewable resource and therefore we need to be mindful of its consumption and how mining techniques and the bulk shipping of materials impacts the planet.

We can reduce the environmental impact of pottery by sourcing materials locally, which is mined on a smaller scale. Ask your pottery supply store for native clay as opposed to clays shipped from across the globe.

Reclaim all waste clay, throwing water and scraps—recycle them back into workable clay instead of throwing them away. I will show you how later in this book (page 34).

Kilns that use electricity or wood rather than gas are preferable because the energy can be from renewable sources.

Types of Clay

There are several different main types of clay: earthenware, stoneware, porcelain and raku. Each of these terms refers to their different properties and the temperature at which the clay is fired (or vitrified—don't worry, I'll explain what this word means a little later). All of these clays come in a variety of colors, from white, buff, terracotta—all the way through to black. The clays I use in this book are all mid-fire stoneware.

Low-Fire Clays

Raku is normally fired between 1472 and 1832°F (800 and 1000°C)

Earthenware is normally fired between 1652 and 2102°F (900 and 1150°C)

Mid-Fire Clays

Mid-fire stoneware vitrifies between 2183 and 2282°F (1195 and 1250°C)

High-Fire Clays

High-fire stoneware vitrifies between 2282 and 2372°F (1250 and 1300°C)

Porcelain vitrifies between 2282 and 2552°F (1250 and 1400°C)

Note: You must never fire low-fire clays to high-fire temperatures, as they will melt and literally turn into a lava-like liquid and likely ruin the kiln.

States of Clay

Clay goes through several states of "being" during the pottery process. Each state is important to wrap your head around as you get to know this beguiling and complex material.

Slip: This is liquid clay that can be made by mixing clay with water. Slip makes an excellent glue for hand building projects, attaching handles, casting or adding decoration or texture to the surface of clay. Slip has the highest water content.

Raw clay: This clay is straight out of the bag (or indeed, the ground). The clay feels damp, cold and squishy; it is pliable and "plastic." The clay needs to be prepared for use and then is ready to be thrown, rolled, pinched, coiled and slabbed. Raw clay has the second highest water content.

Leather-hard/cheese-hard: You will hear me use this term many times throughout this book; it is a very important stage in the pottery-making process. Pottery that has been worked (e.g., thrown into a shape on the wheel, cut and molded by hand or cast in a mold from slip) is then left to dry out to a stage we call "leather-hard," which means it can be (carefully) handled without distortion. It can still be marked easily but is no longer floppy. At this stage the clay is still wet enough to be changed and worked: fettled, carved, trimmed, sculpted, a handle added to a mug . . . Pots made of several different pieces (like a teapot) are constructed at this stage. The clay will often be slightly paler in appearance than in its raw form and it will feel cool to the touch. Leather-hard clay has lost approximately half of its water content compared to its raw state.

Greenware: This is bone-dry clay that has been left to dry out completely before being fired. The clay can no longer be worked, but it is not permanent at this stage and can be recycled or "reclaimed" back into workable clay and used again by adding water. Greenware is very brittle and is easily chipped, damaged or broken, so it needs to be handled with care.

It is essential that your clay is bone dry and feels room temperature before it goes into the kiln. If it feels very cold, it's still losing moisture and therefore is not dry enough to go in the kiln. Though dry at the greenware stage, the clay still has microscopic water molecules (we refer to this as "chemical water") in it, which are only driven out by being fired in a kiln. The clay may be paler in appearance when it is bone dry and the surface takes on a powdery feel.

Bisqueware: This is when the pot has had its first (bisque or biscuit) firing, normally to between 1652 and 1940°F (900 and 1060°C). This stage of the process sets the form and is irreversible; the clay cannot be recycled back into workable clay after it has been fired.

The reason we bisque fire pottery before glazing it is to make it easier to handle and less likely to break during the glazing process. However, bisqueware is still very delicate and can easily be broken, so take your time when handling it (e.g., unloading the kiln and transporting your pots to your work bench). Knocking a handle off a mug or chipping a rim at this stage can be rather annoying—trust me, I've done it many times.

Bisqueware is still very absorbent, so it will suck up the water from the glaze and leave a layer of the glaze material on the surface of the pot ready to be fired a second time.

The clay may change color from its raw state (e.g., a clay with a brown appearance may become powdery pink after being bisque fired [see picture opposite]).

Glazeware: This is the final firing and stage of the pottery process. After a pot has been glazed and fired to glazeware temperatures, the glaze on the exterior melts to form a glass-like surface. The heat of the kiln causes the clay particles to pack tightly together, creating the strength and durability of functional or decorative ceramics. In the case of stoneware and porcelain, the clay is fully "vitrified," which means it is nonporous and watertight. Earthenware clay remains porous even after it has been glazed and fired—this means it is less durable.

Caption Right: These bisqueware pots have just had their first firing. The brown clay of the mug and bowl has turned pink, and the grey clay of the plates has turned white.

FIVE STRANGE AND WONDERFUL THINGS YOU NEED TO KNOW ABOUT CLAY

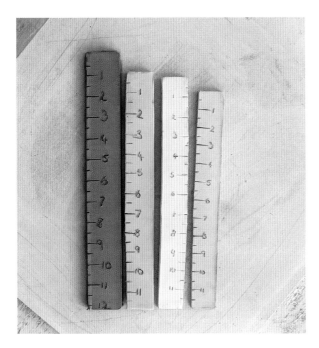

These rulers were are all made of the same clay and were originally all the same size. They're at different stages of the making process and demonstrate the shrinkage rate and color change throughout.

The longest, dark brown ruler on the far left shows the clay in its raw state—fresh out of the bag. The ruler next to it shows the clay in its bone dry or greenware state. The ruler second from the right has been bisque fired. The ruler on the far right (though not glazed) has been fired to glazeware temperatures.

1. Shrinkage: Clay shrinks. Everything you make will shrink 10 to 15 percent on average (although porcelain can be nearer to 20 to 25 percent) from beginning to end! It's important to know your clay's shrinkage rate (you can find this out from your clay supplier). For example, if you want your final mug to be 4 inches (10 cm) in diameter you'll need to make it 5 inches (12 cm) in diameter to account for the shrinkage.

2. Plasticity: Potters describe clay as "plastic," which refers to how well the clay copes with changing shape without tearing. It is related to the size of the particles and the water content of the clay. Generally, you want your clay to have high plasticity, as it will be more forgiving and less likely to crack while working with it.

3. Clay has "memory": Throughout your making process you may notice that the clay might distort in ways you do not expect (we call this "warping"). The clay particles have a kind of "memory" of where they once were and will sometimes try to get back to it. Clay will "remember" any stress it goes through, so handle your freshly made pots with care.

4. Thermal shock: Do you remember your granny warming a teapot with a little hot water before pouring in the boiling water to make tea? This isn't to make the tea taste better; this is to avoid thermal shock. Ceramics are hard yet brittle, and when exposed to rapid changes in temperature (from hot to cold or cold to hot), the stress can cause a piece of pottery to shatter or crack. Thus, it's best to avoid rapid temperature changes.

5. Vitrification: In ceramics we use the term "vitrified" to describe the clay material after it's had its final firing and becomes impervious to water. You need your pots to be glazed and vitrified in order to hold your tea. Clay remains porous and weak until it is fired to its vitrification temperature. Clay comes in a vast range of firing temperatures. It is important to note the firing temperature of your clay and glazes when you buy them, as this will inform the temperature the kiln must be fired to. Your clay and glaze temperatures must always be within the same firing range.

WATER IS INTEGRAL TO POTTERY

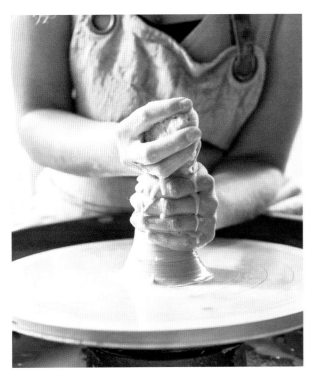

Knowing the right amount of water to use whilst throwing will depend upon what you are making and the type of clay you are using. This knowledge will come through time spent at the wheel.

Clay is made up of 17 to 23 percent water, and it's the careful management of water that helps a potter create successful work.

You may think that being a potter means learning to work with clay, but we are actually learning to work with water too. The clay is always responding to the presence of or the lack of water in itself or in the atmosphere. As soon as the clay is out of the bag, its moisture begins to evaporate. As you handle it you may notice how the clay might start to crack around the edges and get gradually less pliable.

A key skill of a potter is to recognize the changing water content of the clay and adjust the treatment of the clay accordingly, by adding water back in or by a controlled removal of it.

As well as being a potter, think of yourself as a water manager.

Learning to instinctively understand how much water the clay needs is important. For example, too much water added during throwing can cause your pot to flop; too little and the clay will drag through your hands and be pulled off center.

Where you live also has an impact: a hot, dry climate, air conditioning and low humidity means the clay will lose water faster than in a humid, wet and cold climate.

Fast drying can cause problems such as cracking and warping (see the Troubleshooting section on page 186). Slower drying is preferable, since the water will gradually leave the body of a piece of work as evenly as possible. Sometimes pieces will take days, even weeks to dry out. The larger the piece, the longer it will take to dry.

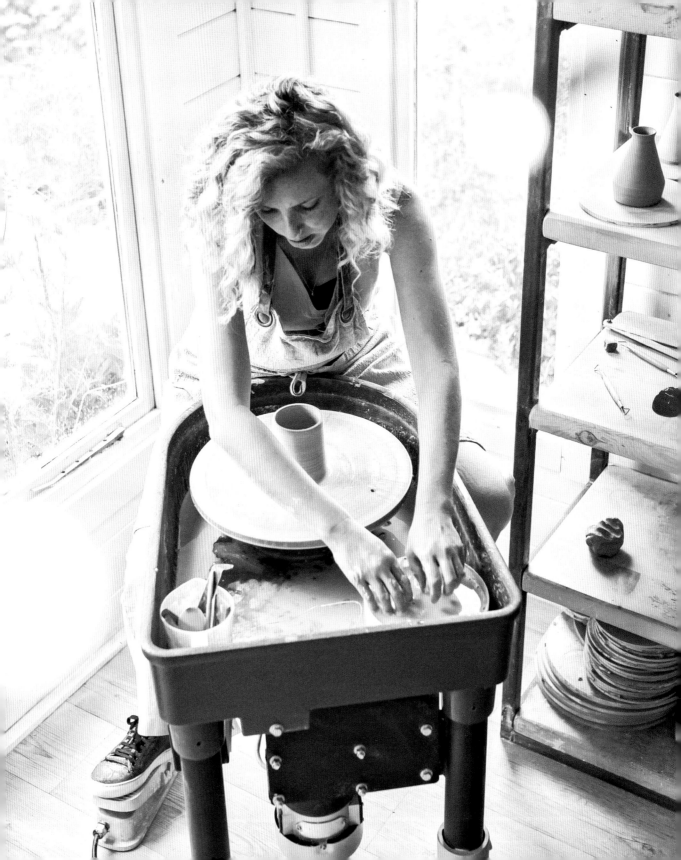

EVERYTHING YOU NEED TO GET STARTED

Choosing the Right Clay

Clay can be sourced from your local pottery supply store or by online ceramic supply retailers. I have listed some suppliers at the back of the book (page 188). It's likely that community studios will have just one type of clay for you to use.

Potters often refer to clay as the "clay body." Think of the clay like your canvas. The color of the clay body you choose will have an impact on the final aesthetic by affecting the color and effect of the glaze. A highly textured dark clay will make the same glaze look completely different than if it were applied to a silky-smooth white porcelain.

Clays will be sold with a recommended firing range. For instance, the buff stoneware I use in my studio can be fired from 2156 to 2336°F (1180 to 1280°C), cone 4 to cone 9 (the hotter the clay is fired, the higher the cone and the more vitrified and stronger it will be. I will explain more about cones later in the book on page 178). I match my glazes to the clay, making sure they can be fired between these two temperatures. You must never exceed the top temperature recommended for your clay or glazes.

I have used a range of mid-fire stoneware clay bodies in this book including white, buff and speckled to show you variation. This is also what I use in my studio. Stoneware is practical for functional pottery because of its strength and durability. All these projects would work well with a vast range of clays.

Here are some things to consider when choosing a clay:

1. Porcelain or white clay is essentially a white canvas and will mean your glaze will have the "truest" color. Porcelain is beautifully smooth and feels dreamy on the hands while throwing, but it's expensive and quite tricky to work with. At this early stage in your pottery journey much of it is likely to end up in reclaim so it might not be the best choice to begin with. There are lots of white or nearly white stoneware clays out there that are cheaper and easier to work with than porcelain.

2. Buff-colored clay will mean you have a biscuity color and the glaze you put over the top will be influenced by that fawn canvas, giving it a warmer tone. For instance, a transparent blue glaze is likely to go slightly green with a buff clay underneath (the yellow tones of the clay plus the blue glaze over the top may make it look green).

3. Dark clay, such as a terracotta or black clay, will strongly affect the final color of your glaze. How much will depend on the opacity of the glaze and how thickly it is applied. We'll talk about this more in the glazing section on page 138. Clays with a strong color tend to stain clothes and surfaces.

It's best to stick to working with one type of clay at a time, as recycling and storage is easier and there is less chance of contamination. Working with terracotta and porcelain at the same time might not be a good idea.

Choosing clay is as important for practicality as it is for aesthetics. Most colors of clays come in a range of textures suitable for all different types of projects and firing temperatures.

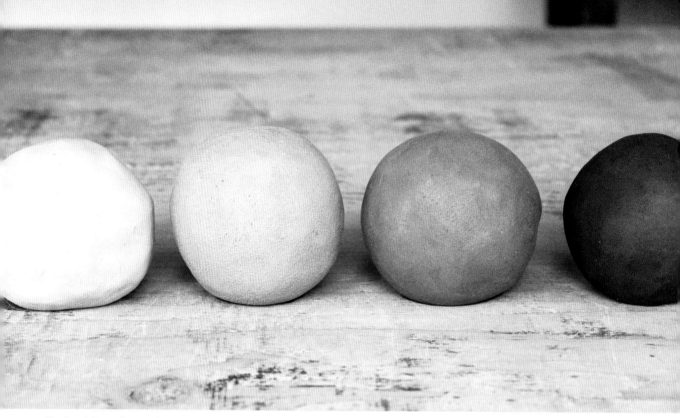

Clay from left to right: porcelain, speckled stoneware, buff stoneware, chocolate black earthenware

Clay for Hand Building Projects

Choose a clay that isn't too soft and has a little "grog" in it. You might see clay described as "grogged" or as containing "grog." Some clay will feel very smooth to the touch and others will feel gritty. The grit you feel is grog. Grog is an additive that is put into some clays. The grog itself is crushed up ceramic material that has already been fired, making it more resistant to warping and less likely to crack. It's a good choice for hand building. Too much grog can make throwing uncomfortable (giving you a microdermabrasion).

Clay for Throwing Projects

Consistency is key. If the clay you are working with is too soft , meaning it has lots of water in it already, it won't hold its shape for long. The water you add during throwing will weaken it and its form, and it will likely collapse. Likewise, if your clay is too hard, you may struggle to center it; the force you'll need will be much greater and you may push it off the wheel head. You'll also get tired and likely frustrated that it's taking so much effort to produce the shape you want.

Be very mindful of how your clay feels. It's easy to get despondent if your throwing session feels extra hard. Ask yourself: Is the clay's consistency right? If your clay has sat for a long time in a warm place it will lose water, even if it's been in a plastic bag. Store your clay in a cool place—sealed in the original bag, inside a plastic box away from sunlight is ideal.

Pro Tip: You can add water back into hardened clay by poking it with lots of holes, pouring on a little water and leaving it sealed overnight in its bag—make sure you wedge it well before use!

My advice is that you practice with an inexpensive all-purpose clay, then as your confidence grows you can start to play with a different variety of clays. Ask your local pottery supply store for advice on the best clay for the type of project you are working on. Clay normally comes in 25-pound (11.5-kg) bags, but you can often buy it in 2-pound (1-kg) trial packs. One 25-pound (11.5-kg) bag of clay will be enough for all of the projects in this book with some to spare.

Accurately weighing out your clay with a mechanical weighing scale will make it easier to keep forms consistent.

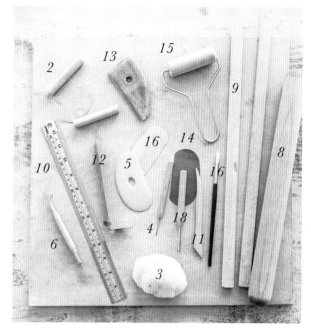

All the tools I have in my studio that I use everyday.

Your Essential Pottery Tool Kit

The most important tools available to the potter are their hands. A potter's tools are an extension of their hands. I have listed all the tools I use most days in my studio and given a brief explanation of their uses. You will need them to complete many of the projects in this book. They can be easily sourced at your local pottery supply store or online. Most of the tools I recommend are inexpensive and will last a long time. You can even use things you may have already hanging about your house, such as old credit or store cards instead of a rubber kidney. One of my favorite tools in my studio is a pair of old wooden chopsticks; I use them as thickness gauges and their ends for smoothing and sculpting while adding handles and spouts. Many pottery supply stores sell beginner tool kits in bundles. In addition to these supplies, plastic bags or plastic sheets are essential. I use these to cover the clay, evening out and slowing down the drying process, ensuring it doesn't dry out too fast.

1. Weighing scales: a set of digital or mechanical scales for weighing out the clay.

2. Wire cutter: a thin but strong wire with two wooden peg handles at each end. For cutting chunks of clay from the bag when weighing out clay for a project, slam wedging and for cutting freshly thrown forms off the wheel.

3. Sponge: a small, palm-sized sponge. An essential tool for both throwing and hand building. Useful for smoothing, shaping, cleanup and as a water reservoir while throwing.

4. Potter's needle tool: a metal pointed needle with wooden handle. Useful during both throwing and hand building. I find knives can be a little too keen when cutting clay, so I use a potter's needle tool instead. It can also be used for scoring edges when constructing pots and popping pesky air bubbles. I have a fine needle and a larger gauge needle in my tool kit. The larger gauge is more useful for scoring and cutting the clay. The fine needle is useful for popping air bubbles.

5. Rubber kidney: a thin and flexible kidney-shaped rubber or plastic card. This tool is useful for adding curves to forms such as bowls and vases while throwing. It can also be used to give a super smooth finish to slabs of clay when hand building. Alternatively, you could use an old credit or store card.

6. Loop trimming/fettling tool: a wooden tool with metal looped blades at each end. This tool is for trimming or fettling your leather-hard pots on the wheel, for carving, sgraffito or sculpting.

You need very few tools to start hand building pottery. Start with a small selection of tools and grow your kit gradually as you gain in confidence.

Hand Building Tool Kit

7. Wooden board: a large marine ply or a medium-density fiber (MDF) board is extremely useful to work on. You can easily move your clay project around on the board without fear of it getting damaged. It also helps to protect surfaces underneath.

8. Large wooden rolling pin: essential for rolling out clay during slab-building projects. Untreated hard wood is the best material, as the clay doesn't tend to stick to it. The larger the rolling pin, the easier it will be to roll the clay.

9. Two wooden gauges: these are made of marine ply or MDF and are useful for ensuring an even thickness of your clay when rolling it out during slab building. A thickness of ¼ inch (6 mm) is ideal for your clay. You could also use a pair of wooden chopsticks.

10. Metal ruler: a flat, straight object for drawing straight lines and measuring.

Throwing Tool Kit

11. Bamboo knife: this is a blunt knife made of bamboo wood with a 45-degree angle at one end and a curved end at the other. This tool is useful for cutting, shaping, sculpting and smoothing during the hand building and throwing processes.

12. Metal potter's knife: a sharp, angled metal knife used to cut a groove at the base of a pot before wiring it off the wheel.

13. Bamboo kidney or rib: a flat, kidney-shaped object made of bamboo wood with one curved side and two straight sides. This shape is useful for shaping forms when throwing and for smoothing out the surface of slabs of clay during hand building.

14. Metal kidney or rib: a thin, metal, kidney-shaped disk. This is an extremely useful tool I use to give a professional finish when trimming wheel-thrown pottery. Be careful, metal kidneys are sharp.

Additional Tools to Complete Your Kit

15. Brayer tool: a small wooden roller with a handle for smoothing out edges and securing joins during hand building.

16. Soft brittle paint brushes (various sizes): smaller paintbrushes are for adding slip (clay glue) to joins and smoothing off details around handles or for detailed decoration. Larger fan-type brushes are for brush-on glazes and decoration.

17. Serrated metal kidney (not pictured): a thin metal kidney-shaped disk with teeth on the curved edge. This is used for scoring the clay when joining two pieces of clay.

18. Potter's hole punch: round metal tube with a wooden handle for making neat holes in clay.

19. Sanding pads or sandpaper (not pictured): for sanding your bisque pots after they have come out of their first firing in preparation for glazing.

20. Turntable or lazy Susan (not pictured): this is a helpful tool allowing you to access all sides of your pot with ease.

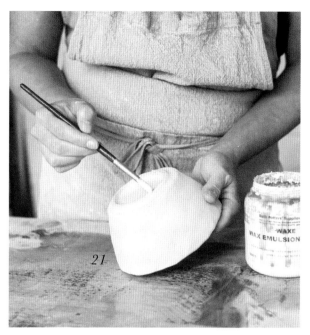

Dilute your wax emulsion with ¼ water to make it easier to brush.

Investing in a set of throwing batts will help you progress with your making.

21. Wax resist: a liquid emulsion potters brush onto the surface of bisque, which acts as a barrier against the glaze. This can be used for decorative purposes and/or to keep the areas in contact with the kiln shelf free of glaze.

22. Throwing batts: these are often made of marine plywood, plastic or plaster. This is a "mother and baby" batt system I use in my studio—a larger batt attaches to the wheel head with batt pins while a smaller tile batt sits neatly inside. The throwing projects included in this book are done not using throwing batts, as many folks may not have access to them when first starting out. It is perfectly possible to throw without them. However, I do advise investing in a batt system if you are keen to progress with throwing. This helps to avoid accidental warping, distorting or mangling of your pots during transportation off the wheel.

Instead of needing to precariously lift or slide a freshly thrown pot off the wheel head, after wiring through, you simply lift the small tile batt out of the mother batt and move your project over to a shelf to dry while still on the tile. It's a neat trick to make your throwing more efficient.

23. Large plastic bowl or jug (not pictured): this is to contain your water for throwing and for glazing; 2-liter (2-quart) volume is ideal.

There are many different types of throwing batts on the market ranging from wood, plastic and plaster. Some potters even make their own.

Setting Up Your Creative Corner

Understandably, many folks think that you need a lot of room and equipment for pottery, but that's only really true if you want to go into production. If you are simply seeking to explore it as a hobby, then all you really need is a surface to work on, a few tools and some clay. You can use wheels and kilns at a community studio. You can, of course, get your own wheel and kiln, but they are not essential to begin.

Firing services are offered by community studios, pottery supply stores, even a friendly local potter could fire your work for you. Normally firings are charged by the weight of the pieces or by the space in the kiln and are pretty reasonable. Simply drop your pots off and then pick them up a few weeks later.

Joining a community studio is a good way to get access to tools and equipment. There are many places popping up that charge by the month, or you can consider joining an evening class—it's great way to meet new friends.

Budget Set-Up

Hand building is the most affordable way to start pottery. It is a fantastic way to learn how the clay behaves, which will give you an advantage when you eventually do get to use a wheel. All you really need is a hard, absorbent surface to work on, the tools listed in the previous section and some clay. The absorbent surface needs to be made of something that the clay won't stick to—a slab made of potter's plaster is ideal because it is highly absorbant and it's heavy so it won't move around while wedging. (I have made a companion video tutorial of how to make a plaster slab over on my website: https://karaleighfordceramics.com/potteryforbeginnersbook.) Alternatively, you can use natural stone, untreated hardwood, a HardieBacker® Cement Board or a concrete board.

Avoid: newspaper (when it gets wet it sticks to the clay), canvas (gets too dusty) and plasterboard (it's too soft and if plaster is accidentally mixed with clay it causes a blowout in the kiln).

Medium Budget

It's only natural to think you should invest in a wheel first, mainly because this comes first in the making process (plus kilns can feel a little scary). However, do consider getting a kiln first. With hand building, you can go through the entire making process from start to finish, learning about greenware, bisque, glazing and firing. You can literally make everything by hand that you can make on the wheel, no exceptions. Creating pottery from start to finish can be done without a wheel, but you can't do it without a kiln. Kilns needn't be as scary as you think. You can pick up secondhand kilns relatively easily. Go to Getting a Kiln (page 181) to learn more about kilns.

Safety Note: The outside of a kiln does get extremely hot and fumes are an important consideration, so you need to make sure the kiln is in a properly vented area or in an area that is sealed off from your main living or working space and never situated within reach of children or animals. I talk about safety considerations in detail on page 26.

Blow the Budget

You might want to go the whole hog and get a wheel and a kiln. Here are a few pointers on what to consider when buying a wheel. It's best to try before you buy. Most pottery supply stores will have display wheels you can go and sit on to try them out. Brands such as Shimpo, Brent®, Skutt, Gladstone, ROHDE and Cowley all have great reputations.

New or secondhand: It is possible to pick up wheels secondhand (my first wheel was secondhand). Ask the seller where it has been stored and if it is in full working order. Ask to try it out if you can. Wheels can be big and heavy, so consider how you are going to transport it. You may have got a bargain secondhand wheel, but make sure you don't end up forking-out more than what you spent on the wheel on the shipping.

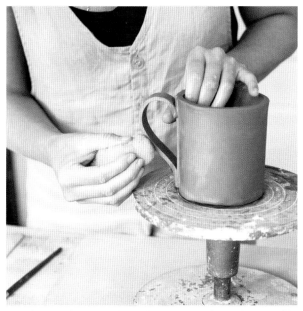

Everything can be made with hand building methods including mugs like this one. See the Simple Slab-Built Mug project on page 70.

My first kiln was a ROHDE 43 L Eco Top Kiln. This is a good size kiln for a beginner potter.

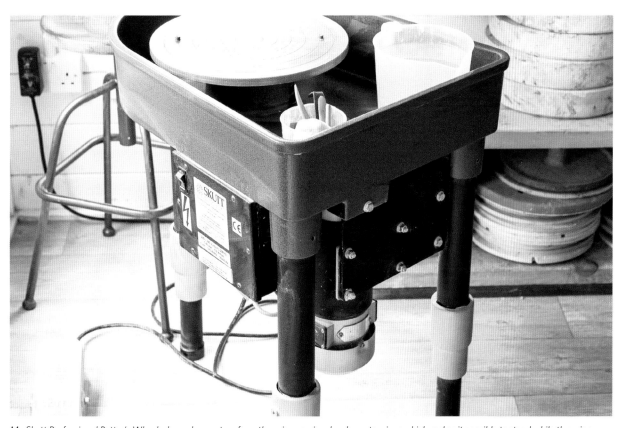

My Skutt Professional Potter's Wheel, shown here set up for a throwing session, has leg extensions which makes it possible to stand while throwing.

Size: wheels come in many different sizes. Consider where you are going to put your wheel before deciding on a model. Some you can store under a table; others are large and bulky. You can buy tabletop wheels which are portable and good for throwing in smaller spaces but have a very different feel to standard wheels.

Your throwing position: Do you want to throw standing or sitting? Folks with sensitive backs may wish to have the option to throw standing up. Many wheels come with leg extensions which make throwing standing up easier. Some wheels come with built-in seats. Consider what would be most comfortable for you.

Avoid Clogging Your Household Sink Using the Three-Bucket Trick

Don't be tempted to wash your tools and hands in your regular household sink; the clay sediment could eventually block your drains. Without the option to install an expensive and/or space-hungry sink trap, use the three-bucket system instead.

1. You need three 1-gallon (3.8-L) buckets, but they can be as small as 2 quarts (2 L).

2. Label each bucket 1, 2 and 3.

3. Fill each bucket two-thirds with water.

4. Bucket 1 is where you rinse most of the clay off your tools and hands.

5. Bucket 2 is for the second dunk and clean.

6. Bucket 3 is where the water should mostly come away clear.

7. When the first bucket gets full of sediment, it's time to reclaim it and turn it back into useable clay (I show you how to do this on page 34).

8. Then relabel bucket 2 as bucket 1, bucket 3 as bucket 2 and the now empty bucket 1 is filled back up with fresh water and becomes bucket 3.

You can use a similar system for glazing tools, this time just using one bucket to rinse off the glaze. When it gets full of glaze sediment you can use it as your "mystery glaze;" many potters do this with surprisingly beautiful results. Buckets with lids are best so you can stack them when not in use.

Always wear a respirator mask when working with ceramic powders.

Pro Tip: Plastic underbed storage boxes are a great way to store leather-hard pots in between making sessions, plus they are stackable and easy to clean.

Health and Safety

The main health and safety consideration when it comes to pottery is dust. Clay and glazes are made from tiny particles of silica so small you can't see them with the naked eye. When dry, these particles can create a fine dust that can be released into the air we breathe. Under a microscope, the silica particles look like tiny fragments of glass, and if they get into your lungs, they can cause scarring and lasting damage. Silicosis is a serious disease that is caused by exposure to silica dust over a period of time. In the olden days this was referred to by the pottery workers in 18th century Staffordshire as "potter's rot."

If all precautions are taken, pottery is perfectly safe, but please take care of yourself and others when working with clay.

My Top Tips for Staying Safe in the Studio

1. Be very mindful of dust at all times. Wet clay is safe, but dry clay causes dust.

2. Keep tools and surfaces clean by wiping down any wet or dry clay debris with a damp sponge.

3. Mop floor areas, and never sweep with a broom.

4. Never ruffle the bristles of a paintbrush that has been used with clay or glaze.

5. Only use a vacuum with a HEPA filter with fine particle filtration in and around your pottery area.

6. Protect clothes from the dust by wearing an apron and wash it regularly.

7. If clay or glaze gets on clothes or aprons, never be tempted to brush, scratch or scrape it off since this will only produce dust. Put soiled clothes straight into the washing machine.

8. When dealing with any dry powders, sanding or when there is a high chance of dust, such as when mixing glazes, always wear a respirator with fine particle filtration. These can be bought at pottery suppliers or DIY stores.

9. Some tools are sharp, so they need to be handled with care.

10. Only use glazes which have been rated as dinnerware safe on items designed to come in contact with food and drink. Glaze manufacturers will provide details on the packaging.

11. Never eat or drink while making pottery.

12. Keep animal friends and young children away from your pottery area. Supervise older children at all times.

13. Be mindful of protecting your joints and back while throwing or carrying bags of heavy clay.

Kiln Safety

Kilns reach temperatures of 2372°F (1300°C) and must be respected. Kilns are a serious piece of equipment, but are safe if used correctly and with care.

1. Always follow all kiln manufacturers' instructions regarding usage and installation.

2. Supervise your kiln closely while it is firing and cooling, and especially around peak temperature.

3. Kilns need to be adequately ventilated to the outside or isolated from your working or living space.

4. Never fire a kiln in a closed room in close proximity to people or animals.

5. The outside of a kiln gets extremely hot.

6. Never put anything on top of a kiln, even when it is off.

7. Never lean items against a kiln, even when it is off.

8. Always situate a kiln in a suitable area, on a concrete floor or slab and at least 18 inches (46 cm) away from walls, furniture or any combustible materials.

9. Never open a kiln unless it is at room temperature.

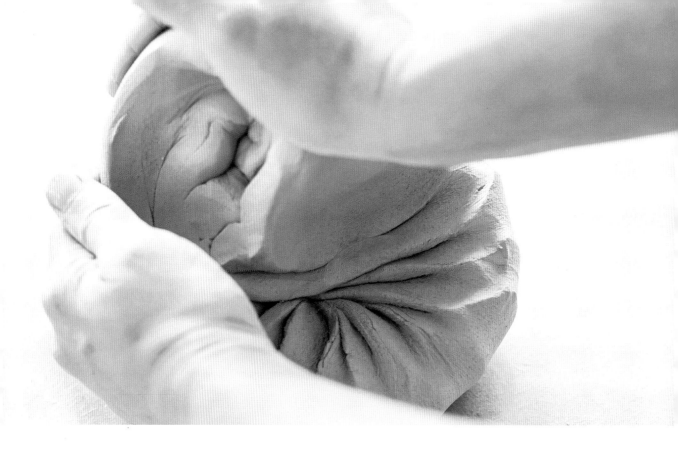

PREPARING THE CLAY

It is super important to prepare your clay before you start using it. The best pots come from taking your time with preparation. It's all too easy to think you can skip this step, go straight into the fun making part and if things go wrong, make it right later. I have learned the hard way that this is not true.

The clay you buy from a pottery supply store has been processed and packaged in a controlled environment, so it is likely that the moisture content will mostly be fairly even. However, the clay may have been stored for a while before it got to you and may have uneven moisture. This can cause difficulty working with the clay and lead to problems such as cracking or warping.

When working in a community or shared studio, the clay you will be using will likely have been recycled and probably be very uneven in its moisture content and the particles may not be sufficiently packed together. In all instances it is super important to prepare the clay properly before you use it. In this next section I will show you how.

Wedging: Cut and Slam, Ram's Head and Spiral

Wedging is a way of mixing the clay by hand to even out the moisture contained in it, rid the clay of any air bubbles and get it into the best shape to work with. This will mean you are far less likely to have problems later on in the making process—it is an essential step and cannot be skipped. Wedging may feel a little tricky at first, which is normal. But the more you practice, the easier it will become. It is worth the effort, I promise. And as a bonus, after wedging you won't need to go to the gym!

Use your absorbent surface to wedge on.

There are three main ways to prepare your clay:

1 . Cut and Slam Wedging

2 . Ram's Head Wedging

3 . Spiral Wedging

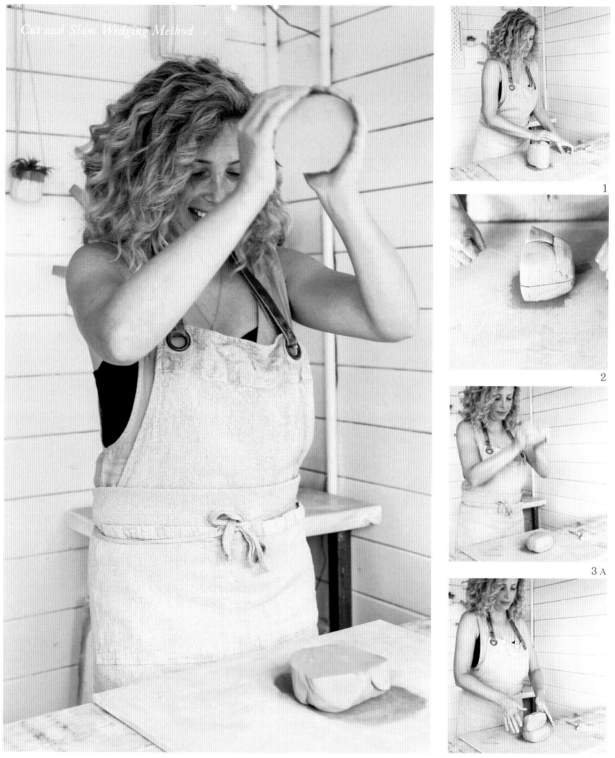

1

2

3 A

3 B

Use the Cut and Slam method for driving out air bubbles from your clay.

Cut and Slam Wedging Method

The Cut and Slam method is great for driving out air bubbles in the clay. It is also very useful when it comes to mixing two clays together. You might want to do this if you have some clay that is too hard and some that is too soft. This method is also excellent for preparing clay after it has been recycled to ensure the particles are closely packed together (see images on page 29).

1. Start with 4 pounds (1.8 kg) of clay. You can increase this quantity as you gain confidence. Pat the clay into a rough cube.

2. Using a wire cutter, cut the clay in half horizontally, pulling the wire toward you.

3. Place the wire down and pick up the top half of the clay. Rotate it towards you 90 degrees. Slam the top half of the clay down into the bottom half.

4. Pat the clay back into a rough square or rectangle. Flip the square 90 degrees toward you and repeat steps 2 through 4.

Do this 100 times and the clay will be well mixed. You can check if the clay is free of air bubbles by studying the inside of the clay after you have cut it. If there are visible holes, then you need to keep going until the clay looks smooth and uniform.

I always follow Cut and Slam wedging with Ram's Head or Spiral wedging as I find this finishes off the mixing process really well and asks the clay particles to line up nice and orderly, awaiting further instructions from you.

Ram's Head Wedging Method

So called because the clay will take on the appearance of a ram's head during the wedging process, what you're doing here is similar to kneading bread, but instead of adding in air, you are pushing air out. You are mixing the clay and forcing the particles to pack tighter together creating a homogenized lump which will be stronger and easier to work with (see images on page 31).

1. Start by weighing out 2 pounds 3 ounces (1 kg) of clay. Pat the clay into a stocky log shape.

2. Place the log on the surface in front of you, with the long edge of the log parallel to the table's edge. Place your palms at each end of the log, fingers loosely gripping the clay at the back, thumbs pointing away from you.

3. Keep your arms straight and use your upper body weight as much as possible (this will be kinder on your wrists). Put one foot in front of you and one behind, which enables you to keep your balance while slightly rocking back and forth during the wedging motion. Using the heel of your hands, in a short firm movement, push into the clay away from you and toward the surface of the table. You're only aiming to press about ½ inch (1.3 cm) into the surface, forming two kind of eye sockets with the ram's nose in the middle.

4. With your fingertips behind the log, gather the clay and tilt it slightly toward you (only by a couple of degrees). The heel of your hands will now be on a slightly different part of the clay. Push down again with the same motion as before. Repeat. After approximately 100 of these motions, the clay will be thoroughly wedged.

With this repeated action on the clay, you'll be forcing the clay to compact together and mixing it at the same time.

Many people are too enthusiastic with their pressure at first, so be mindful of how hard you are pressing into the clay—avoid flattening it. It will be very hard to get the rhythm if the first push squashes down the clay too much. You might find you end up putting more air into the clay than you're taking out. Try to avoid folding the clay over on itself—this will trap air too. If you find you did the first couple of pushes too enthusiastically, roll the clay back into the log shape and begin again. Finding the rhythm of wedging is integral to the process and this only comes with practice.

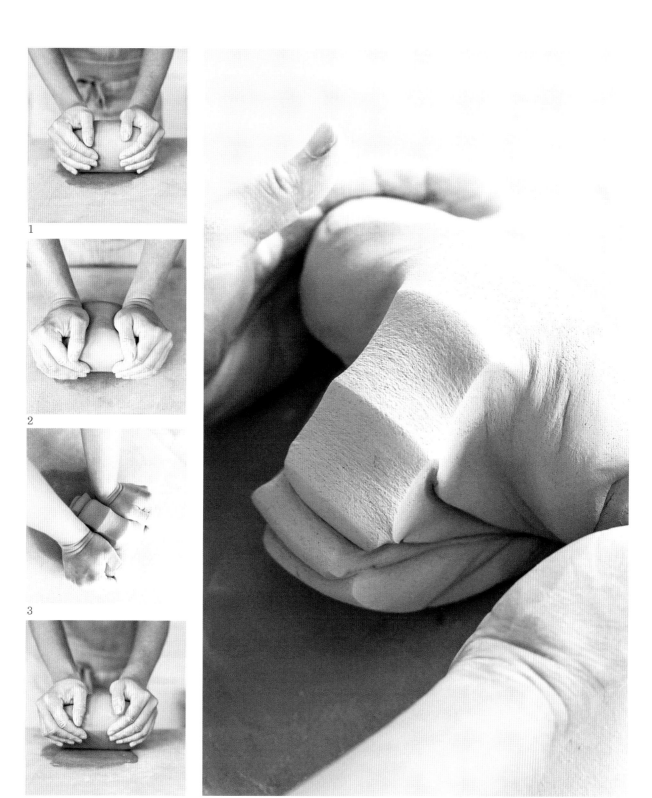

1

2

3

4

The Ram's Head method is good for wedging smaller amounts of clay.

Spiral Wedging Method

Spiral wedging takes its name from the shape created in the clay during the process: The clay creates a spiral pattern. The Spiral wedging technique is a little more advanced than the Ram's Head method and takes a little more skill to master. It's worth putting in the time though, as I find you can wedge more clay in one go. It is also quicker, which gets you started faster. This method is actually very difficult to do slowly; building up your speed and rhythm makes it easier (see images on page 33).

1. Take 4 to 5 pounds (1.8 to 2.2 kg) of clay. A larger amount like this is easier than starting with a really small amount. Wedging a larger quantity and then cutting it down to the size you need also saves time, instead of wedging the exact smaller amounts for each project. Pat it into a rough fat log shape, slightly thicker at one end. Take care to get rid of all creases and scars by smoothing them over; this helps prevent air from getting trapped.

 Getting the spiral going is the hardest part, but once you have started the spiral shape it will become easier. Lay the fat log of clay on its side in front of you on the absorbent surface. Position your hands together at the fat end of the log, the heel of your thumbs touching, your dominant hand on the top (I am right-handed so this would be my right hand) and the nondominant hand on the side (this would be my left hand).

2. Your nondominant hand is guiding the clay and your dominant hand is doing all of the pushing. Using the heel of your dominant hand, push down and away from you, keep your arm straight and use your upper body weight so your muscles don't get too tired. Push into the clay (toward the table) about ½ inch (1.3 cm). Again, you don't need to push in very far. Avoid flattening the clay.

3. With your nondominant hand, gather the clay and pivot it toward you, turning it approximately 10 degrees clockwise. This means the heel of your dominant hand is now positioned over a new part of the clay.

4. Push down with your dominant hand again with the same force as before, repeating steps 2 through 4 again and again. After a dozen or so rotations, the clay will begin to form the spiral shape you are looking for—the clay is being mixed in the middle of the spiral and compressed by the pushing action. Repeat the action 100 or so times until all of the clay has been mixed through the spiral.

Finding the rhythm of wedging is the key. Take a look at the useful companion videos I made for these techniques on my website: https://karaleighfordceramics.com/potteryforbeginnersbook.

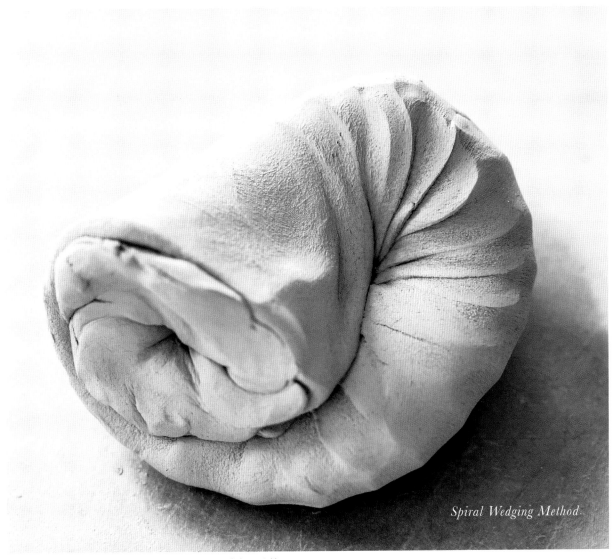

Spiral Wedging Method.

Spiral wedging is useful for preparing larger quantities of clay quickly.

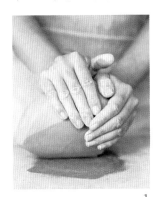

1

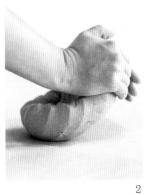

2

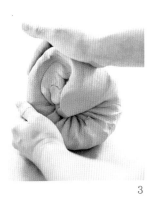

3

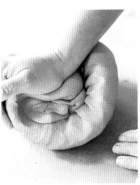

4

How to Recycle Your Clay

During the making processes of pottery, much of the clay that passes through our hands never gets fired. A lot of it gets trimmed off or maybe even the piece will develop a crack during the drying stages. I always encourage my students to be actively critical of their work: Is it good enough to keep? Is it likely to be a successful mug, bowl or vase? Is it too small to be useful? Are the walls too thick? Is the base heavy? Is it really worth going into the kiln? If not, still nothing should be wasted. Everything that has not yet been fired can be recycled back into workable clay and reused again and again.

If you are member of a community studio, the clay recycling will be taken care of for you. But, if you're working at home here's how you go about it.

Have a dedicated reclaim bucket for collecting all trimmings, throwing water and scraps. When the bucket is full, it is time to recycle it. It is really important to include all your throwing water as well as your trimmings. The throwing water is full of the tiniest particles, which makes sure that your clay is plastic. Remember, you want it to be pliable and nice to work with; it should feel like it is fresh out of the bag and not short and crumbly.

How to Reclaim/Recycle the Clay When Your Reclaim Bucket Is Full

1. First siphon off the clear standing water that's accumulated at the top of the bucket. I like to use a big plastic syringe to do this because it sucks up the water and leaves the clay where it is. That clear water can be disposed of down the drain. Never put cloudy clay water down the drain, as it will clog your pipes.

2. When you've gotten rid of most of the clear water, use a hand blender tool to whizz up the rest of the clay and the remaining water that's in the bucket. Do this until it is the consistency of thick custard. (Liquid clay is called slip.)

3. Use a sieve to sift the clay slip you've just made into another bucket. You don't want to use a sieve that has a very fine mesh, as it will trap all of the larger clay particles (grog) and you need that in your clay. Scoop out a cupful at a time and work it through the sieve using a silicone spatula. This might be a little tedious,

but it is a really worthwhile step, as this will get rid of any debris that may have fallen into the reclaim bucket such as bugs, leaves, fluff or hair (gross!). Discard anything left at the bottom of the sieve once you're done.

4. Once you've sieved your way through the entire bucket of slip, slop it out onto a large plaster mold like I am using in the photo or a flat plaster slab (the same one I talked about earlier in the book on page 24). Alternatively, you can use a cement board from a DIY store. Never use drywall or plasterboard, as it isn't hard enough, and the paper will disintegrate and end up in your clay. Plaster and clay should never mix; this will result in an explosion in your kiln.

5. Spread out the slip with a spatula to about 2 inches (5 cm) thick. Raise up the mold/slab using kiln stilts or glaze tubs. This means that there's air flow underneath, which helps the reclaimed clay dry much quicker. Now you want to leave your clay to dry for a day or so, coming back to it when it's more of a solid than a liquid. Make sure you check on it regularly so it doesn't dry out too quickly. You can even use a fan and direct a flow of air over your reclaimed clay; this will decrease drying time dramatically.

6. When you can start to peel the clay off the plaster, the underside will most likely be drier than the top, so you'll want to flip it over. Using a rubber kidney, lift one end of the clay and then carefully peel it off the plaster and flip it over so the other side can dry. Leave it to dry for another few hours until it starts to all feel like the clay does when it is fresh out of the bag.

7. To ensure your reclaimed clay is a really good consistency, you're going to need to wedge it really well. This will help get rid of any air that was added during the reclaim process and tighten up the clay pores, ensuring the particles are closer together and making it stronger and easier to work with. You could even mix it with some fresh clay to get a good consistency. The Cut and Slam wedge method is the best way to do this.

8. Finally, use the Spiral wedge technique to homogenize the clay and make all the moisture even throughout the body. Do at least 100 spirals of your clay to make sure it's ready to use again. Store your clay in the original plastic bags and a plastic box.

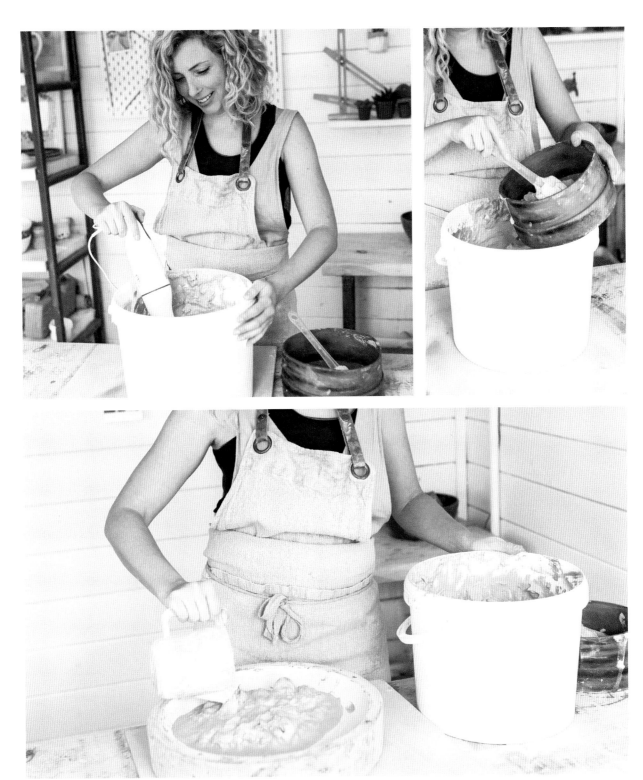

Though a messy job, recycling clay reduces waste and means you will save money on buying new materials over time.

HAND BUILDING

Creating Beautiful Pottery Without a Wheel

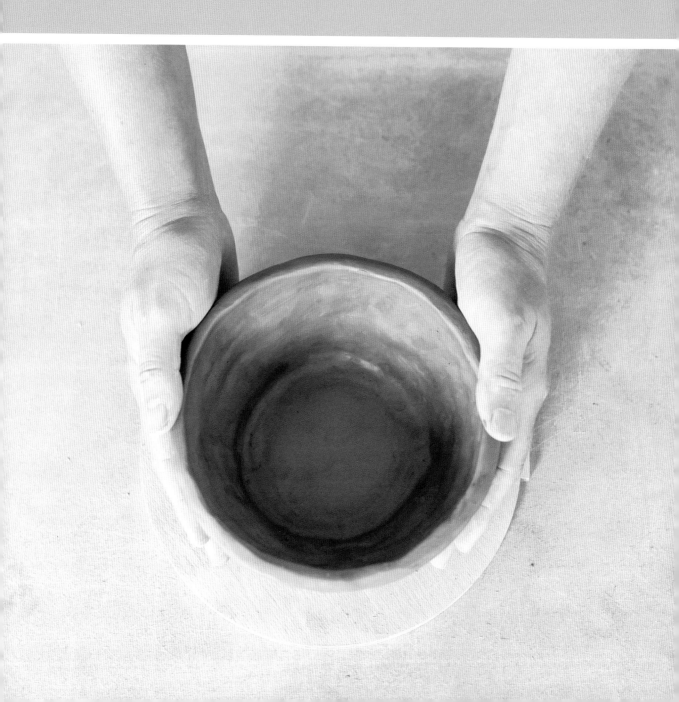

What's the one essential tool you need in order to make beautiful pottery?

Your hands. You don't need a wheel or lots of fancy equipment to start enjoying pottery.

Hand building simply means using your hands as your primary tools to create pottery. In this book I talk about hand building first, as this is the most natural and instinctive way to learn about clay and the processes involved in pottery. It's a sensible place to start your journey into clay. The subtleties of touch are super important in pottery. As we grow up and enter adulthood, many of us stop being as curious with touch. It is as if society wants us to stop exploring the world with our fingertips, like we did when we were small children. Swiping on a smartphone or typing on a keyboard is how many of us spend our days, and so we may have forgotten how to use touch in other ways. Hand building helps us to rediscover and refine our haptic skills, retuning our brains to our wonderful sense of touch.

Even though hand building goes at a more languid pace than throwing, it is actually quicker to get your pieces from lump of clay to greenware. Hand building uses less water than throwing, which means it's less messy and requires less drying time. You can have a hand-built mug made and ready to dry out in a single afternoon. You don't need to wait quite so long for pieces to dry to become leather-hard before moving on to the next stage of the construction process. It's also versatile, allowing you to create more angular shapes such as square boxes, rectangles and triangles, which are difficult to achieve on the wheel.

Many students are keen to skip past hand building and rush straight to the wheel. I understand the excitement and enthusiasm to get started on the wheel straight away, but I would ask that you quiet this urge. Building a connection with pottery from the most fundamental standpoint and gradually developing understanding between you and the material will give you the best foundation to your ceramics education. It is key to get to know the clay from the ground up (excuse the pun). This will ultimately give you a better experience, and when you do eventually get to explore the wheel, the familiarity you have gained from these first interactions will benefit you immensely.

Hand building is an exceptionally mindful activity. It not only offers you the utmost control of the clay, but it is also super relaxing. Enjoy these early phases of exploration; they are an important part of your pottery journey.

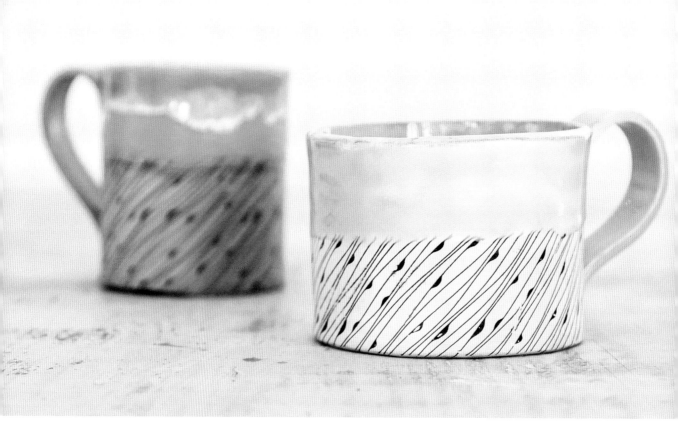

SIMPLE HAND BUILDING TECHNIQUES: PINCHING, SLAB BUILDING AND COILING

This section of the book talks you through several simple, yet fun hand building projects designed to help you become accustomed to working with clay, but also enable you to make beautiful and useful objects while you learn. I am going to guide you through the simplest and most ancient methods of creating with clay. All of the techniques in this section will be used on their own or in combination with other techniques in the hand building projects in this book.

Pinching

Pinching is the simplest and possibly most instinctive way of interacting with clay. Moving the material with just your fingertips, convincing it to become something other than its natural unorganized state. Pinching is exactly as it sounds. You simply pinch the clay between your fingertips to create the desired shape. A great way to practice this technique is to start with small forms called pinch pots, one of the inaugural forms most potters will make when they first acquaint themselves with clay. Pinching is often used in combination with the other hand building techniques I will go on to describe in this chapter.

MINDFUL MINI
PINCH POT PROJECT

Skill Level: Absolute Beginner

This is a great mindful exercise for both beginners and those who have previous experience with clay. It's always good practice to take some time away from the desire to actually make anything in particular and simply come back to the essence of pottery, which is your hands and the clay. Being slow and mindful about your movements and how the clay reacts to your touch and the warmth of your skin can reconnect you to the material and make you a more effective and sympathetic potter.

Materials

7 oz (200 g) any clay of your choosing

Weighing scales

Brushes for glazing

Glaze Notes

After drying and bisque firing to 1940°F (1060°C) I glazed my pinch pots using brush-on glazes and fired again to 2231°F (1222°C) For detailed instructions for brush-on glazing see page 143. Testing out brush-on glazes is a great use of these little pots.

1. Start with a ball of clay of approximately 7 ounces (200 g). You can practice with any type of clay here because we are less concerned with producing a final product as we are about getting to know clay through this technique.

2. Moving slowly and mindfully, gently pat the ball with your palm so it forms a sphere. Make sure the surface of the ball is smooth and doesn't have scars or cracks.

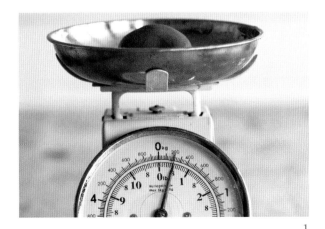

1

2

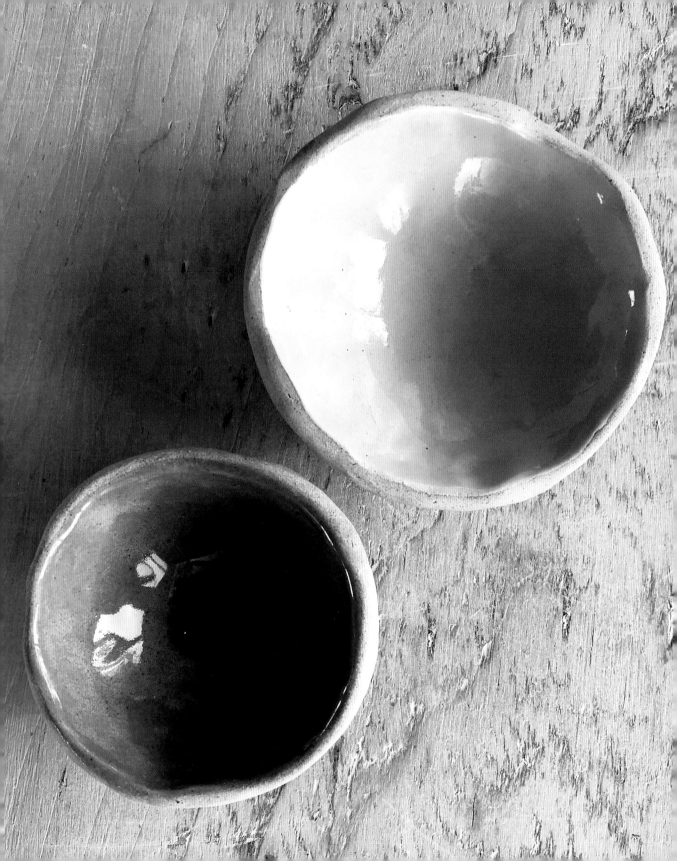

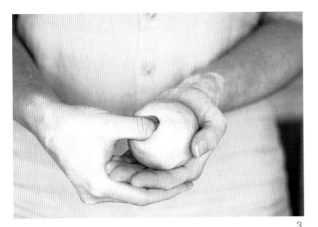

3

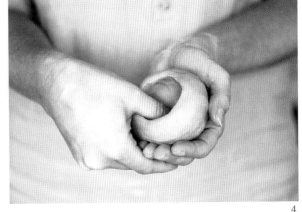

4

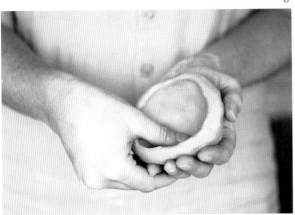

5 A

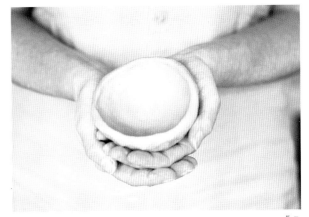

5 B

3. Hold the ball of clay in the palm of your nondominant hand (I am right-handed so that would be my left hand). With the other hand, place your thumb on top in the middle of the ball. Slowly press into the clay with your thumb until you are approximately three-quarters of the way through. Be careful to not push too hard and go all the way to the other side (don't worry if you do, just squish up the clay, pat it into another ball and start again). Remember to adjust your pressure, which depends on the softness of the clay: firmer clay needs more pressure, softer clay needs less.

4. Now you are going to start opening out the ball of clay into a pot by forming walls and a base with the pinching action. Change the angle of your thumb pressure; instead of pushing straight down, use your thumb pad to direct your pressure toward the outside of the ball. We are working with subtle, gentle squeezes rather than decisive, big gestures here. Begin by gently squeezing the clay between your thumb and fore and middle finger, a little at a time. Carefully rotate the ball a few degrees clockwise after each squeeze. Gradually, with gentle, even pressure, push out the walls of the pinch pot.

5. Work your way around the entire circumference of the pot, steadily and methodically, rotating only a few degrees at a time. The goal is for the walls of the pot to be approximately ¼ inch (6 mm) thick. You will start to see a little pot forming in front of you. This pot may be more of a bowl shape or it might be more of a cup. Either way, observe what happens to the clay. Did it move as you expected? What adjustments could you make to your pressure to control the clay better next time?

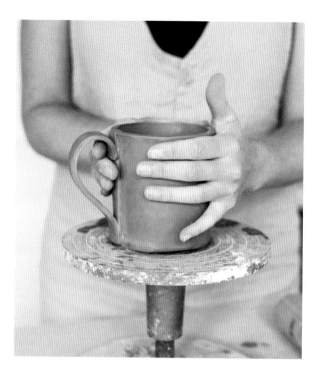
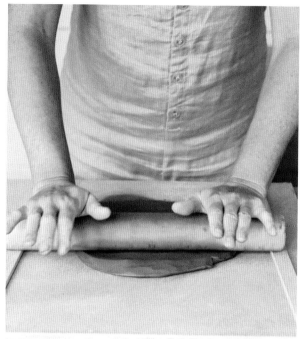

Slab Building

Slab building is a technique that involves rolling out the clay with a specially made slab roller machine or, more likely in the case of a beginner, a rolling pin. The slabs of clay are then cut into pieces, which are joined together with slip (clay mixed with water to create clay glue). Slab building can be used to create the walls, handles, bases and other elements of functional forms such as mugs and teapots, as well as decorative pots like vases and sculptures. Slab building is a relatively quick way of making pots. It's also great for making uniform sets, as the clay can be rolled and cut in exactly the same way using templates and thickness gauges. Slabs can also be used in conjunction with molds to make bowls, plates and platters.

How to Make Slabs

1. Weigh out the amount of clay needed in your project. Prepare it by using one of the wedging techniques mentioned on page 28.

2. Work on your absorbent board material. First, using a wooden rolling pin, bash the clay to approximately 1 inch (2.5 cm) thick to make rolling easier.

3. We use wooden thickness gauges here to help us get the desired thickness. Roll it out to a thickness of ¼ inch (6 mm). This is a good thickness for most ceramic household pieces.

4. To be able to effectively work with the slabs, the clay needs to be at a dryer state than it is when fresh out of the bag. So once rolled, leave the clay out for it to dry to the leather-hard stage as described earlier in the book on page 14. At this stage, the clay has lost some of its water content to evaporation and has the consistency of leather or cheddar cheese. It is still malleable but it's not as floppy and therefore less likely to collapse during the making process.

Note: It is important that the slabs we are working with contain the same level of moisture; this prevents issues such as cracking and warping, so make your slabs all at the same time and dry them evenly away from drafts or direct sun. You may want to cover your slabs in plastic, which will help to slow down and even out the drying.

Coiling

Coiling is the hand building process of rolling out coils of clay, then stacking them one on top of another and sticking them together to create a form. It's a method of building very big pots without anything but your hands, a lot of time and a little skill. The coiling technique involves rolling clay between a surface and your palms creating long, spherical coils that are then spiraled together to create the walls of a pot. The thickness of the sausages can range from ¼ inch (6 mm) to 1 inch (2.5 cm) depending upon the size of the pot you are creating. The larger the pot, the larger the coil. Coiling a pot is a time-intensive process compared to that of throwing on the wheel, yet it teaches you a lot about the physics of the clay, the possibilities and the limitations of the material in terms of weight bearing, angles and the behavior of the pieces of clay. You want your coils slightly thicker than what the walls of your pot will ultimately be, as you'll be using some of the clay to blend the pieces together.

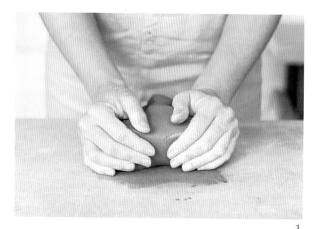

1

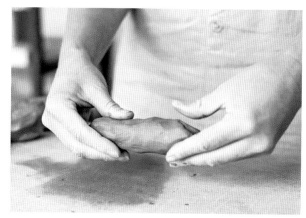

2

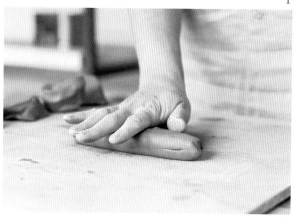

3

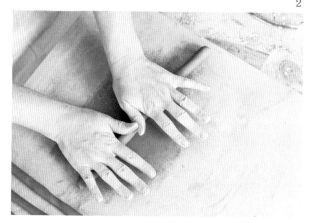

4

How to Make Coils

1. Prepare your clay by wedging it. Then, break off chunks of clay to about the size of your fist.

2. Create thick sausages by gently squeezing the clay in your palm; it's important to keep the coils an even thickness.

3. Once you have achieved thick sausages, begin rolling the clay between your hand and the surface you are working on. Keep your rolling pressure light. Simply rolling the clay over the surface will form the coil. Adding too much pressure will cause the coil to flatten. Start by placing both hands in the middle of the sausage and gently roll backward and forward, gradually moving your hands apart so the coil gets longer and thinner.

4. If your coils start to flatten, you will need to correct them. Stop rolling and squish the flattened sausage back into a rounder shape.

Pro Tip: Hold the coil at each end and twist in opposite directions to form a kind of helix; this will encourage the coils to stay round. For the projects in this book, you will want your coils to be approximately ½ inch (1.3 cm) thick.

I'll show you how to make bowls using this coil method later on page 61.

Now that you are armed with all this knowledge, it's time to put it into practice. Let's move on to the projects!

HAND BUILDING PROJECTS: EXPERIMENTING WITH FORM AND TECHNIQUES

CARVING A KIRINUKI HANGING PLANTER

Skill Level: Absolute Beginner

In this project, I am going to be showing you how to make a hanging planter using a Japanese technique called Kirinuki. The literal translation of *Kirinuki* is "to cut out." It is a way of carving a form from a single block of clay by using simple tools to cut away the clay from the outside and then from the inside. The beauty of Kirinuki is that every pot will come out completely different from the last. The deeply textured surface will emphasize whatever glaze you choose to decorate it with. It works really beautifully with darker clays and produces really interesting results with porcelain. It would even work well with air drying (clay that doesn't need firing—perfect for holding air plants). Just be aware air-dry clays will not hold water and are therefore not suitable for liquids. You can really make this technique your own by experimenting with lots of different shapes, sizes and tools to create unique textures. There really are no rules.

These little planters look great hung together in groups. This is a fun and quick project that anyone can enjoy and allows you to experiment with texture and form. It will help you get to know clay and understand the different states it goes through.

Tools

Your Essential Pottery Tool Kit (page 21)

1 lb 9 oz (700 g) buff stoneware clay

Wooden board

Large loop trimming tool (if you don't have one, you could use a blunt kraft knife or even a tablespoon)

Pottery hole punch (or you can use the end of an old Biro pen)

6.5 ft (2 m) of 3/16-inch (5-mm) cotton cord

Optional Extras

Turntable

Brayer tool

Candle wax

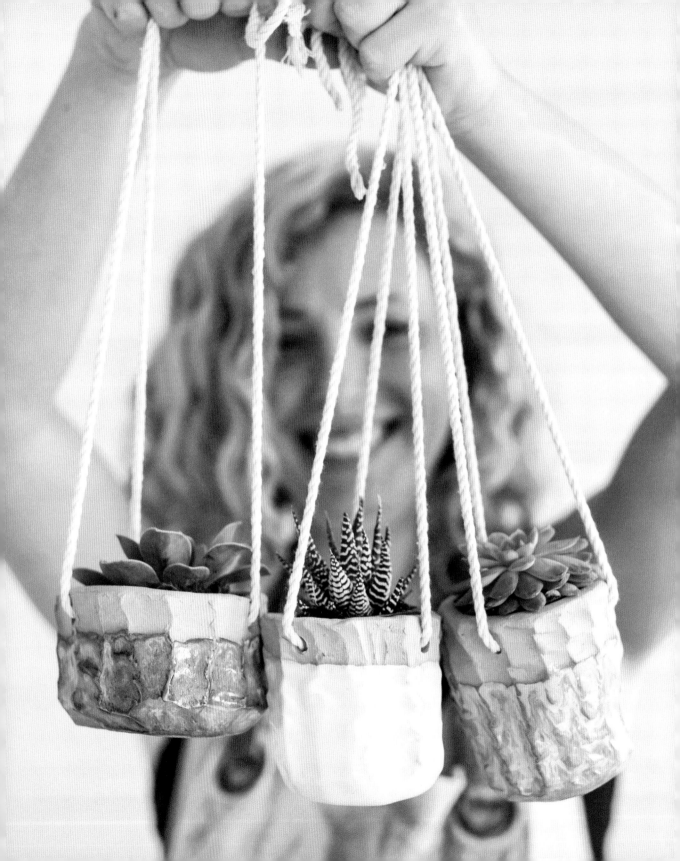

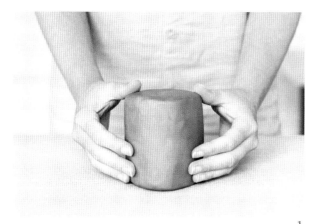

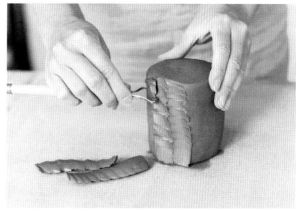

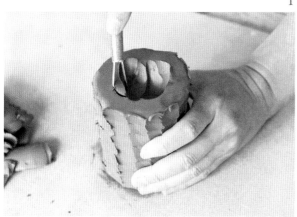

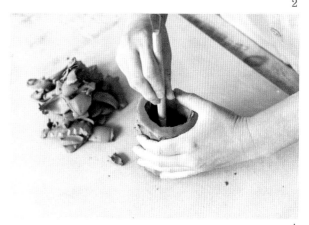

1. Weigh out 1 pound 9 ounces (700 g) of your chosen clay. I chose a buff stoneware. Prepare your clay by wedging it well using the Ram's Head wedging technique. Pat the clay into a rough squat cylinder shape with a flat bottom. For this technique I prefer to use clay that's a little bit harder than super squishy fresh out of the bag. When it's stiffer it's easier to carve and doesn't collapse so easily. My advice would be to prep the clay, leave it out to harden for a few hours or up to a day (depending on your climate) and come back to do the carving later.

2. Work on your board or turntable. Take your large loop tool and start cutting down the surface of the clay about ¼ inch (6 mm) deep toward the board. A kind of sawing back and forth stroke with your loop tool will give you an interesting texture. Work your way all around the outside, trimming off the top layer of clay. The beauty of Kirinuki is that it's really organic; it doesn't have to be neat. In fact, it's better if it's not.

3. To get more of a pleasing planter shape, bevel the bottom edge to create more of a curve. When you have the outside roughly the way you'd like it, then you can start working on the inside. Use your loop tool to carve out the inside of the hanging planter. If you don't have a loop tool you can use a spoon at this stage—just be careful to gently support the edges of your planter while you're scooping out the insides. Scooping out a small amount at a time will help to avoid smushing the walls. Keep going all the way until you get to about ½-inch (1.3-cm)-thick base. You don't want it to be any thicker than this, but be careful you don't go too far down and go through the base.

4. Turn the pot around as you are working to allow you to get access to all of the inside. You are aiming for your walls to be about ¼ inch (6 mm) thick. Be careful as the walls get thinner; they will get a little unstable. Support the wall with your hand. You don't really want the walls to be much thicker than ¼ inch (6 mm) because it will just take too long to dry out.

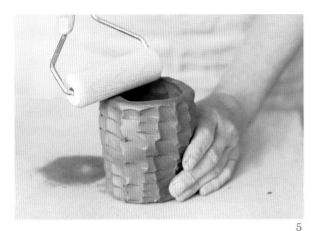

5

5 . Once the inside is all scooped out, tidy up the rim using your fingertips. A brayer tool is a great way to smooth over any rough edges (be careful to support the walls with your hand while you're doing this). Flip your planter upside down and do the same to the base. Every part of the texture you create in the clay will remain as is, meaning that it won't soften in the firing, but quite the opposite. If you have any sharp bits, you might want to soften them with your brayer or a damp sponge at this point. Give the base of the pot a little tap on the tabletop to make sure it sits straight (if you are not going to hang it).

Smooth out the inside using your fingers, being careful not to disturb the texture on the outside too much.

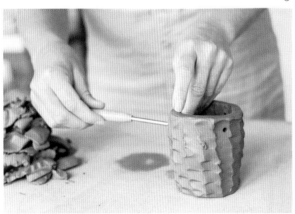

6

6 . This pot would make a lovely tabletop plant pot just as it is. Or you can add holes from which to hang it. At 6 o'clock on the pot—using your pottery hole punch or the end of an old Biro pen—make a hole at about ¼ inch (6 mm) down from the top (you don't want it to be too close or it will be weak). The hole will need to be big enough for the cord to pass through. Don't forget about shrinkage; you will need to make your hole slightly bigger to account for this. Turn your pot around so the hole you just made is at 10 o'clock and make a second hole at 6 o'clock. Now turn it again so the second hole is at 10 o'clock and make your third and final hole at 6 o'clock. This method means the holes are evenly spaced.

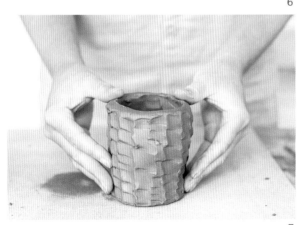

7

7 . Give it one last look over. Kirinuki is not supposed to look even or be uniform—the more organic it looks, the better. Once you're happy with how it looks, you want to set your little planter to dry upside down; this will increase air flow around the base and reduce the risk of cracking. Because the walls are quite thick, we want to make sure that you've given it long enough to dry out completely before it goes in the kiln. If your weather is quite damp or humid, then it might take longer to dry, so make sure that you've allowed plenty of time. I would normally give a pot like this at least a week before I even consider putting it in the kiln. Once it's bone dry, bisque fire it to 1940°F (1060°C), cone 04. For details on firings, go to page 178.

Pro Tip: A really good trick to test if your greenware is ready to go in the kiln is to put it against your cheek. If it feels very cold, it's still losing water, so it's not dry enough to go in the kiln yet.

For the Glaze

8 . After the first firing, prepare your hanging planter for glazing by wet sanding any sharp edges or gnarly bits (see page 142 for a detailed explanation of wet sanding). Wipe the surface of the pot with a clean, damp sponge to get rid of any dust. Dip glaze your hanging planter in a glaze of your choice (see instructions for dip glazing on page 148). I like to glaze the bottom half of my planter to just below where the holes are. I put it in the kiln upside down, resting on the rim, leaving the inside unglazed. This is really great for plants because the unglazed clay remains a little absorbent and aids with drainage.

Once glazed, fire your planter to the temperature/cone recommended by the glaze manufacturer. Remember your clay and glaze temperatures must match. I fired mine to 2231°F (1222°C), cone 6. See page 178 for an explanation of cones.

9 . Once cool and out of the kiln, take three pieces of the cotton cord that are equal in length (about 23 inches [58 cm]) and thread them through the holes from the outside in. Tie each piece of cord with a tight double knot on the end so that it won't come loose. Give it a good tug to check. Gather the three ends and tie them together in an overhand knot, which forms a loop for hanging on a hook on a wall or ceiling. Seal the ends of the cord with hot candle wax to finish them off neatly and stop them from fraying.

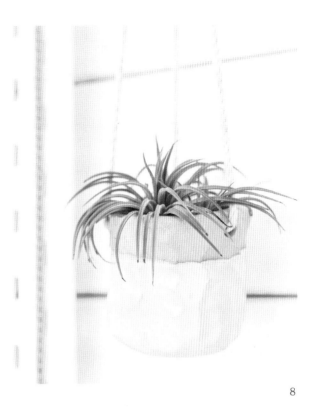

8

9

DECORATIVE
POTTERY SPOONS

Skill Level: Absolute Beginner

These spoons are super cute and make a lovely gift. You can use them for decoration, for measuring condiments or even for stirring your tea. During this project, you will be using a combination of slab building and pinching techniques. The beauty of these spoons is that because they are small you can "raw fire" them, meaning that they can go straight into a glaze firing (skipping the bisque firing) as long as they are completely bone dry. They're a great project if you are a little impatient or have irregular access to a kiln. You might not want to actually eat with these spoons because they have an unglazed bottom, and they might feel a bit rough. This project will help you learn the limits of clay—how thin it can go before it breaks, the subtle forces needed to manipulate the surface and the different way raw (unglazed) clay looks and feels compared to glazed pottery.

Tools

Your Essential Pottery Tool Kit (page 21)

1 lb 5 oz (600 g) buff stoneware clay

Wooden board

2 wooden ¼-inch (6-mm) thickness gauges

Wooden rolling pin

Container of water

Teaspoon (ideally with a thick neck)

Optional Extras

Rubber or plastic letter stamps

1. Cut the clay out of the bag using your wire tool. Weigh out 1 pound 5 ounces (600 g) of clay. Wedge it using the Ram's Head method. This should make at least 12 spoons. The more clay you use, the more spoons you can make.

Lay your weighed-out and wedged clay in the middle of the wooden board. Using your rolling pin, bash the clay to help flatten it out. You don't need to use too much force here; the clay is very soft and will flatten quite easily. You want it to be approximately 1 inch (2.5 cm) thick. It doesn't matter if it is lumpy and bumpy at this stage.

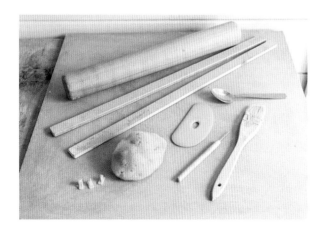

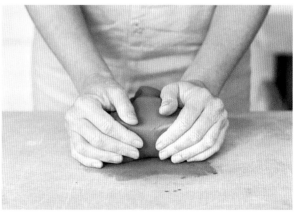

1

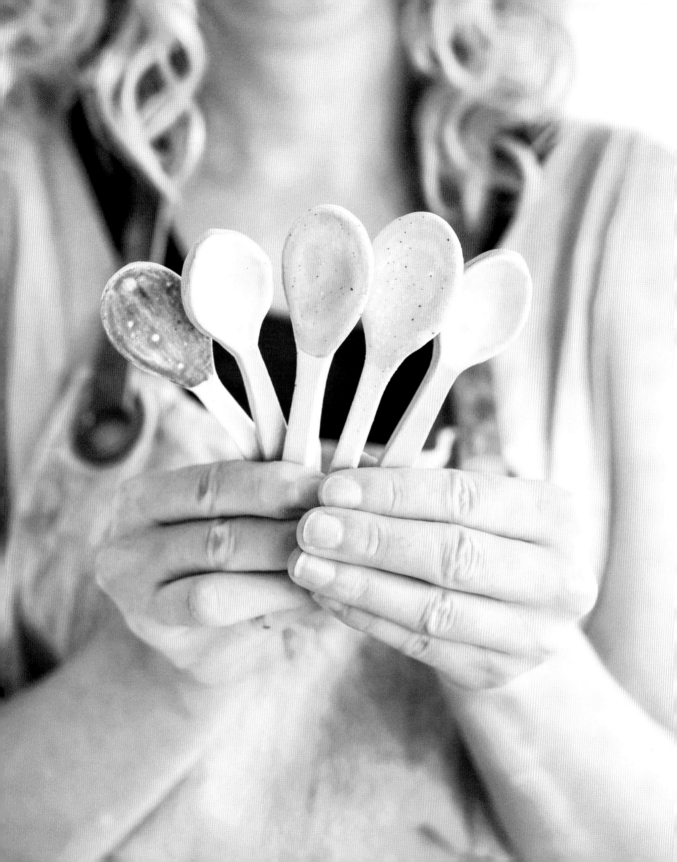

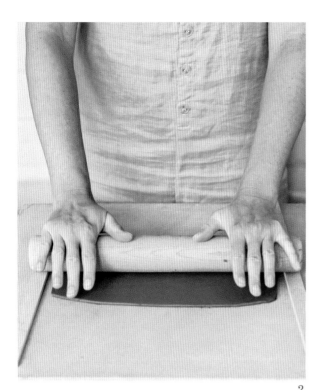

2

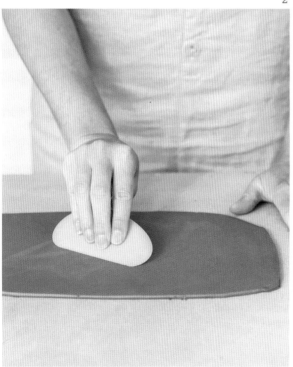

3

2 . Place the two wooden thickness gauges on either side of the flattened clay. Using the rolling pin, start rolling the clay out so it is nice and flat and even all the way round. Aim for a rough rectangle shape rather than a circle; this will allow you to cut more spoons out of the clay. You can achieve this by turning the board 90 degrees after every few rolls.

3 . Once you've rolled the clay to a thickness of ¼ inch (6 mm) all the way around, smooth the surface of the clay. Dip the straight edge of the rubber kidney or credit card into your water so it's damp (you could also use a spray bottle to moisten the clay). Then, use the straight edge to smooth over the surface of the clay, getting rid of any texture caused by the rolling. This smoothing action will strengthen the clay, bind all the tiny clay particles on the surface together, as well as highlight any air bubbles. You can gently pop these with your needle tool and smooth over the hole with your rubber kidney.

Cover the entire board with a plastic bag and leave it to dry. The plastic will even out and slow down the drying process, ensuring the clay doesn't dry out too fast. You are aiming for the clay to be at leather-hard consistency. If it dries past this point, the clay will no longer be workable. The reason we do this is so that it doesn't stick to your tools, it's not as floppy and it's a bit easier to work with. If the clay dries out too much, it will become too brittle.

Pro Tip: Keep the clay away from direct sunlight or drafts as this will cause uneven drying and potential cracks. Check the clay every few hours. Touch the surface with your fingertip; if you can leave a fingerprint easily, then it's still too wet. The clay needs to give under pressure but you want to be able to lightly touch the surface without leaving a fingerprint.

When your clay is leather-hard, gently turn it over. Do this by lifting up the shortest edge using the rubber kidney and gently peeling it up while being careful not to stretch or tear it. Using the same method as described in step 3, smooth this side. Don't get it too wet; you want the clay to retain its leather-hard consistency.

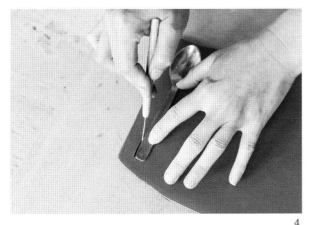
4

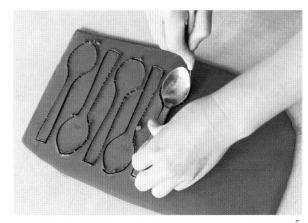
5

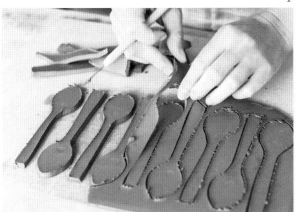
6

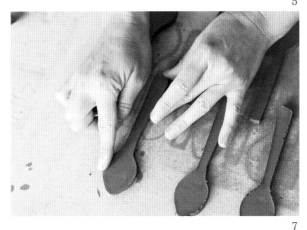
7

4 . Take your spoon (I used a 4¾-inch [12-cm]-long metal teaspoon with a nicely shaped head/bowl). The neck was ¼ inch (6 mm) wide at the narrowest point; it's best to use one with a neck that isn't any thinner than this, otherwise your spoons may be weak or break. Place it face up on the surface of the clay, parallel to one edge. Using the spoon as your template, gently hold the spoon in place with one hand, then use the needle tool to draw around the spoon cutting all the way down through the clay to the board beneath.

5 . Take your time. You're less likely to slip and accidentally cut off the head of one of your spoons. Be very careful not to make your handles too thin or they may be weak. Fit as many spoons as you can on your piece of clay. Keep going until you run out of clay. If you're finding the clay is ragged along the cut edges, then it has gotten too dry and needs to be sprayed with water to soften up.

6 . Use your needle tool to help you pick up and carefully peel away the spare clay around the edges of your spoons and move it out of the way. Roll it up; you can make it workable again by spraying it with water and popping it into a plastic bag for a few hours. Or you can wedge it with some softer clay to use again.

7 . Use a damp finger to gently smooth around the edges of your spoons where you have cut. Any snags or sharp edges will remain during the firing, so you want to make sure they are nice and smooth. Don't use too much water or the clay will get wet again and become floppy and difficult to handle. It also may start sticking to your board. Keep your finger just damp enough so it does not drag on the clay.

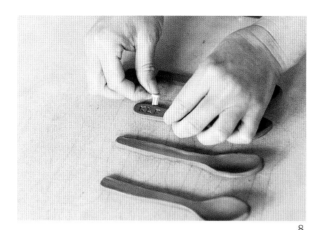

8

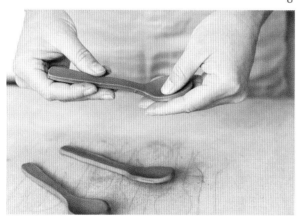

9

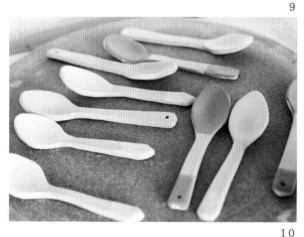

10

8 . If you'd like, use your stamps to decorate your spoons. You can personalize them by stamping or carving initials onto the end of the handles. It's best to stamp into the clay when it is on the slightly dry side of leather-hard. The stamp must also be dry, or it will stick. Push the stamp gently into the surface of the face of the spoon, on the handle or wherever you fancy some texture. Don't press too hard or you'll flatten the clay and make it thin and weak.

You can also use a needle tool to make a hole in the handle so your spoons can be threaded on a ribbon and hung on a Christmas tree or in your kitchen (be careful you don't go more than 1/8 inch [3 mm]). Remember clay shrinks, so you need to account for this with the size of the hole by making it slightly bigger than it will eventually need to be for the ribbon to pass through easily.

9 . Use your thumb to gently push a bowl shape into the face of the spoon. You can use your template spoons as a depth guide or just freestyle it. This step will make them look much more spoon-like and be functional for spooning things, meaning your chili flakes won't roll straight off. You can even add more shape to the handles; bowing them a little gives them a bit more personality than just leaving them perfectly straight. I will sometimes carve away the sharp edges of my spoons with the edge of my needle tool; this helps to give them a softer, less uniform feel.

When you are happy with the shape and texture of your spoons, leave them to dry out completely. The time it takes for your spoons will vary according to the weather. I normally leave my work to dry for at least a week (it's damp in the UK). You want your clay to look pale and feel room temperature before it goes in the kiln. If it still looks dark in any areas, it's not dry yet.

10 . Once your spoons are completely dry, you can raw glaze them, skipping the bisque firing. The best way to do this is by using brush-on glazes, as they offer more control and are less likely to damage your spoons than dip glazing. I only glaze one side of the face and the tip of my spoons (see picture), but you can glaze all of one side if you like. Don't pick the spoons up to glaze them; it is far better to leave them flat on the board. If you handle them too much there is a higher chance of breakage. If you are nervous about raw glazing, you can of course bisque fire them first, as I have done here, which will make them easier to handle.

Important: The bottom of your spoons must be completely free of glaze. Glaze is essentially glass; when melting in the high temperatures of a kiln, it acts as a glue and will weld your spoons to the kiln shelf if you do not leave the underside free from glaze. If you get glaze on the underside by accident, then wait until it is dry and scrape it off the surface carefully using the metal kidney. Use a respirator when creating any dust. If your spoons are bisqued you can simply wipe with a sponge.

For the Glaze

11. I used brush-on stoneware glazes, in colors inspired by the ocean. You can use any combination of colors you like, but always check the firing temperature of your clay and glaze, following the manufacturer's instructions on the packaging (see glazing section for brush-on glaze application details on page 143). Normally, brush-on glazes require three coats, making sure to allow each one to dry in between.

 Using a soft bristle paintbrush, stir your glaze in the pot very well for at least a minute. Use a separate brush for each different glaze color. Use smooth strokes to apply the glaze to one side of the spoon only. Don't be tempted to dab or stipple on the glaze, as you may break your spoons. Wait for each layer to completely dry before you paint the next. This may take longer on greenware than on bisqueware.

12. Be very careful when you're handling the spoons, as they are extremely fragile at this stage. If you break one, it can be recycled back into workable clay by adding water (see How to Recycle Your Clay on page 34).

 Make sure the glaze is completely dry before firing your spoons. Fire the spoons to the temperature as instructed on your glaze packaging. I fired mine to 2231°F (1222°C), cone 6 (see Stacking a Kiln for a Glaze Firing on page 184).

Pro Tip: A pottery teacher once told me that only your best work should go in the kiln. Choose the best spoons to glaze and fire. This helps you to train your critical eye—a key skill in pottery. Concentrate on making these spoons as good as they can be and recycle the rest.

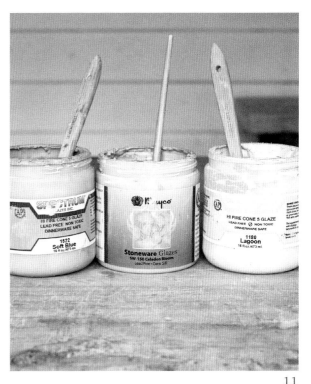

11

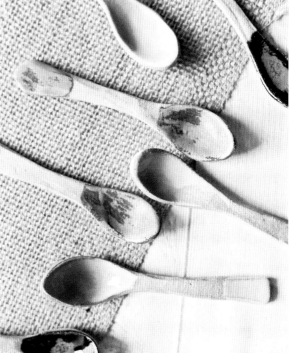

12

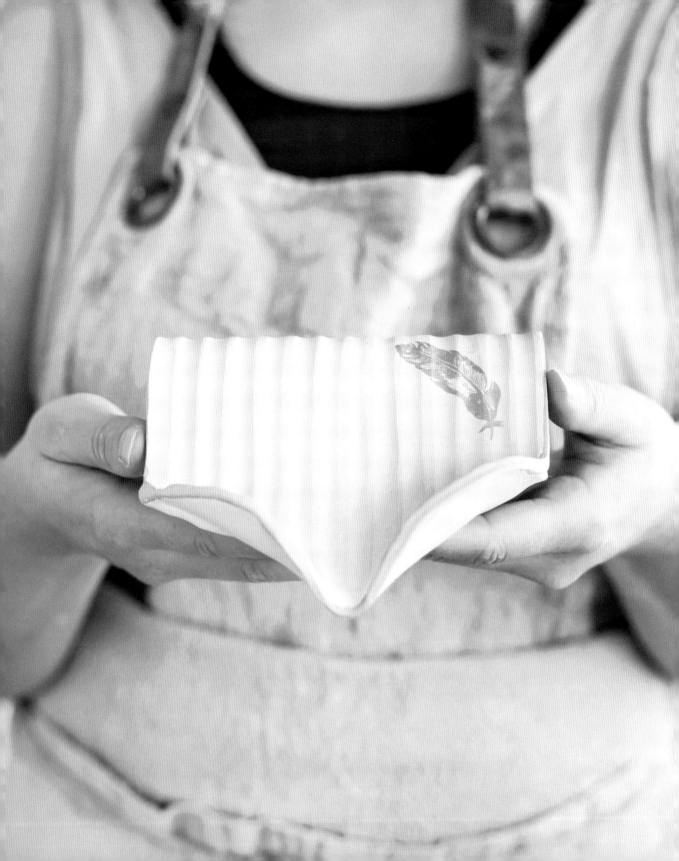

RUSTIC SOAP DISH

Skill Level: Adventurous Beginner

This Rustic Soap Dish is a beautifully simple project that is super satisfying to make and is a charming and practical addition to your home. You're only using one slab of clay in this project so it's super quick to make. This project will familiarize you with the plasticity of the clay and the importance of working with it while it's at the correct state of dryness. It will also help you practice various decoration methods including carving and decals. Don't feel like you need to glaze it how I have here—you can really make this design your own. These self-draining soap dishes look lovely in any bathroom or kitchen. Helping you to reduce plastic waste, it makes a gorgeous gift alongside some handmade soap. The upright nature of this soap dish means water drains away and the bar of soap won't get soggy.

Tools

Your Essential Pottery Tool Kit (page 21)

1 lb 5 oz (600 g) buff stoneware or any clay of your choosing

Wooden board

2 wooden ¼-inch (6-mm) thickness gauges

Wooden rolling pin

Container of water

Metal ruler

Paintbrush

Optional Extras

Serrated metal kidney

Turntable

Wax emulsion resist

1. Weigh out 1 pound 5 ounces (600 g) of clay. I am using an all-purpose buff stoneware for this project because I like the biscuit color of the fired clay. It's a good clay for hand building because it has a little grog in it. Wedge the clay using the Ram's Head or Spiral method. Pat it into a log shape.

Lay your clay log in the middle of the wooden board in front of you. Using your rolling pin, bash the clay to flatten it out. You don't need to use too much force here; the clay is very soft and will flatten quite easily. Aim for it to be approximately 1 inch (2.5 cm) thick. It doesn't matter if it's a bit lumpy and bumpy at this stage.

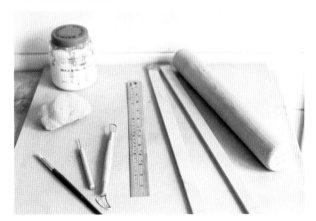

2

2 . Place your wooden thickness gauges on either side of the clay. Using the rolling pin, start rolling the clay out so it is nice and flat and an even thickness throughout. You will want a long, rectangular piece of clay to work with; you can achieve this by rolling the clay six times, then turning the board 90 degrees and rolling it three times. Repeat. You might need to shift the wooden gauges so you can get to all of the clay as it stretches out and gets longer. The final length of clay you need for a soap dish of this size should be at least 9 inches (23 cm) long x 5 inches (12.5 cm) wide. You can, of course, make your soap dish smaller if you wish. You're aiming for the clay to be an even ¼-inch (6-mm) thickness all over.

3

3 . Once you've rolled the clay out, smooth the surface. Dip the straight edge of the rubber kidney/old credit card into your water so it's damp (you could also lightly spray the clay with a spray bottle instead). Use the straight edge to smooth over the surface of the clay, getting rid of any texture caused by the rolling. This smoothing action will strengthen the clay, bind all the tiny clay particles on the surface together and highlight any air bubbles. You can gently pop these with your needle tool and smooth over the hole with your rubber kidney. Turn it over and smooth the other side, being careful not to tear it.

Leave your clay in a cool place to dry out. You want the clay to be a slightly wetter consistency than leather-hard. If it dries past this point, the clay might crack as you try to fold it. You want the clay to still be flexible enough so you can bend it easily without snapping or developing cracks, but stiff enough that it will hold its shape. If your clay has dried past this point you can spray it with water and cover it with plastic for an hour or so; the clay will absorb the water and become more plastic again.

Pro Tip: Covering the clay with a plastic bag will slow down the drying process.

4

4 . Using your metal ruler, measure out a rectangle of 9 x 5 inches (23 x 12.5 cm). Use a needle to cut out the rectangle shape. Cut off the corners of one of the short ends using the needle tool. Smooth the edges with a wet finger; this will give the piece more of a professional finish.

5

6 A

6 B

6 C

5 . Now we are going to carve your soap dish. As an alternative to carving, you could use stamps or pattern rollers to create texture (see page 172 for details on using stamps with clay). Be creative and make the design your own. Using the metal loop tool and metal ruler, we are going to carve down the length of the clay on one side. Place your ruler approximately ¼ inch (6 mm) from the long edge. Starting at the top and using the ruler as a guide, carve into the clay with your metal loop tool, pulling the loop tool through the clay to make your first groove. Don't go too deep; you want to retain at least half the thickness of the clay for strength. Shift the ruler across approximately ¼ inch (6 mm) and repeat the carving action to make another groove. Repeat this along the whole width of the clay.

6 . Now we are going to form the shape of your soap dish. Make sure your board is clean of any carving debris or it will get stuck to your project. Flip over your carved slab of clay so that the carved side faces down. You are going to be using your rolling pin as a drape mold. Place your rolling pin on the slab approximately a quarter of the way down from the short straight edge. Be careful not to squash the clay. Using your serrated kidney or needle tool, score an approximately ½-inch (1-cm) strip of the short straight edge—scoring roughs up the clay creating more surface area to stick, making the joins stronger. Add water to the scored area using your paintbrush. Fold the long side of the clay over the rolling pin and back on itself. Gently press the top slab to the scored edge fixing the two pieces together (be careful not to squash the carving texture). You should have 2 inches (5 cm) of clay "flap" still to work with; this will become the water draining channel.

7

7. Now it's time to create the water draining channel. Raise your project off of the wooden board. I used a turntable, but you can use a carboard box or simply the edge of the table; the important thing is the flap of clay is hanging over the edge. Support the outer edges of the flap of clay with the fingers of your left hand. Wet the index finger of your right hand and locate the center of the lip of clay. With small side-to-side movements, work the clay into a lip that angles slightly down. This lip will enable the water to drain away. Folding up the rounded corners will help to hold the soap in place. Your form is now finished and ready to dry.

Leave the soap dish somewhere safe to dry completely. I stood it on its side to protect the lip. Once it's bone dry, bisque fire it to 1940°F (1060°C), cone 04.

For the Glaze

8

8. Once cooled and out of the kiln, prepare your soap dish for glazing by wet sanding any sharp edges or gnarly bits (for wet sanding details go to page 142). Wipe the surface with a clean, damp sponge to get rid of any dust. You will fire your soap dish stood on its side, so the underneath can be glazed. Paint wax emulsion on the edges of your soap dish so they do not absorb any glaze (for details on wax emulsion go to page 147). The wax emulsion resists the glaze, but it's important to sponge off those areas too, as any glaze left on them that touches the kiln shelf will make it stick. I wax both edges to make it look symmetrical (the unglazed parts become a design feature). If you don't have wax emulsion resist, you can use brush-on glaze and avoid the sides of the dish with the glaze. I used a simple white stoneware glaze here, but you can use any color you'd like (see page 151 for detailed instructions on how to use pouring glaze).

9. Glaze fire your soap dish to the temperature/cone recommended by the glaze manufacturer. I have also added an overglaze decal of a gold feather as a final flourish on my soap dish and fired it a third and final time (see page 165 for details on how to use overglaze decals).

9

COILING AN ORGANIC BOWL

Skill Level: Adventurous Beginner

This is a great project for practicing hand building, as it incorporates coiling, slab building and pinching techniques. Here we are making a medium-sized bowl, perfect for serving ice cream, nibbles with friends, storing jewelry or keys or simply as decoration. This bowl can be adapted to any size by increasing the base diameter and amount of clay you use. You can use any clay you like here depending upon the aesthetic you are aiming for. Clay with some grog in it will give you a more rustic feel and works well with coiling because it is less likely to crack. I used a buff stoneware that has a little grog in it. You can leave the coils visible on the outside or smooth them away depending on the look and feel you prefer. However, if you want the bowl to hold liquid, you will need to ensure the inside coils are well blended together to make it watertight. I encourage you to make a set of four to six bowls to practice and really hone this technique.

Tools

Your Essential Pottery Tool Kit (page 21)

2 lbs 3 oz (1 kg) buff stoneware clay

Wooden board

Wooden rolling pin

2 wooden ¼-inch (6-mm) thickness gauges

Tin can, plant pot or plastic cup (I use a 3½-inch [9-cm]-diameter tin can.)

Container of water

Paintbrush

Bamboo knife

Optional Extras

Serrated metal kidney

Turntable

Brayer tool

1. Using the wire cutter, cut 2 pounds 3 ounces (1 kg) of clay from your bag. Wedge the clay using the Cut and Slam method and then the Ram's Head to make sure it's thoroughly mixed. Then, cut the clay into approximately six ¼-pound (100-g) lumps of clay. You'll be left with approximately 14 ounces (400 g) to make the base.

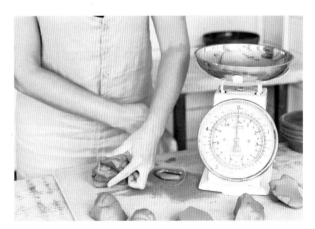

1

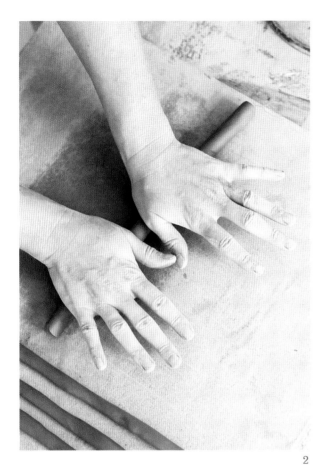

2 . Begin coiling. We are going to use the same method described in the coiling introduction (page 44). Take one of the ¼-pound (100-g) lumps of clay and squish it into a thick sausage. Place it on the wooden board and start rolling it with your fingers and the palm of your hand. Use gentle, even pressure. Once the coil has gotten long enough that you can fit both hands on it, begin stretching it out further by using both hands and rolling away from the middle toward the edges. If the coil does begin to flatten, stop rolling and reshape it to be round. Keep moving your hands along the clay length to make sure you're rolling it evenly. Each coil should end up being ½ inch (1.3 cm) thick, approximately the width of your finger. The coils might seem a bit thick at the moment, but don't forget that some of the thickness in the coils will be lost when you squish it into the clay beneath it. Repeat for all six lumps of clay; these will form the walls of your bowl.

Pro Tip: Twist the ends in opposite directions to create a helix; this will help keep the coil from flattening.

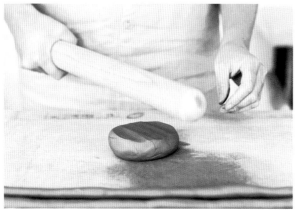

3 A

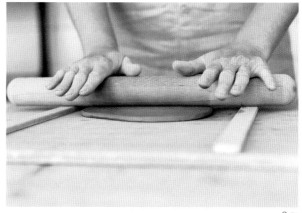

3 B

3 C

4

3 . Pat the remainder of the clay into a ball to make the base of the bowl. Working on your wooden board, gently tap the ball with the rolling pin so it begins to flatten. Rotate the board 90 degrees every couple of taps. Then, using your wooden thickness gauges or chopsticks, roll the clay out so that it's ¼ inch (6 mm) thick. Rotate the board 90 degrees every couple of rolls so the slab becomes a circle rather than an oval. Smooth over the slab of clay on both sides with a damp rubber kidney; this will make it stronger and less likely to warp.

4 . For the base of your bowl, use a tin can, plant pot, plastic cup or other round object of your choice as a template. I used an old tin can. Place the tin lightly upside down onto the clay. Using your needle tool, carefully cut through the clay down to the board all the way around to make a circle. Take away the waste clay from around the outside and put it back into your bag to use for another project. You now have the base for the bowl.

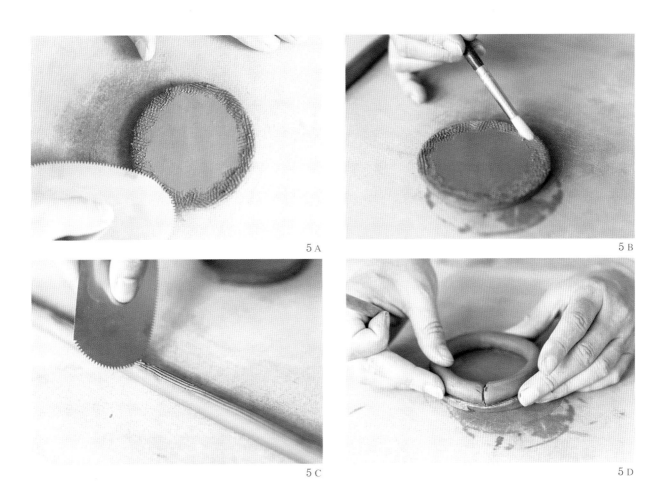

5 A

5 B

5 C

5 D

5 . Using your needle tool or serrated metal kidney, score ¼ inch (6 mm) around the outer edge of the circle; this is where your first coil will be laid and attached. Use a paintbrush to add a little water to the scored area of clay. Take one of your coils and score along the full length of one side. Using the paintbrush, wet the scored edge of the coil. Take the coil and lay it score side down on top of the scored edge of the base, adjusting it so you have a nice round shape.

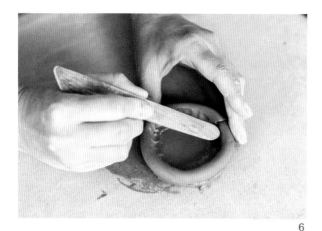

6

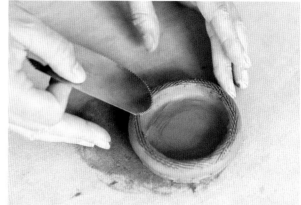

7 A

7 B

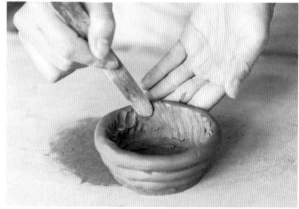

7 C

6 . With your needle tool, cut the end of the coil on a diagonal where it overlaps in order to form a neat join. Using the curved end of your bamboo knife, work the clay from the middle of the coil into the base thoroughly on the inside all the way round. Take your time to ensure the two pieces of clay blend to become one. Don't worry about tidying it up too much at this stage, you will do that last. This is the beginning of your bowl.

7 . With your needle or serrated kidney, score the top of the first coil and along the whole length of a second coil. Wet the scored areas with a paintbrush to create the slip (clay glue) and lay the second coil on top of the first. Place each new coil slightly wider than the last so your bowl curves outward. You want your bowl to grow outward as well as upward. Repeat this step with the rest of your coils. You will need to support the side of the bowl with your hand while blending the coils together, as it will get a little unstable as it grows. Depending on how thick you made the coils, your bowl should be 3 to 4 inches (8 to 10 cm) tall. If you run out of coils before reaching the bowl size you desire, simply prepare more clay and roll more coils. The taller your bowl grows, the more unstable it will become, so you may need to wait for it to dry slightly before adding more coil layers. Instead of turning the bowl, turn the wooden board as you're working; this will make it easier to access all of the interior. (This is where a turntable comes in handy.)

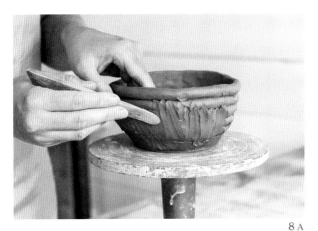

8 A

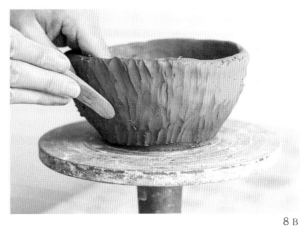

8 B

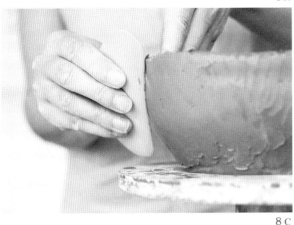

8 C

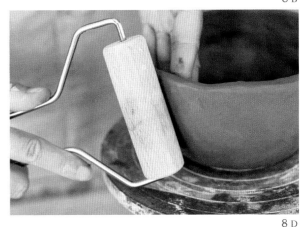

8 D

8 . Smooth over all the joins on the interior with the end of the bamboo knife and then your fingertip. Use the curved edge of your rubber kidney to help get rid of any unwanted texture and create a strong, smooth surface. You can leave the coil texture visible on the outside of your bowl. If you prefer to erase the coil texture on the outside like I've done, blend the coils together with the bamboo knife, like you did in the interior. Leaving this texture could create really interesting glaze results. If you want a smooth surface, use the rubber kidney to help smooth over any unwanted texture, using the flatter side this time. You can also use a wooden brayer tool over all the outside surfaces to give it a really smooth finish.

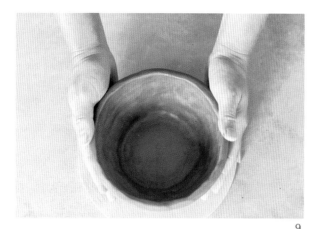

9

10 A

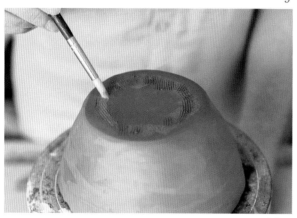

10 B

10 C

9 . If the walls still appear a little thick, pinch them between your fingertips all the way around to refine them. You are aiming for the walls to be no more than ¼ inch (6 mm) thick.

Pro Tip: Adding a foot ring on a bowl elevates the form. It will give your bowl a shadow and a feeling of lightness. It's worth that extra effort. To add a foot ring, go to step 10. To skip this step, dry and bisque fire your bowl as directed at the top of page 69.

10 . Once your bowl is the correct height and width, you can add a foot ring. Adding a foot will make your bowl look more finished and professional. The foot will remain unglazed and raise the bowl off the kiln shelf so you can glaze the underneath if you desire. Ideally, you would wait for the bowl to stiffen up slightly before adding the foot (this will make the bowl less likely to collapse).

Make a coil ½ inch (1.3 cm) thick. Carefully turn the bowl upside down and place the coil lightly on the base, creating a circle approximately ¼ inch (6 mm) away from the outside edge. With your needle, score lightly around the coil to mark where it will be, remove the coil and score, with your serrated kidney or needle, where the foot will sit. Score along the full length of the coil on one side. Add a little water to the scored areas. Place the coil into the scored circle and then, with the end of the bamboo knife, blend together each side of the foot into the bowl, being very careful not to crush your bowl. You may need to support the underside while you are doing this. Smooth over the blended join with your fingertips to neaten it, finishing with a damp paintbrush.

Dry your bowl slowly under a plastic covering for a few days. Check the bowl every so often to make sure no cracks develop. If the bowl is cracking as it dries, this means the pieces of clay were not blended together well enough. While it would be tempting to try to fill the cracks with clay, in my experience, this rarely works and the cracks just keep forming. It's better to recycle the bowl and start again.

Once the bowl is thoroughly bone dry, fire it to bisque temperatures. I fired mine to 1940°F (1060°C).

For the Glaze

11. Prepare your bowl for glazing (see Prepping Your Pots for the Best Glazing Results on page 141). Now you are going to glaze your bowl. I used a simple white speckled dipping glaze (you can of course choose any color you desire). Make sure you match the firing temperature of the glaze to the firing temperature of your clay.

12. If you made your bowl without a foot ring, wax the bottom and then follow the instructions on page 148 for the dipping or brushing glaze technique. If you made the bowl with the foot ring, wax the foot ring and follow the steps outlined in step 13 below.

13. Pour the glaze into the bowl, hold it for 3 seconds and then pour it out. Wipe off any drips or spills on the outside. Wait until the interior glaze has fully dried and then glaze the exterior. Hold the bowl by the foot, dip it into the glaze and hold it for 3 seconds to allow it to absorb enough glaze on the surface. Then, gently pull the bowl back out of the glaze and allow any drips to fall back into the glaze bucket before turning it upright.

Tip: If the foot isn't quite big enough for you to hold, you can glaze the whole bowl by dipping it using tongs instead (see page 148 for details).

To glaze under the foot, use a small jug to pour a little glaze into the inside rim of the foot, hold for 3 seconds and then pour away. Be careful to wipe away any glaze that goes on the bottom of the foot or your bowl will get stuck to the kiln shelf. Allow the glaze to dry thoroughly. I normally wait a full day before I will fire glazed work.

Fire the bowl to stoneware temperature, being careful to follow the glaze manufacturer's temperature guidelines. I fired mine to 2231°F (1222°C), cone 6.

11

12

13

SIMPLE SLAB-BUILT MUG

Skill Level: Adventurous Beginner

My pottery students are often most excited about making their own mug. There really is something special about creating a functional item that you can use every single day for your morning coffee or tea. Making a mug really isn't as tricky as you may think, and by using this simple hand building technique, you can create gorgeous unique designs that can be used and adored. Decorate your mug with one of the glazing techniques (see page 143 for Basic Glazing Techniques) in this book or use underglaze decals to add pattern or even a touch of gold from overglaze decals (see page 165 for Decorating Techniques). The clay I am using in this project is my favorite buff stoneware, which is chocolate brown when raw but fires to a warm biscuit color. Choose a clay that suits your aesthetic. Stoneware is the most practical for food items.

Tools

Your Essential Pottery Tool Kit (page 21)

2 lbs 3 oz (1 kg) stoneware clay

Wooden board

Wooden rolling pin

2 wooden ⅛- or ¼-inch (3- or 6-mm) thickness gauges

Container of water

Scalpel

Metal ruler

Cutting board

Thin cardboard or thick paper

A cylindrical object measuring approximately 3½ inches (9 cm) in diameter (I am using an old glaze tub)

Paintbrush

Scissors

Optional Extras

Serrated metal kidney

Brayer tool

Wax resist

Cutting the Templates

1. Weigh out 2 pounds 3 ounces (1 kg) of clay. Prepare the clay by wedging it well using either Spiral wedging or the Ram's Head method on your absorbant surface. Use your rolling pin to bash the clay to be roughly 1 inch (2.5 cm) thick. Then, roll it out in between the wooden thickness gauges. Aim for a long rectangle shape here, as the mug requires a long piece of clay for the body. This needs to be at least 11½ x 3½ inches (29 x 9 cm). Remember shrinkage will mean the mug will be 10 to 15 percent smaller after it's fired.

1

2

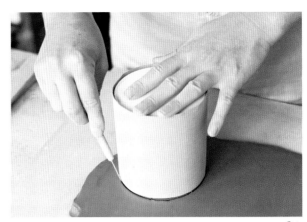

3 A

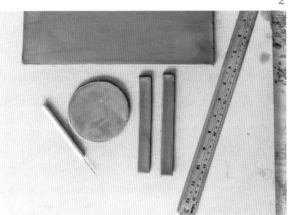

3 B

4

2. Once you've rolled the clay approximately ¼ inch (6 mm) thick all the way around, you want to smooth the surface. Dip the straight edge of the rubber kidney/credit card into your water so it's damp. Then, use the straight edge to smooth over the surface of the clay, getting rid of any texture and popping any air bubbles. Carefully lift the clay and turn it over. Use the rubber kidney/credit card to smooth the other side.

3. To make the body of the mug, I used a template made from a thin card (an old postal envelope works well). Using the scalpel and metal ruler, on the cutting board cut out a rectangle from the cardboard measuring 11½ x 3½ inches (29 x 9 cm). Draw around your cylindrical object to make the base. Use one of your wooden thickness gauges as a template for the handle and cut around it to create a long, thin rectangle measuring 5 x ¾ inches (12.5 x 2 cm). Using templates like this ensures that you can easily make multiple pieces of consistent size.

You want the clay to dry out a little before cutting it. You are aiming for the clay to be a slightly wetter consistency than leather-hard. Aim to dry the clay evenly and slowly. Cover with plastic if need be. The clay still needs to be flexible enough so you can bend it easily without snapping or developing cracks, but stiff enough so it will hold its shape. If your clay has dried past this point, you can spray it with water and cover with plastic for an hour or so; the clay will reabsorb the water and become more plastic again. Once the clay is the correct consistency, place the templates on the slab of clay and carefully cut around them using your needle tool. You now have the pieces which make up the mug: the body, the base and the handle.

4. Form the handle by draping it over your wooden rolling pin, creating a nice curve. Allowing the clay to dry to leather-hard while in this shape helps prevent cracking. I always make two handles just in case one goes wrong.

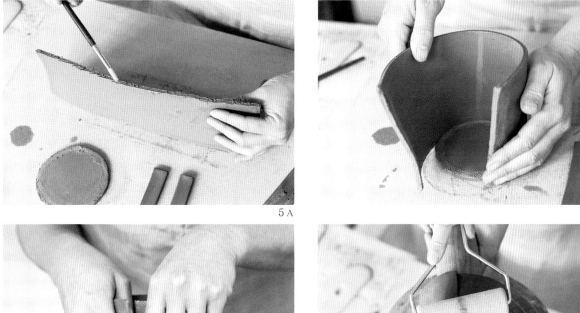

5 A

5 B

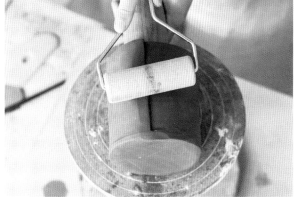

5 C

5 D

Constructing the Mug

5 . Now that you have your mug body, base and handle, it's time to construct your mug. Use your serrated kidney or needle to score ¼ inch (6 mm) around the outer edge of the base, the long edge of the rectangular slab and where the two edges of the rectangle will overlap. Using a brush, apply some water to the scored areas. Curve the clay rectangle around to form a cylinder ensuring it's the same diameter as the base. Use your brayer tool to gently but firmly roll over the joins to ensure the body is securely attached to the base. Thread the rolling pin into the cylinder to offer support as you secure the joins. If you don't have a brayer tool, simply press the pieces together with your fingers.

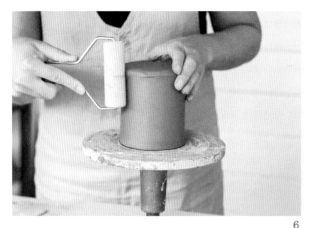

6

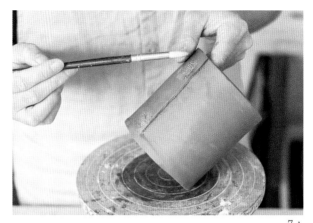

7 A

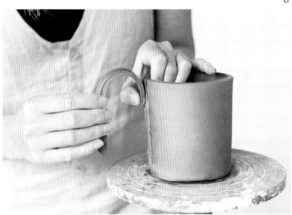

7 B

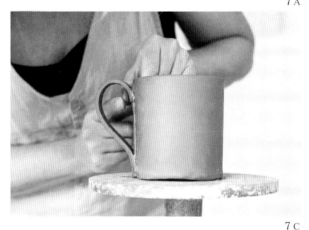

7 C

6 . To ensure the body of the mug is bonded well to the base, turn the mug upside down. With gentle pressure, use your brayer tool to roll over the base, being sure to concentrate on the edges where it meets the walls (if you don't have a brayer tool you can just use your fingers). Use a damp paintbrush to clean up any score lines on the inside join.

7 . Attach the handle. Line up the handle with where you would like it to sit on the mug (the join on the mug body is the strongest place for the handle to go). Use your needle tool to lightly mark where you want the handle. Score the mug body where the handle will be attached. On the side of the handle, where it will join to the body, score ¼ inch (6 mm) of the short edge with your serrated kidney or needle tool. Add water to the scored areas using your paintbrush. Carefully line up the handle to make sure it's sitting straight, and gently push on the ends of the handle to join it to the body of the mug. It is important to support the inside of the mug while you are doing this so as not to squash it.

8 . Use a damp sponge or a paintbrush to go around the edges of the handle and all the joins, tidying up any scrappy edges, inside and out. Use a damp finger to get rid of any scoring marks you don't want. Leave the mug upside down to dry, away from drafts and direct sunshine.

Pro Tip: Paint on wax emulsion on the area where the handle meets the body of the mug. This will slow down drying and help avoid cracking. The wax will burn off in the kiln during the bisque firing.

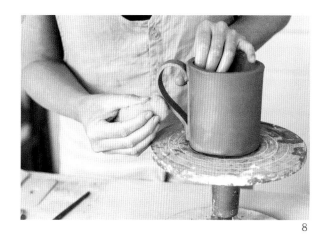

8

When the mug is completely bone dry, fire it to 1940°F (1060°C), cone 04.

Glazing Your Mug

9 . To get your mug ready for glazing, follow the detailed steps in the Prepping Your Pots for the Best Glazing Results section (page 141). Take extra care, wet sanding around the handle and the rim, to make sure there are no sharp edges. Wipe all surfaces of the mug with a clean, damp sponge to get rid of any dust. Choose a glaze for your mug that is dinnerware safe (manufacturers will have health and safety guidance on the labeling).

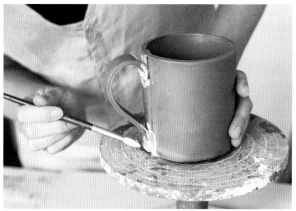

PT

I created the pattern on the bottom half of the mug using underglaze decals (for detailed instructions see Decals: Printing on Clay on page 165). I first glazed the interior using a clear glaze. Using a jug, I poured the glaze into the mug, swirled it around for a few seconds to coat the inside and poured it back into the bucket. I then dip glazed the top third into a green dipping glaze by holding the mug upside down and dipping it into the glaze up to one third from the base. Then, I dipped the handle. The underglaze pattern provides an attractive contrast to the drippy glaze.

Glaze fire your mug according to the glaze manufacturer's instructions. This glaze was fired to 2231°F (1222°C), cone 6.

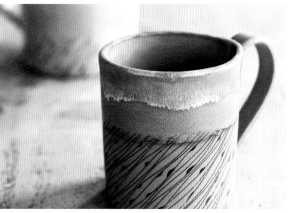

9

THROWING ON THE POTTER'S WHEEL

Body & Machine Working in Harmony

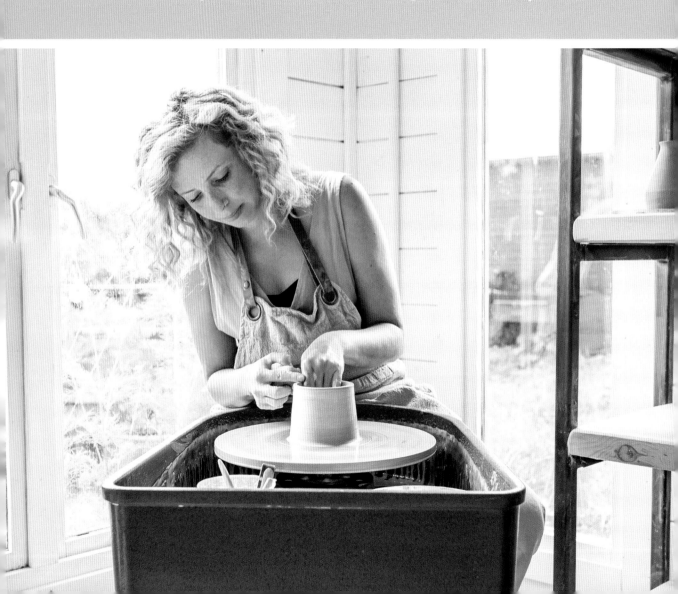

Throwing requires us to engage both physical skill and mental skill. I often compare learning to throw on the wheel to learning to drive a car—at first there seems to be so many things you need to remember. At the beginning, it may feel a little like rubbing your tummy and patting your head at the same time. Eventually though, like driving, throwing will start to feel more natural and muscle memory will take over. You'll be able to listen to music, an audiobook or even have a conversation while you throw. With practice, it will become a thoroughly enjoyable, relaxing experience.

There's an old saying that's shared a lot among potters: It takes 10 minutes and 10 years (of practice) to throw a good pot.

In the modern world we have become so used to doing things quickly with our hands: typing, texting, swiping on a smartphone. Throwing on the potter's wheel forces us to become super aware of each one of our fingers and our entire body. You will need to slow down; every movement must be controlled and feel almost rhythmical. You need to be mindful of each gesture and every finger placement. Never rush throwing. Always allow yourself enough time to get absorbed in the process. It may sound a bit out there to say, but if you come to the wheel feeling rushed, this will come out through the clay and likely nothing you do will turn out right. Breathe!

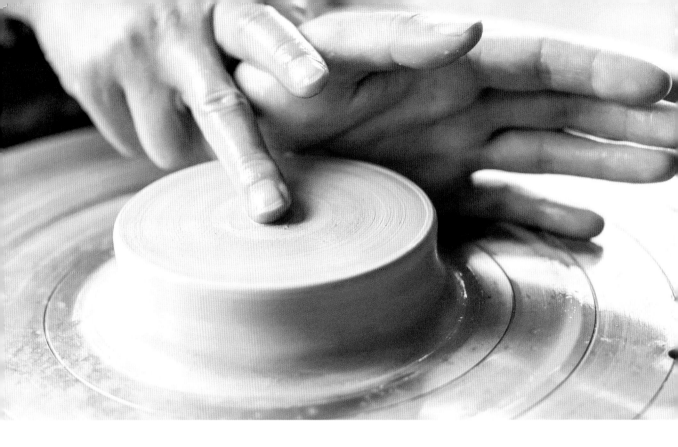

THE BASICS OF THROWING: THE THREE "Cs"

The three Cs are the three basic skills you need to master to successfully throw on the potter's wheel: centering, coning and cylinders. Breaking them down into their individual stages makes it easier to master each one separately and then combine them.

I'm going to walk you through each of those processes step by step to get you started. The only real way to get good at throwing is to practice. And when I say practice, I mean hours and hours at the wheel repeating each of the steps over and over. I know you are super keen to actually make something on your first go on the wheel, but I urge you to use the time you have to practice these steps first. This will develop your skill much further than if you just try and make something from the get-go.

To help demonstrate hand gestures and movements, I refer to key points on the wheel as times on a clock face. Imagine the wheel head is a clock face: 12 o'clock is the furthest point away

from you and 6 o'clock is closest to you. When throwing, you'll mostly be working between 3 o'clock and 9 o'clock positions. I'm right-handed and my wheel is traveling counterclockwise. If you are left-handed, you will need to mirror your hands and your wheel will be travelling clockwise.

For all the throwing projects, you will need the studio essentials and throwing tools mentioned on pages 21 and 22. Remember to pick a good clay for practicing throwing; ask your pottery supply store to recommend one.

An uncentered piece of clay will turn into a wobbly pot. It is important for your clay to be perfectly centered on the wheel before you begin making anything. This will ensure the walls of your pot are nice and even. Even if your clay is only very slightly off center to begin with, the centrifugal forces of the wheel spinning will mean it will only get increasingly off center until eventually it may even fly off the wheel!

Centering: How to Easily Center Your Clay

1. Cut 4 pounds (1.8 kg) of your clay of choice using your wire cutter. Before you start throwing on the wheel, you want to prepare your clay really well by following the steps explained in Preparing the Clay (page 28). Make sure that you've wedged your clay to get rid of any air bubbles. Use either the Spiral method or the Ram's Head method to make sure it's nicely homogenized and ready for throwing. If there are dry bits or wet bits in the clay, they will make this process doubly hard for you, so don't skip this step.

 For this practice session, cut your clay into four 1-pound (450-g) lumps of clay. Pat your clay into balls. Throwing a round ball is much easier than throwing with clay cut straight out of the lump, which is likely to have all kinds of funny angles on it. You've also likely had to add bits of clay to make up the weight; this can trap air and make it really hard for you to convince the clay to go into the center of the wheel. Try and smooth over any scars or creases to reduce the chance of air bubbles. Re-wedge each ball a little if necessary.

2. Dampen your finger and wipe a little water on the metal of the wheel; this will help the clay stick. Don't use too much water or it will have the opposite effect and your clay will slide right off. Throw your ball of clay down as close to the center of the wheel as possible. It doesn't matter if it's not perfectly centered, you can just give it a little tap to get it more or less into the middle.

3. Your body position is key when throwing. Sit as close to the wheel as possible. I have my stool right up against the side of the splash pan. Sometimes the wheel has a built-in seat. If you are small like me (5' 1"), you may need to use a cushion to boost yourself up. Your inner thighs should be touching the splash pan of the wheel. Make sure the pedal is in a comfy position and your leg isn't overstretched. You want the weight of your upper body to be over the top of the wheel head so you can really lean into the clay. If you sit too far away from the wheel, you're going to be relying on your arm muscles and not on your skeleton; you'll get tired quickly and centering the clay will be much harder.

4. The key to centering your clay is to make sure your foundation arm is strong and consistent. This is what is going to persuade the clay into the center of the wheel with ease. I'm right-handed so my wheel is going to be turning counterclockwise, therefore my foundation arm is my left arm. If you're left-handed,

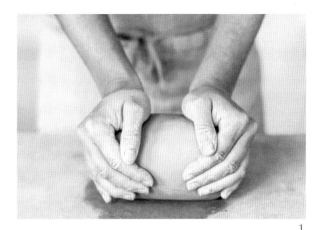

1

2

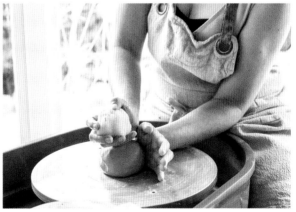

3

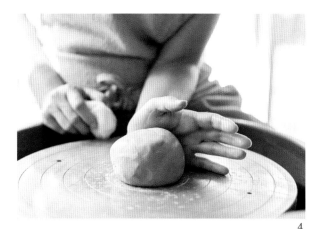

4

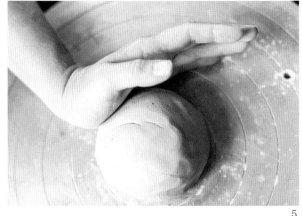

5

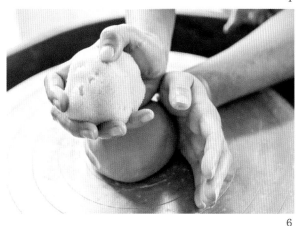

6

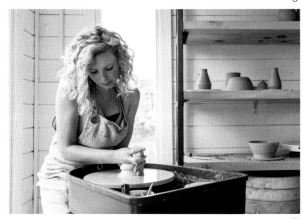

7

then you want the wheel to be going clockwise and you'll be using your right hand as your foundation. Tuck your foundation elbow into the crook of your hip, where your leg joins your body. Remember to use your skeleton rather than your muscles to make things easier and prevent injury.

5 . While the elbow of your foundation arm is in the crook of your hip, brace the heel of this hand (careful not to involve your fingers) against the ball of clay at about 7 o'clock. The more you have in contact with the clay the more water you'll need to use. You want to try and keep your water usage to a minimum without the clay ever getting tacky.

6 . Get your sponge completely full of water in your dominant hand (I use a responsibly sourced natural sponge because it won't rot in the water and go smelly). Your sponge will provide a constant dribble of water onto your clay so it stays glossy at all times. You never want your clay to get dry and sticky while you're throwing because that causes friction, the leading cause of pulling it off center. Your dominant hand is going to be on top of the ball of clay putting downward pressure with the side of your fist.

7 . Now that you have your body in the right position with your hands supporting the clay so it doesn't fly off, turn your wheel to full speed. Lean in toward the clay. Remember to keep the clay glossy with water at all times. The rotation of the wheel and the resistance you are putting on the clay will force it into the center of the wheel. You want the wheel to be doing the work for you. Full speed is best.

8 . You want to get that clay into the center of the wheel as quickly as possible, because that means you have more time to work with the clay. The longer you take

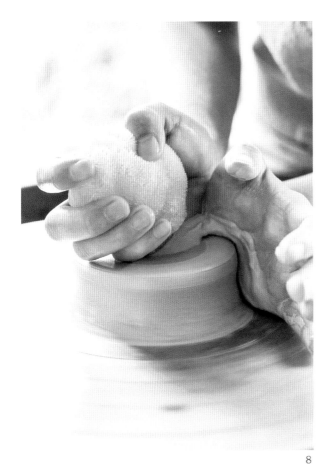

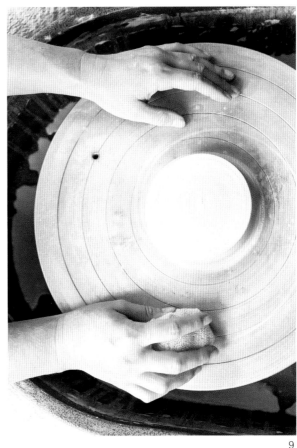

8

9

to center, the more water the clay will absorb and the more clay will erode into your splash pan. You should aim to center your clay within 10 to 15 seconds. With practice it should only take 3 to 5 seconds to center an average-sized ball of clay.

Your hands should be perfectly still; if there is any kind of wobble, then your clay is not centered. If this is the case, check your foundation arm is braced and solid. Lean in a little more, increase the pressure down and inward very slightly; this will persuade the clay to center on the wheel. It may take a fair few rotations of the wheel for the clay to move into the center. Be patient; 5 seconds is longer than you think.

9. Once you are confident your clay is centered, move your hand away from the clay slowly. If you jerk away too quickly you can pull the clay off center. The clay will look perfectly stationary as the wheel continues to turn.

When you have your ball of clay centered, cut it off the wheel. Yes, you read that right! Cut it off the wheel and do the exercise again with the next ball. Once you have centered that ball, cut it off the wheel again. Repeat until you have run out of balls. Make another four balls and do it all again. And again. The aim of this is to get this step ingrained into your muscle memory, meaning you don't really have to think about it, you just feel it. This is the only way to truly nail throwing. Once you're confident with centering, then move onto coning up.

Put all your used clay balls to one side to dry out a little before wedging it up and starting again.

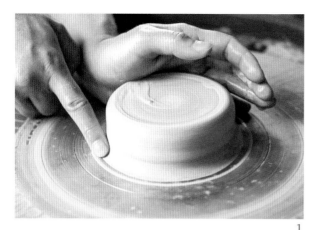

1

Coning Up: How to Cone Up and Why

Coning up is the second of the three Cs in the wheel throwing process that you will need to master before being able to make a successful pot. We cone up for several different reasons: it helps potters to center the clay in the middle of the wheel and it helps homogenize the clay particles together, mixing the clay by forcing it up into the cone shape and then pushing it back down, ready to shape into a cylinder. It is also useful in eliminating any pesky air bubbles that may be left over from wedging (they get forced up through the middle and out through the top). You can sometimes hear them pop as the air is released by the clay. I cone my clay one to two times before I go on to create a cylinder and then the final form. Coning is essential to achieve an even-walled, level and symmetrical pot. I also find coning makes the final shaping part of the throwing process much easier.

1. Weigh out 4 pounds (1.8 kg) of clay and prepare it by wedging and cutting it into four balls. Take one ball of clay and center it on the wheel as quickly as you can, following the steps laid out in the previous section. Immediately after you have centered your clay, hold your sponge in your dominant hand. Get your sponge full of water—think of it as your reservoir. Ensure the elbow of your foundation arm is in the crook of your hip. Make sure that your clay is glossy with water.

 Hold your index finger next to where the clay meets the wheel, with the wheel turning half speed for two to three rotations. This will help to create suction, which sticks the clay to the wheel, reducing your chances of pulling the ball of clay off the wheel head.

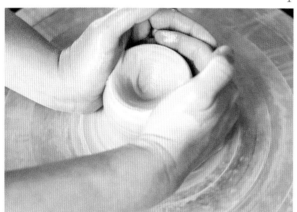

2

2. With the wheel travelling at full speed, position your hands at opposite poles of the clay, left hand at 7 o'clock and right hand at 2 o'clock with your foundation arm braced. Use the heels of your hands rather than your palms. Applying even pressure (as this will dry out your clay less), pull the clay toward you with your right hand and push the clay away with your left, essentially squeezing it together to form a cone.

3. Keep your hands low on the wheel head; don't be tempted to follow the clay up immediately as it rises. Focus on pushing your hands together rather than pulling up, so that you are less likely to pull the clay off the wheel. Keeping the clay between the heels of your hands rather than your fingers will give you the most amount of stability.

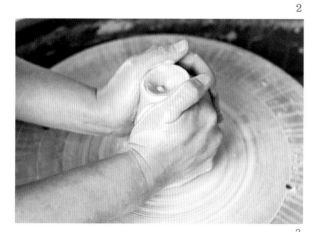

3

 It doesn't matter if your clay goes off center during the coning up part of the process, because as you cone back down it will be pushed back into center. So, don't panic if it gets a bit wobbly as you're coning up.

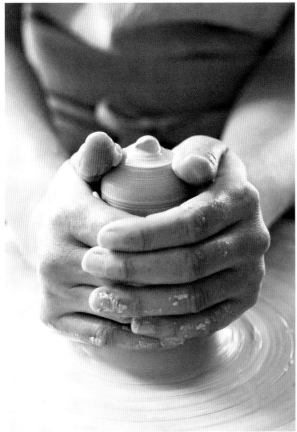

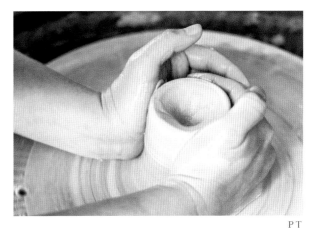

PT

PT

4

4. You want to make sure that you give that clay enough time to move into the cone shape. If you think about it, you're asking the clay to move quite a long way, so make sure that you keep your hands steady and in the same place for long enough. In reality, this should only take 20 seconds, but that can feel like a long time for our modern brains. So many beginner potters move their hands too soon because they get frustrated and want to try a new position, but actually they just haven't given the clay enough time to respond to what you are asking it to do.

Pro Tip: If you find you're getting a kind of volcano-like crater in the middle, this is because the middle of the clay lump always takes much longer than the outside to rise up into the cone shape. Try keeping your hands lower down on the clay toward the wheel head and focus on pushing them toward each other to allow the middle of the clay to catch up with the outside. It may take longer than you think for the clay to move—be patient. Don't rush to move your hands into trying a new position until you have given the clay long enough to react to what you are asking it to do.

Always think logically about the forces you and the wheel are exerting on the clay: the wheel is forcing the clay outward against your hands, so pushing on either side of the clay will force it up as that's the only place that the clay can go.

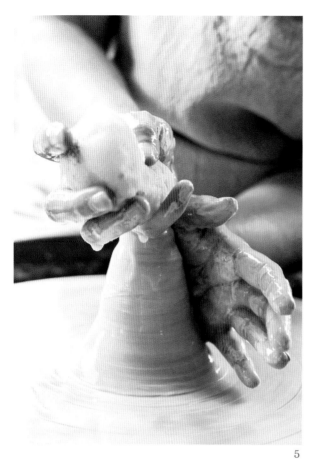

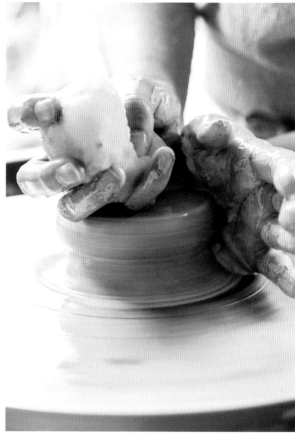

5

6

5 . When the clay is in a nice cone shape (not a volcano), take your dominant hand in a fist and place it on the top of the cone. Push the clay back down with the heel of your hand or the side of your fist, keeping it steady with the other hand supporting the side. The elbow of your foundation arm should be securely positioned in your hip at all times. Use your sponge to provide water. Keeping a water-filled sponge in your right hand means you don't have to keep going back and forth to your water jug, which may well pull the clay off center and cause you to lose your hand position.

6 . Repeat steps 1 through 5 to cone your clay up and down twice. Be mindful that speed is of the essence; the longer you take for the first steps in the throwing process, the more water your clay will absorb and the more clay will erode into your splash pan. You want to practice this to become quick at it. The whole process of centering and coning up this amount of clay shouldn't take you longer than 1 minute. (Obviously the bigger the ball of clay the longer it will take to move—but not much!)

Cut the ball of clay off and start again. Repeat steps 1 through 6. Repeat, repeat, repeat!

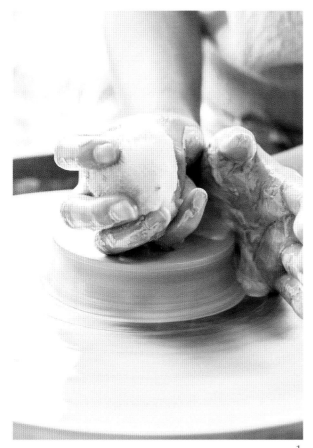
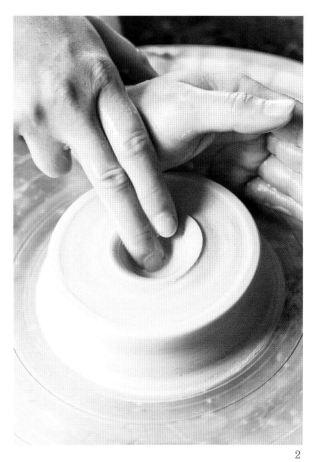

1

2

Cylinders: Pulling Up the Walls

The third of the three Cs is cylinders. Cylinders are the basis of most pottery shapes thrown on the wheel. From mugs to bowls, bottles, lemon juicers and vases, they all have one thing in common: after centering and coning, they start out as a cylinder. If you can master throwing a good cylinder with good height and even thickness walls, then you can pretty much throw any other shape. This cylinder I am showing you here is a good starting point for most size mugs using 1 pound (450 g) of clay.

1. Center your clay and cone it up twice. Make the clay into a disk shape the same diameter as the base of the form you are going to make. For example, if you want to make a mug of 3 to 4 inches (8 to 10 cm) in diameter, then that is the diameter of the clay disk you are aiming for. Your foundation arm should be secure with your elbow in the crook of your hip (it never really leaves). Ensure the clay is glossy with water.

2. Adjust your wheel so it is going at about three-quarters speed. Support the clay lightly with just the heel of your left hand. Anchor your right thumb over your left to give it support, making sure it's nice and stable for opening out the clay (remember, if you are left-handed, you'll need to mirror all steps). Use your middle finger on your right hand to locate the middle of the disk of clay. Only when you have found the middle, begin to push down through the clay, making a hole. Stop when you have neared the base, approximately ¼ inch (6 mm) from the wheel head.

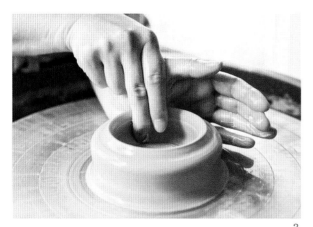

3

Pro Tip—The Needle Trick: Lots of students ask me how do they know how far down they need to go. There is a little cheat I can share with you. Use your needle tool, stop your wheel and push it straight down through the center of your newly created base until it touches the wheel head. Then push your finger down the needle until it meets the clay. Carefully lift the needle up and out and look at the length of needle that is above your fingertip. That's the thickness of your base.

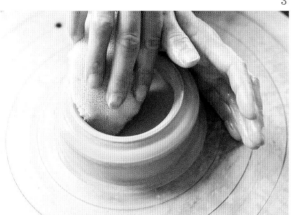

4

3 . Now we are going to open out your clay. Keep your wheel at three-quarters speed. When you are confident you have gone down far enough (but not too far!), open out the base of your pot. Using your middle finger on your right hand, start pulling back the clay toward the heel of your left hand. This movement needs to be smooth and at one speed. Your finger needs to be a consistent speed and your wheel needs to be a consistent speed. If either speeds up or slows down, your walls will be uneven, and your pot will be wonky. Make sure the clay does not get dry at any point throughout this process, as any friction will affect the symmetry of your pot. Stop when you have the desired diameter.

4 . When you have the diameter that you require (check with a caliper or a ruler), slowly move your hands away so as to not pull the form off center. Use your sponge to get rid of the water you may have accumulated in the base. The clay is going to be absorbing that water all the time and that's going to make it weak.

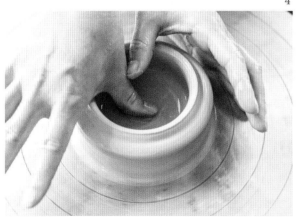

5

5 . Now to compress the base. This will strengthen the base and help to avoid "S" cracks (see the Troubleshooting section on page 186 for what "S" cracks are). Using the outer edge of the tip of your thumb, run over the surface of the base from the center over to 9 o'clock with firm yet even pressure. Repeat two to three times, being careful not to dig your thumbnail into the clay.

6 . Now you're going do your first pull. I call this the thumb pull. Maintain the wheel at three-quarters speed. Using your left hand (if you are right-handed), working at about 3:30 to 4 o'clock on the wheel, place your thumb on the outside of the pot and your middle or index finger (whichever feels more natural) on the inside of the pot. In your right hand, have your water sponge and position it over the top of your left. Slowly trickle water over where your fingers are to make sure that there's no friction.

Starting right at the bottom, where the clay meets the wheel, begin putting pressure on the clay with your thumb toward the center of the wheel and use your finger on the inside as a back stop. The inward pressure will mean the clay will begin to slowly rise up, beginning the walls of your pot. Slowly follow the clay upward with your thumb as it rises. You always need to be moving slower than the wheel. If you move quicker than your wheel is rotating, then the walls will become uneven.

Pro Tip: You are aiming for a cone-shaped cylinder; this ensures that the centrifugal force from the wheel turning fast is driving the clay back down into the wheel head itself. If you begin by pulling the clay straight up, the force of the fast wheel will start opening it out at the top and it may collapse outward.

7 . Setting the rim. This is an essential part of throwing any shape; it strengthens the rim of your pot and helps to prevent warping, chipping and cracks. While the wheel is still spinning, carefully position your middle finger and thumb of your left hand at 3 o'clock, on either side of the clay, at the very top of the rim of your pot. The clay needs to pass through your fingers easily without friction, so add a little water if needed. Then, use the index finger of your right hand to exert gentle downward pressure on the top of the rim. This compresses the clay particles together between each pull, giving strength and durability to a notoriously delicate part of your pottery. You should set the rim of your pot after every pull.

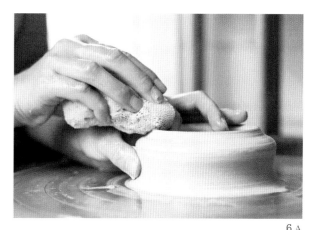

6 A

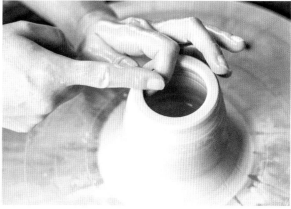

6 B

7

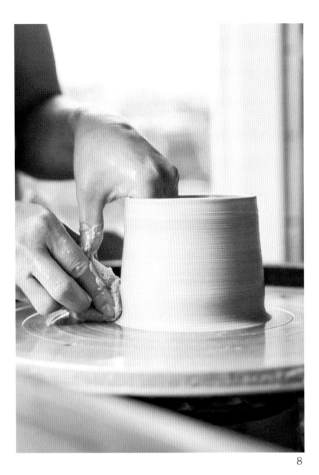

8

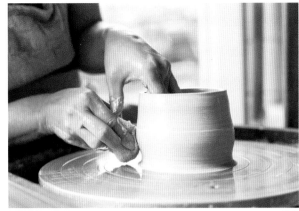

9 A

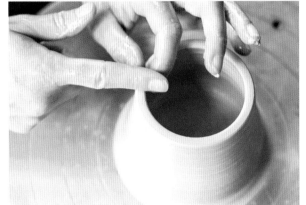

9 B

8 . Now do your second pull. I refer to this as the sponge pull. Slow your wheel down to half speed. Hold your sponge in your right hand and use the very edge of it as a kind of buffer between your fingertips and the clay. This helps the clay not dry out and prevents friction. Keep your foundation arm elbow in the nook of your hip and your right forearm resting on the splash pan. At about half past 3 o'clock on your pot (make sure the clay is glossy with water), place the index finger or middle finger of your left hand on the inside, whatever feels comfortable. Use your sponge to gather up clay from the base and push it toward the center of the wheel. Your cone shape will begin to grow and get taller and wider. As the clay gets thinner, slow the wheel down slightly to give you more control. Remember you still need to be moving slower than the wheel. Keep your left thumb hooked over your right hand at all times for added stability.

9 . The third pull. This pull will start to open out the clay from a cone to a cylinder. Keep the wheel at half speed. Use the same sponge pull, evening up the pressure with your inside finger to guide the clay straight up this time. As you move your sponge and your finger up the clay, ease off that pressure ever so slightly toward the top, because the further you move up the thinner the clay is and the less clay you need to move. Set the rim again.

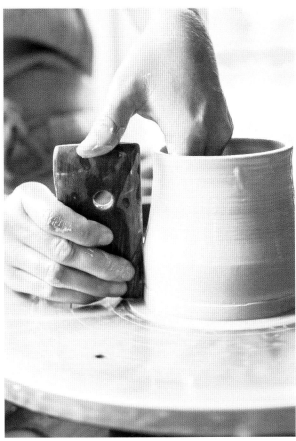
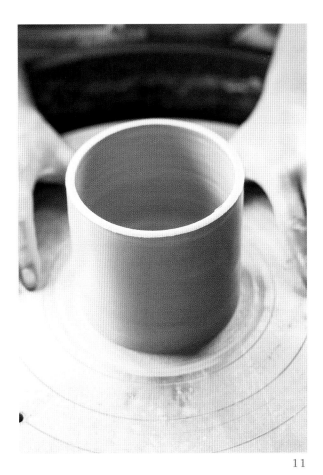

10

11

10. Reduce your wheel to a quarter speed. To give you that perfectly straight-sided cylinder, use a bamboo rib. Ensure the clay is glossy so it doesn't stick. Rest the point of the rib on the wheel head at the 3 o'clock position on the outside of the cylinder with the longest side closest to your clay. Place the middle finger of your left hand inside the cylinder and guide the clay up to meet the rib. Have your right arm leaning on the side of the splash pan for support and your left thumb linked to the bamboo rib.

Make sure that you don't get any friction at any time. If the clay starts to drag, then add a little water. This action should result in a perfectly straight-sided cylinder shape, a good size for a mug.

11. A cylinder could be stretched out into a bowl or collared in to make a vase—the opportunities are endless. I will show you all the techniques you will need to make a variety of shapes in the projects section in this book. Now, practice making a cylinder a hundred times and you'll be a pro!

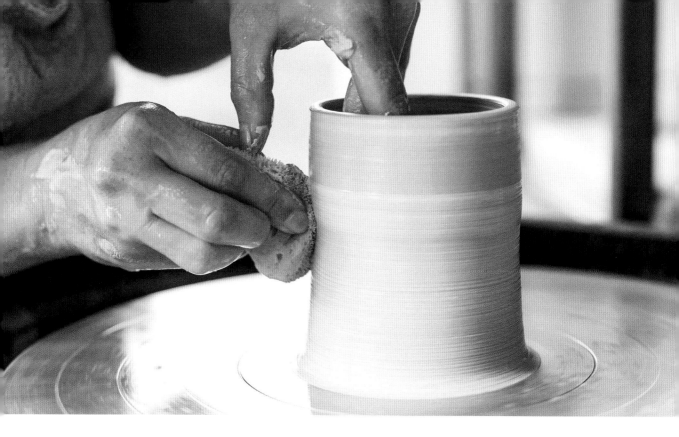

The Cylinder Challenge

Now that you know the basics of a cylinder, I challenge you to throw the tallest cylinder you can (with a base), using just 1 pound (450 g) of clay. As you know, the cylinder is the basis of most thrown pots. This challenge is a favorite for pottery teachers across the globe because it pushes your cylinder skills to the next level and makes you a better thrower of all shapes.

The rules of the challenge:

1. Use a digital scale to weigh your clay (no going slightly over).

2. The cylinder has to have a viable base (no 1/16-inch [2-mm] bases).

3. You can practice as many times as you like.

4. The cylinder has to be at least 3 inches (8 cm) in diameter.

Once you have thrown the tallest cylinder you can, measure it and make a note. Then, cut it vertically in half—yes, you read that right! Cut it in half so you can see how even the walls of your cylinder are and check if they are the same thickness as the base. You are aiming for the walls to be even all the way up and the base to have a similar thickness. You may find you still have quite a lot of clay left in the base and toward the bottom of your cylinder. This is clay that can be pulled up into the walls to create a taller and more even cylinder next time.

Come back and do this challenge again in a few weeks or months of practice and you will be amazed at your own progress. Take a picture of your cylinder cut in half; it will give you a reference from which you can compare.

Use your skeleton, not your muscles, to brace against the clay.

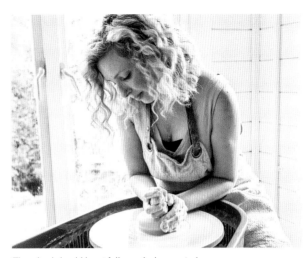

The wheel should be at full speed when centering.

MY TOP TIPS FOR THROWING

As with driving, you need to learn the practical skills and the theory of wheel throwing. The clay isn't going to do anything you don't ask of it. The earlier you understand how the clay responds to the forces you and the wheel are putting on it, the easier it will become. Here are some top tips I have accumulated over years of throwing. Read these before getting on the wheel.

Top Tip #1: Brace, Brace!!!

When throwing, imagine you're in a plane crash (Ha! Not really—but hopefully that will help you remember). If your elbows aren't braced against something, you're making everything 100 times harder for yourself. I always have my left elbow braced against my left hip—this is called my foundation arm—and my right forearm resting on the splash pan. My arms only become free when the pot is pretty much finished.

Top Tip #2: Speed

The speed of your wheel is so important. The wheel needs to start out fast and gradually get slower. Centering should be done with your wheel at full speed. This feels counterintuitive, but trust me, the faster your wheel is going the easier it is. Once centered, you need to shift down the gears as your pot gets bigger. The taller your pot, the stronger the centrifugal forces will be on it, the thinner the walls and the more likely it

is to flop. Your wheel should be at three-quarters speed when opening out and compressing the base, then move to half speed for pulling up the walls. The taller your pot gets, the slower your wheel needs to turn.

You always need to be moving slower than the wheel is turning. If your hands are moving quicker than your clay, you will end up with a wonky pot! Do every step s-l-o-w-l-y.

Transition your hands from one position to the next slowly. Pulling your hands away from the pot too quickly will pull it off center. Even when you don't have your hands on the clay, move slowly! So many times I have leaned over to get a tool, moved too quickly and knocked my beautiful freshly thrown pot.

Having said that, you need to work to get quick at centering. If you spend 10 minutes trying to center your piece of clay, it is likely to get smaller and smaller because all the clay you've just spent ages centering will be eroded by all the friction and water and end up in your splash pan.

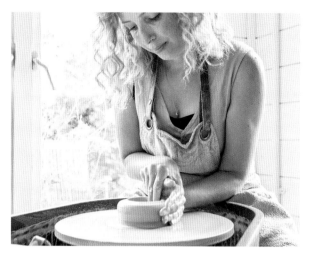

Keep your hands linked for extra support.

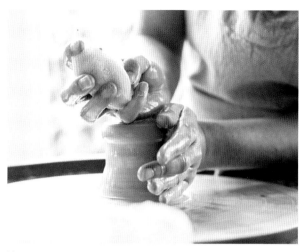

Use your sponge as a water reservoir.

Top Tip #3: Technique Over Strength

Once you have fallen in love with pottery, you want to ensure you are able to keep throwing forever, so it is really important to look after your body.

Throwing is essentially about physics and working out how to ensure the wheel you've potentially just spent a lot of money on is doing all the hard work. Picking up bad habits at the start will often lead to injury or make your progress as a potter much slower.

The importance of body position when throwing pottery cannot be overstated. You do not have to have masses of upper body strength when throwing, even for larger pots. You just need to get your body position right so you are using the weight and the strength of your skeleton (not your muscles) to work with the forces of the wheel and not against them.

This kind of harks back to the elbows point; bracing against your skeleton will give you much more strength and require less effort than trying to brace with your muscles. I often find lots of new potters aren't sitting close enough to the wheel head. Throwing at arm's length is asking way too much of your body; you should be utilizing the weight of your upper body to guide the clay. You shouldn't come away from a session at the wheel achy. Think hard about minimizing the pressure on your joints, wrists, knuckles, elbows and back. If you have a weak back, I know quite a few potters who work standing up. Alternatively, try bracing your back against a wall.

Excluding old injuries, if something is hurting, you probably aren't doing it right and need to work out why before you do yourself a disservice.

Top Tip #4: Water

We are back to being water managers again. The amount of water you use while throwing is key; you don't ever want your clay to feel sticky, which is a surefire way of getting a wonky pot. But at the same time, if you use too much water your piece is likely to get smaller and smaller because all the clay you've just spent 30 minutes centering will be washed away into your splash pan. If the clay absorbs too much water, the walls won't be strong enough to hold themselves up and your shape will flop. To keep the balance right, try not to flood your pot with water, but instead keep it glossy with water at all times. Remove any excess water from the base of the pot regularly with your sponge. Only with a little experience will you be able to get your water usage right. I always throw with a trickle of warm water. It's better for your hands. If you have ever tried to put a key in your door on a January morning after walking the dog, you'll know that cold hands don't quite respond in the way you want them to. The muscles and ligaments in your hands and fingers work better when they are warm, so do yourself a favor and throw with warm water! You want the entire process to be a nice one.

Top Tip #5: Be Okay with Being a Beginner

Getting good is not a quick process (for most people). When learning to throw on the wheel, you might be one of those annoying people who centers on their first try (I was not one of those people and you likely won't be either). It will take time, patience and perseverance. Don't beat yourself up; give yourself the time to learn. Enjoy the process.

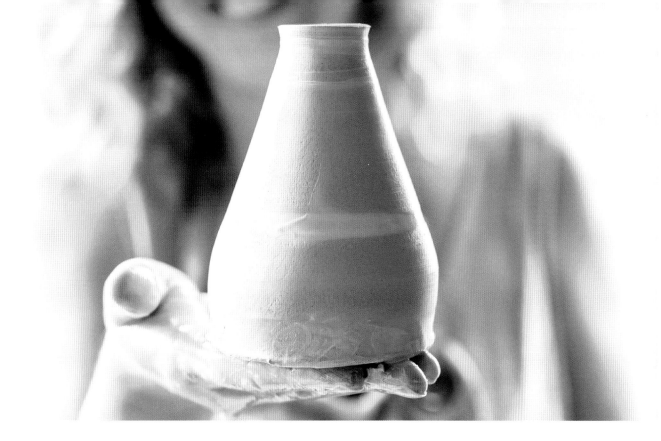

Top Tip #6: Finish on a High

Clay is a bit like a horse. Bear with me on this one . . . When I was a teenager, I learned how to ride horses (a lot of cars had to be washed to afford those lessons!). Even though I wasn't a natural on horseback, I had a great teacher who gave me the confidence to keep going even when I fell off. I feel like there are a lot of parallels between learning pottery and riding horses. Clay is essentially a wild animal; you need to understand its behavior in order to work with it, not against it. Granted, pottery is a bit safer than getting on the back of a 17 hand thoroughbred, but the disappointment felt when not achieving what you want can be equally as painful as falling off said thoroughbred.

My riding instructor taught me to always finish on a high. So, if after an hour sitting at the wheel you finally manage to center your clay or to make a perfect cylinder, then stop and give yourself a pat on the back.

It is really important to hold on to positive energy when learning something new. This will take you into your next session with gusto and help you build confidence to know that the last thing you did was good.

An important point when just starting out is not to focus on making something every session; just try and get a grip on one part of the process (like centering, pulling the walls, compressing the base or getting a nice 90-degree angle where the base and the walls meet). Don't overwhelm yourself; instead, follow the steps I've provided for you on the following pages and enjoy!

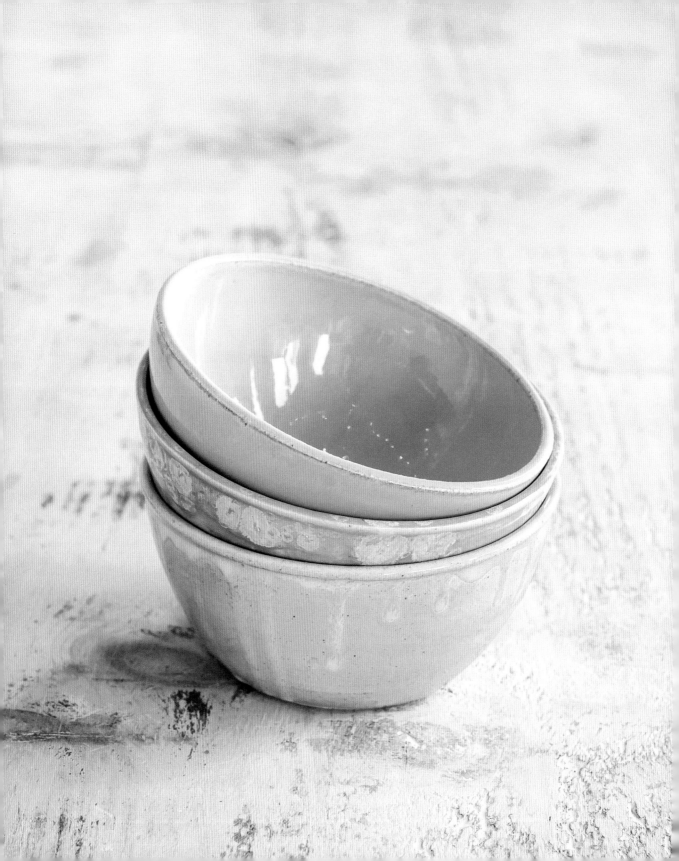

THROWING PROJECTS: PRACTICING THROWING TECHNIQUES WITH FUNCTIONAL FORMS

COMFORTING SOUP BOWL

Skill Level: Absolute Beginner

There is nothing quite so comforting as a big bowl of homemade soup eaten from a ceramic bowl you made. Bowls are a staple in any potter's repertoire. Learning to throw a good-sized bowl with a beautiful curve helps to really hone your throwing skills beyond the cylinder. Opening out the walls requires control, speed and water management to ensure it doesn't flop. Before embarking on this project, I invite you to study the bowls in your cupboard—look at the curve, the base (does it have a foot?), the thickness of the walls, the glaze. Each of these components contribute toward a well-balanced and pleasing bowl to use as well as to gaze upon. Try to encompass some of the observations you made about one of your favorite bowls into your own project.

Tools

Your Essential Pottery Tool Kit (page 21)

Throwing Tool Kit (page 22)

1 lb 5 oz (600 g) stoneware clay

Throwing Your Bowl

1. Weigh out 1 pound 5 ounces (600 g) of stoneware clay—choose the color of the clay to suit your aesthetic. Remember you don't want a clay with heavy grog in it or it will be very rough on your hands while throwing. Wedge your clay using the Spiral or Ram's Head method to ensure it has no air bubbles and is homogenized and ready for throwing.

1

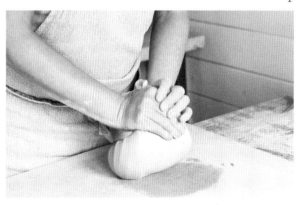

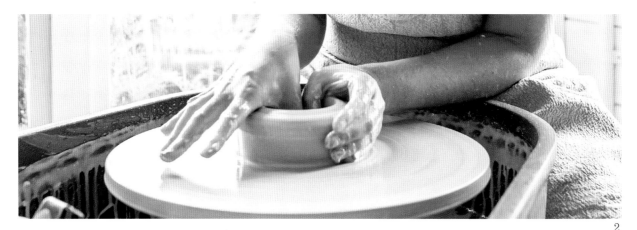

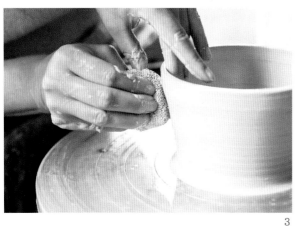

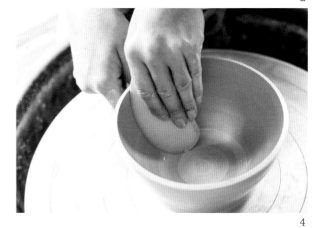

2 . Follow the steps in The Basics of Throwing: The Three "Cs" (pages 78 to 90) to center and cone up your clay twice. To make a bowl a similar size to the one in the picture, you will need the base to be approximately 3½ inches (9 cm) in diameter. Compress the base using the outer edge of your thumb.

3 . Pull up the walls to 2¾ inches (7 cm) high using first the thumb pull and then the sponge pulls. On the third pull, you can flair out the walls very slightly to make the next step easier. Remember to set the rim in between each pull.

4 . Once the clay is at the correct height for your bowl, take your rubber kidney in your left hand and angle it at about 3 o'clock on the inside of your bowl, the curved side toward the clay. You are going to use this to shape the inside of your bowl. With your wheel turning at about half speed, hold the kidney in your left hand at a slight angle so the clay glides beneath it and doesn't catch. Support the outside wall with the side of your index finger on your right hand. Make sure the clay is glossy with water so there is no friction. Gently lean the rubber kidney outward in a gentle, smooth motion to form the curve of the bowl. You are aiming for the diameter of the bowl to be approximately 5 inches (13 cm) across. Once you are happy with the diameter, slowly pull the kidney and your finger away at the same time. Set the rim to give it strength.

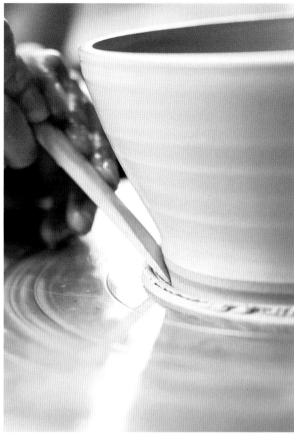

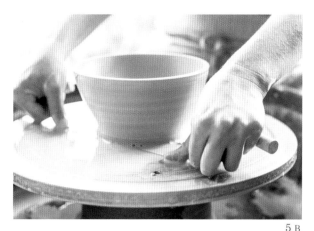

5 B

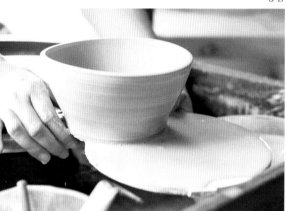

5 C

5 A

5 . Take out any excess water from the bowl with your sponge. Using your bamboo knife angled at about 45 degrees on the wheel head, cut away any excess thickness toward the base of the bowl. Use your wire to cut the bowl off the wheel. Hold the wire taught against the wheel head with your thumbs and pull it through the base towards you. If you are throwing directly onto the wheel head (i.e., not on batts), use your sponge to soak the wheel head and use your wire again to drag through some water underneath the pot until it sits on a film of water allowing it to slide easily. You might need to do this a couple of times. From the base, so as to not warp it, slide the bowl carefully off the wheel onto a batt or onto your hand and softly place it down somewhere safe to dry to the leather-hard state. If you warped your bowl while moving it, you can reshape it with your hands once it has dried out a little.

Pro Tip: I recommend using throwing batts to minimize warping your pots. You will still need to wire it through but without needing the water. Leave it on the batt to dry until it is leather-hard.

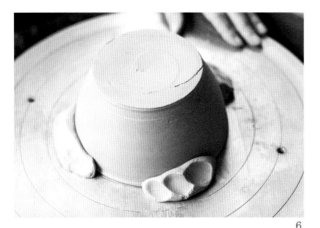

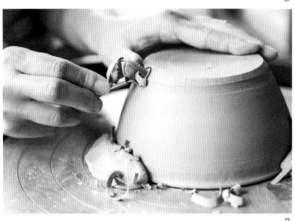

6

7

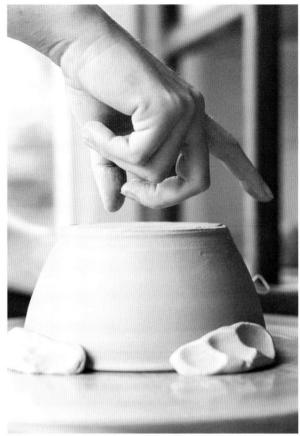

PT

Trimming Your Bowl

6 . Once your bowl is at the leather-hard stage of dryness, it's time to trim it. Wetting the rim of the bowl with your finger, place it upside down on the wheel. Carefully make sure it's in the center, then give it a gentle pat on the bottom; this will create an air lock and secure it to the wheel. Use sausages of clay at even intervals squished to the rim securing it to the wheel to help keep the bowl from flying off if the air lock fails. Be careful not to warp your rim though.

7 . The aim of trimming is to take any excess weight from the base, to even out the walls and to give your bowl a professional finish. Rest the fingers of your left hand on top of the bowl mirroring where you are trimming; this will help stabilize the bowl. Hold the trimming tool in your right hand, palm facing down, and use your index finger extending toward the loop for maximum control. Set the wheel to turn at half to three-quarters speed. Angle the trimming tool at 45 degrees at 3 o'clock on the clay and carefully trim away any unwanted bulky clay on the shoulder of your bowl, extending the curve of the bowl through to the base. The clay should come away in thin ribbons.

Pro Tip: To check the thickness of your base, flick it gently with your finger. If it sounds very hollow, the base is very thin and you must take care not to go through it while trimming.

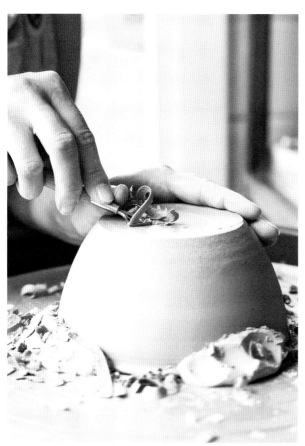

8 A

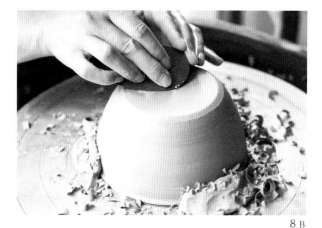

8 B

8 C

8 . Now to tidy up the base. Using your loop tool angled flat against the base, work from the center over to 3 o'clock and trim off any rough or unevenness. Once the base is flat and the outside of your bowl is beautifully curved, use the metal rib to burnish the base; this will give it a really professional finish. Hold the curved edge of the metal rib against the clay between the center and 3 o'clock. With the wheel spinning at three-quarters speed, move the metal kidney along the clay on all the areas you trimmed, you'll see the clay beneath become super smooth. Be careful, metal ribs are sharp. Lastly, don't forget to sign your pot! Remove the clay sausages. To release the air lock, hold the bowl gently between your hands and start the wheel turning slowly; this will release the suction on the bowl. Tidy the rim with your sponge if necessary.

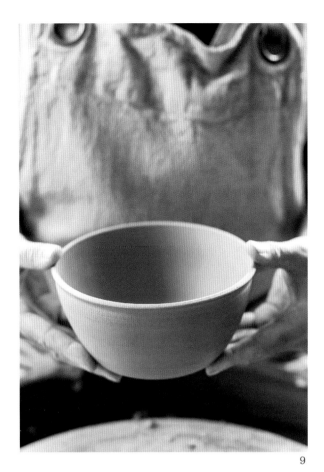

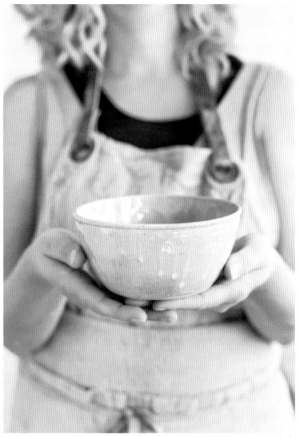

9

10

9 . Leave your bowl to dry upside down somewhere out of direct sun, drafts or heat sources. Dry your bowl slowly to avoid any cracking or warping. If you live in a hot climate, cover the bowl lightly with some plastic to slow down evaporation.

Bisque fire your bowl in a kiln to 1940°F (1060°C), cone 04.

For the Glazing

10 . Once cooled and out of the kiln, prepare your bowl for glazing by wet sanding any sharp edges or gnarly bits, as instructed on page 142. Wipe the surface of the bowl with a clean, damp sponge to get rid of any dust.

Choose a glazing technique from pages 143 to 157 and decorate your pot following those steps. I used a combination of two dinnerware-safe stoneware brush-on glazes for this bowl to get the drippy effect (see page 153 for details on layering glazes). Fire the bowl to the temperature as instructed on your glaze packaging. This bowl was fired to 2231°F (1222°C), cone 6.

ADORABLE BUD VASE

Skill Level: Adventurous Beginner

Have you ever wondered where to put that posy of flowers little hands so lovingly picked for you? I can't think of a more perfect way to display blooms from your garden or a single stem rose than in a handcrafted pottery bud vase. This is a relatively simple shape that can be given heaps of personality. Bud vases are a really great way of practicing your throwing technique and experimenting with different glazes and decoration combinations; you can be really adventurous with colors and textures. Think about using decals, carving and colored underglazes. You can choose glazes that have crystals or are heavily textured because these bud vases won't be used with food. I used the layering glazes technique (page 153) for this project, as I love the element of surprise. I also show you how to decorate a bud vase using underglaze and sgraffito in the Decorative Techniques chapter on page 158.

Tools

Your Essential Pottery Tool Kit (page 21)

Throwing Tool Kit (page 22)

11–14 oz (300–400 g) stoneware clay

Clay chuck (A chuck can simply be a cylinder you have thrown earlier and left to go leather-hard)

Optional Extras

Sponge on a stick is a useful tool to take out water from the base of skinny forms

Spirit level

1 . Weigh out 11 to 14 ounces (300 to 400 g) of stoneware clay. Choose a color of clay to suit your aesthetic; pale clays give you a "whiter canvas" for achieving brighter colors, but colored clays can be fun for experimenting with texture and carving. Wedge your clay to ensure it has no air bubbles and is homogenized, ready for throwing.

Follow the steps in the Three Cs section (page 78) to center and cone up your clay twice. Now open out the clay. To make a bud vase a similar size to the ones in the picture, you need to open out the base to approximately 3¼ inches (8 cm) in diameter. Compress the base using the outside edge of your thumb.

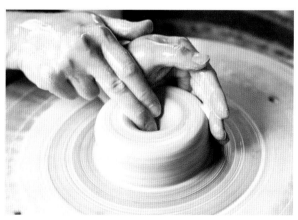

1

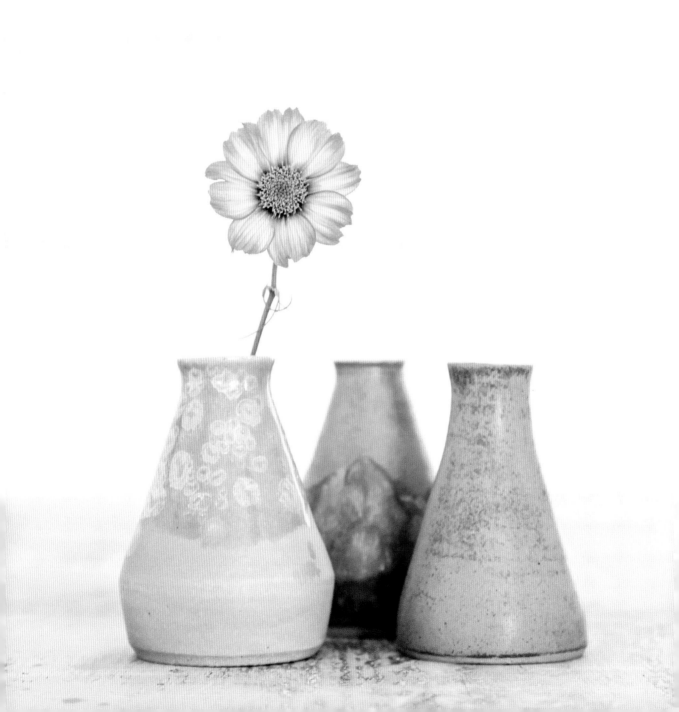

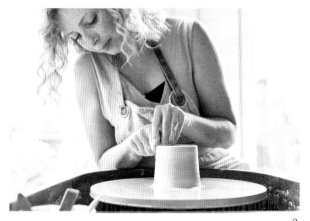

2

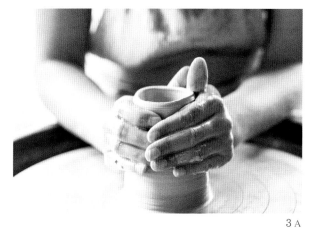

3 A

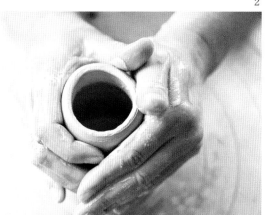

3 B

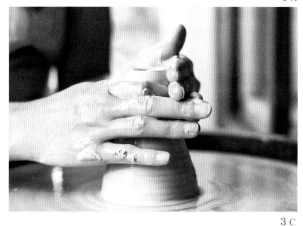

3 C

2 . With the wheel going at three-quarters speed, pull up the walls to approximately 4 inches (10 cm) high using first the thumb pull and then the sponge pull. Remember to pull the clay toward the center of the wheel, creating a cone shape, to avoid splaying out the clay. Set the rim in between each pull to give it strength.

3 . Once the clay is at the correct height for your vase, you're going to collar the clay in. Ensure the clay is glossy with water. Using both hands on either side of your vase, gently cup the neck of the vase in at about ¾ inch (2 cm) from the top. With your wheel at a consistent medium speed, slowly and gently close your hands together, causing the neck of the vase to narrow (this is called collaring). The walls toward the top of the neck of your vase will thicken with the collaring action. To keep them delicate you can thin them out with another pull, using just your fingertips.

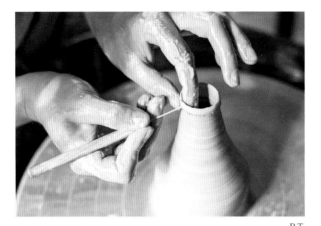

P T

Pro Tip: If the rim of your vase has gone a bit wobbly during this process you can straighten it by chopping a little clay off the top. With the wheel spinning at about half speed, take your needle tool and carefully poke it through the clay a few millimeters from the top, using the index finger from your other hand to steady the rim from the inside. Once the needle is all the way through and has gone all the way around, lift the cut circle of clay off and away from the vase. Set the rim to tidy up the cut.

4 . Now we are going to refine the shape. Take the rubber kidney in your right hand and place the straight side at about 3 o'clock on the outside of the vase. With your wheel turning at about half speed, gently hold the kidney against the clay, supporting the inside with your middle finger. Make sure the clay is glossy with water so there is no friction. Gently lean the rubber kidney into the clay and with the tip of your middle finger of your right hand on the inside, follow the straight edge of the kidney from near the bottom to the top; this will give the vase a pleasing profile. Once you're happy with the shape, slowly pull the kidney away.

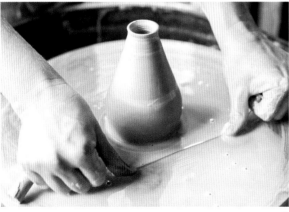

4

5 . Take out any excess water from the vase with your sponge on a stick, being careful not to nudge the rim during the process. Angle your bamboo knife at about 45 degrees on the wheel head and cut away any excess thickness toward the base of the vase. Use your wire to cut the vase off the wheel. If you are throwing directly onto the wheel head (i.e., not on batts), use your sponge to soak the wheel head with water and use your wire again to drag through some water underneath the pot. When slippery, gently push the vase from the base toward the edge of the wheel, sliding it onto a wooden batt or onto your hand. Carefully place the vase on a shelf to dry to leather-hard.

5

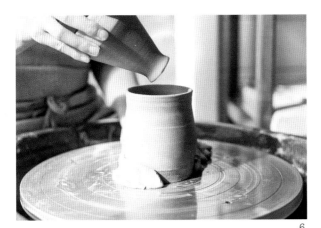

6

7

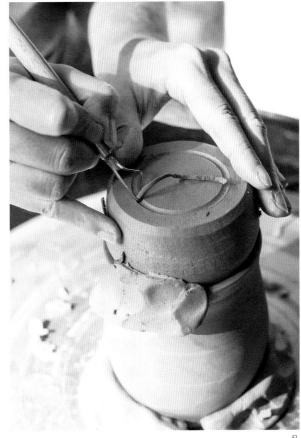

8

6 . Once your vase is at the leather-hard stage of dryness, it's time to trim it. In order to hold your vase on the wheel and not damage the rim, you're going to need a chuck to hold it in place. A chuck can simply be a cylinder you have thrown earlier and left to go leather-hard (I used a mug body). The key is that it needs to be sturdy enough to not rock over on the wheel, but narrower than the widest part of the vase so the vase will be able to sit inside the rim of the chuck. With the wheel stationary, dampen the wheel head with your sponge; this will help create an air lock to keep your chuck in place. Center the chuck on the wheel with the open end facing upwards and give it a gentle tap down. Secure it to the wheel using sausages of clay. Place your vase upside down in the chuck. You can use a spirit level to ensure the bottom is straight. Now secure the vase to the chuck with sausages of clay. It is important to use the same clay for your chuck and sausages since another color may leave a mark on your vase.

7 . During trimming, the wheel is always turning at half to three-quarters speed and you will be working at 3 o'clock. Using your loop trimming tool, trim away any excess clay around the shoulder of the base of the vase. Lightly rest the fingers of your left hand on the base to steady it. Hold the trimming tool in the palm of your hand with your index finger extending toward the loop for maximum control. Angle the trimming tool at 45 degrees and carefully trim away any unwanted bulky clay on the corners of your vase. The clay should come away in thin ribbons.

8 . Now you are going to add a foot. This takes away any excess weight and also allows you to glaze the bottom of your vase. Holding the trimming tool like a pencil, using the point, mark at approximately ¼ inch (6 mm) from the edge of the vase. Now push the pointed end of the trimming tool into the clay by ⅛ to ¼ inch (3 to 6 mm); this will give you a guide for the diameter and depth of your foot.

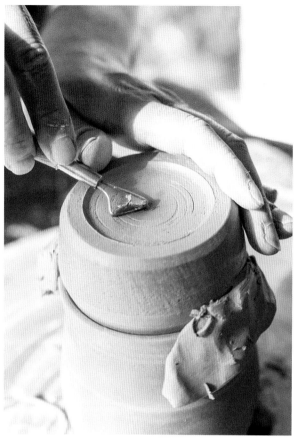

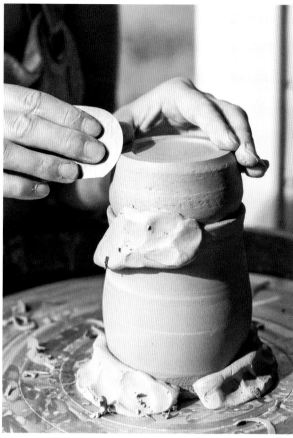

9

10

9. Rest the fingers of your left hand on top of the base mirroring where you are trimming; this will help stabilize the vase. With the wheel turning at three-quarters speed, work from the center over to 3 o'clock (being careful not to cut into your foot), and angle the trimming tool on the point to cut away excess weight from the base.

Now, hold the trimming tool in the palm of your hand with your index finger extending toward the loop for maximum control and use the flat edge of the tool to carefully trim away the ridges in the clay to create a smooth base. Trim off any roughness or unevenness on the foot-ring itself.

10. Once the foot is trimmed, use the metal rib to burnish the base and the shoulder of the vase; this will give it a really professional finish. Be careful, metal ribs are sharp.

When you're happy, leave your vase to dry out slowly. Upside down is best, placed somewhere out of direct sun, drafts or heat sources.

When the vase is bone dry, bisque fire it to 1940°F (1060°C), cone 04.

11A

11B

12

11. Once cooled and out of the kiln, prepare your vase for glazing by wet sanding any sharp edges or gnarly bits. Wipe the surface of the vase with a clean, damp sponge to get rid of any dust.

12. Choose a glazing technique from pages 143 to 157 and decorate your pot following those steps. Fire the vase to the temperature as instructed on your glaze packaging. My glazes are fired to 2231°F (1222°C), cone 6. I have layered this vase with two different brush-on glazes using the layering technique on page 153 to achieve the effects you see on page 102.

CRAFTING A BARREL BELLIED MUG

Skill Level: Advanced Beginner

A mug or a cup is perhaps the most familiar of functional pottery forms. On a cold morning, warming your hands on a hot cup of tea or coffee will give you the ultimate feeling of home. With this project I am showing you how to make your own comforting mug. This project will take practice—getting the size and handle right is tricky. At first you may end up with more of an espresso cup than a full-sized mug, and handles are an especially finicky thing to master, but stick at it because with practice, this form will be one of the most satisfying things you can make with your own two hands. This mug holds approximately 16 to 17 ounces (475 to 500 ml).

Before embarking on this project, I encourage you to take your favorite mug from your cupboard and study it. Why do you like it? How does the weight feel? What does the handle feel like to hold? Where does the handle join the body? Try and think about these factors when you are making your mug.

Tools

Your Essential Pottery Tool Kit (page 21)

Throwing Tool Kit (page 22)

1 lb 2 oz (500 g) stoneware clay, plus 14 oz (400 g) for the handle

Ruler

Wooden board

Rolling pin

Optional Extras

Calipers

Serrated metal kidney

Wax resist

Throwing Your Mug

1. Weigh out 1 pound 2 ounces (500 g) of stoneware clay and 14 ounces (400 g) for the handle. I used a speckled stoneware clay here, but you can choose any clay that you feel drawn to as long as it's good to throw with. Prepare your clay as directed in the wedging section (page 28).

 Follow the steps in the Three Cs section on page 78 to center and cone up your clay twice to ensure it has no air bubbles and is nicely homogenized. Now open out the clay. To make a mug a similar size to the one pictured, open out the base to approximately 3½ to 4 inches (9 to 10 cm) in diameter (measure this with a ruler or calipers). Compress the base using the outer edge of your thumb.

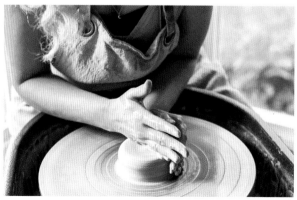

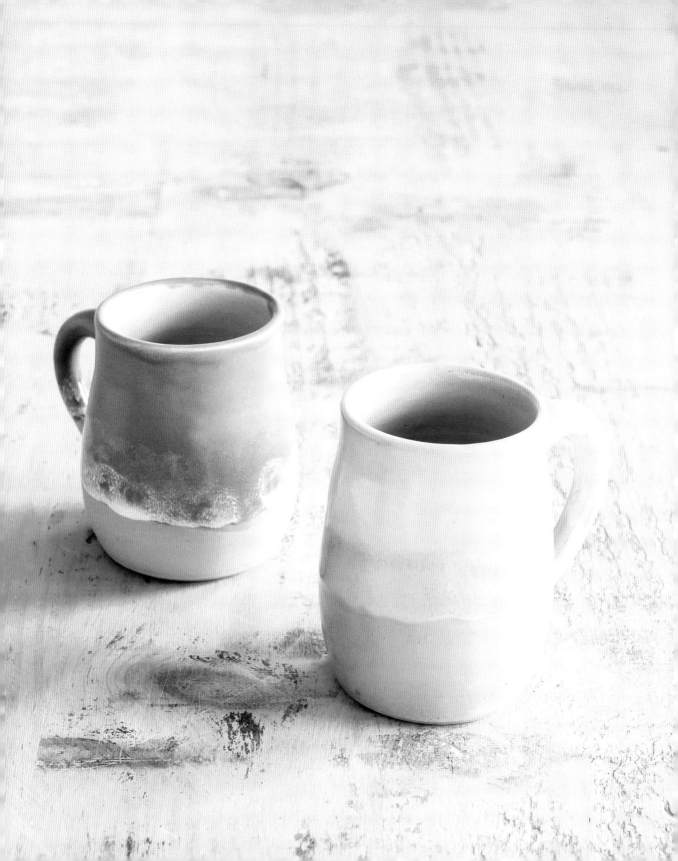

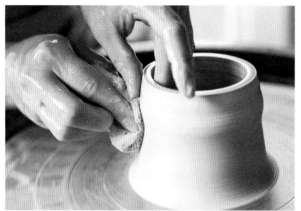

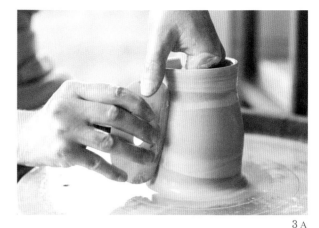

2

3 A

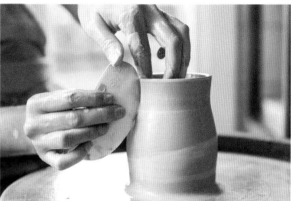

3 B

4

2 . Pull up the walls to 4 inches (10 cm) high using first the thumb pull and then the sponge pull. Try and do this in as few pulls as possible. The clay will get tired the more you work it and will be absorbing water all the time, so aim to do this in three to five pulls if you can. If you struggle, go back to practicing your cylinders. Remember to set the rim in between pulls to give it strength.

3 . Once the clay is a cylinder approximately 4 inches (10 cm) high, you are going to shape the mug. Make sure the clay is glossy with water so there is no friction. Working on the outside of your cylinder at 3 o'clock, take the flexible rubber kidney in your right hand, using the straight side toward the bottom half of the cylinder. With your wheel turning at about three-quarters speed, gently hold the kidney against

the clay. Carefully support the wall with the fingers of your left hand on the inside of the cylinder. Gently push the clay outward towards the kidney with the tip of your middle finger to form the curvy barrel belly of the mug. Once you are happy with the shape, slowly pull the kidney away.

4 . Take out any excess water from the mug with your sponge, being careful not to knock the walls. Now we are going to shape the neck of the mug. Flip over the kidney so you are now using the curved side. Hold the curve against the top third of the mug, pushing in with gentle pressure and supporting the inside with the fingertips of your left hand to form the concave curve near the top. You might find these two steps take practice to get right. You may need to alternate between step 3 and step 4 to get the final shape the way you want it.

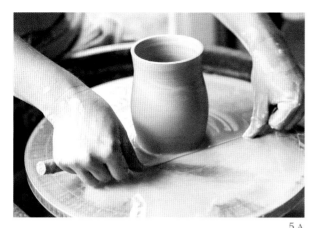

5 A

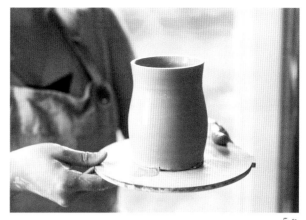

5 B

6

7

5 . Angle the bamboo knife at about 45 degrees on the wheel head and cut away any thickness toward the base of the mug. Use your wire to cut the mug off the wheel. If you are throwing directly onto the wheel head (i.e., not on batts), use your sponge to soak the wheel head and use your wire again to drag through some water underneath the pot. Then, with your fingers at the base, slide the mug carefully toward the edge of the wheel. Slide it onto a wooden batt or onto your fingers and carefully place it down somewhere safe to dry to leather-hard.

Pro Tip: If you accidentally warp your mug, then once it is leather-hard you can reshape it using an upturned wine glass, gently pushing the upturned glass into the top of the mug to make it back into a circle. Don't press too hard or you'll crack the clay. Thanks to @hildacarrpottery for this great tip!

Trimming Your Mug

6 . Once your mug is at the leather-hard stage of dryness, it's time to trim it. Wetting the rim of the mug with your finger, place it upside down on the wheel. Carefully make sure it's in the center and then give it a pat on the bottom; this will create an air lock and secure it to the wheel. Also use sausages of clay at even intervals squished to the rim to help keep the mug from flying off if the air lock fails.

7 . Lightly rest the fingers of your left hand on top of the mug. Hold the trimming tool in the palm of your hand with your index finger extending toward the loop for maximum control. With the wheel turning at three-quarters speed, working at 3 o'clock, angle the trimming tool at 45 degrees and carefully trim away any unwanted bulky clay on the corners of your mug. The clay should come away in thin ribbons. Using your triangle loop tool angled flat against the base, work from the center over to 3 o'clock and trim off any roughness or unevenness on the base.

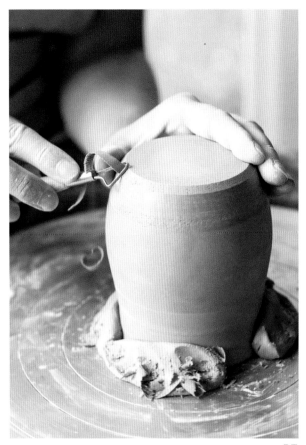

PT

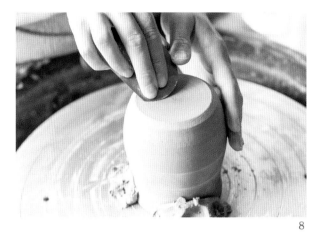

8

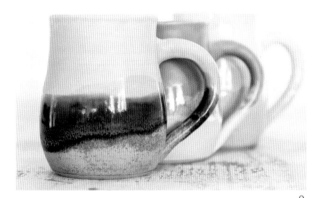

9

Pro Tip: Cut a 45° angle bevel to the corner of the base to give a sense of lightness to your mug.

8 . Once you've trimmed your mug to your liking, use the metal rib to burnish the base. Hold the curved edge of the metal rib against the clay between the center and 3 o'clock. With the wheel spinning three-quarters speed, move the metal kidney along the clay on all the areas you trimmed. You'll see the clay beneath become super smooth, giving it a really professional finish. Be careful, metal ribs are sharp. Put your leather-hard mug in a plastic storage box or in a plastic bag so it doesn't dry out further while you make your handle.

Pulling the Handle

9 . Mug handles come in lots of shapes and sizes, so I invite you to study the handle of your favorite mug before creating your handle. Is it chunky? Is it round or flat? How does it feel to hold? What do you love about it? Pulling handles to suit your preference takes practice. In this book I will give you all the tips I have learned in my years as a potter to help you get it right.

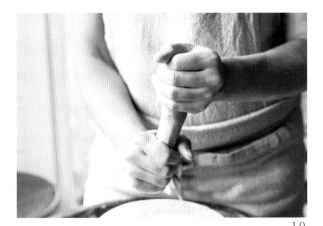

PT

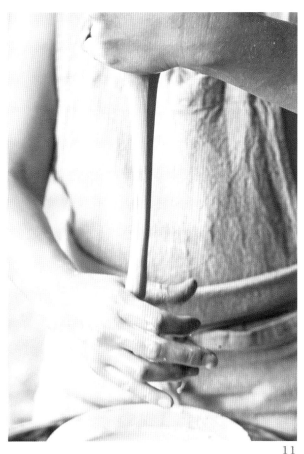

11

10. You are going to need a jug of water for this next step (you can use your throwing water). Take the 14 ounces (400 g) of clay you prepared earlier; it is important that the handle is the same type of clay as the mug body. This prevents a mismatch of shrinkage rates and helps avoids cracks. Shape the clay into a fat sausage between the palms of your hands. Grip one end of the sausage in your left hand, angling the tail of the sausage down. Dunk the sausage into the water all the way up to your hand to make it wet. Completely wet your right hand too. Now wrapping your right hand around the clay (thumb up) and with even pressure, in one smooth motion slide your hand down the clay with a gentle yet firm stroke. You don't want any friction. Avoid yanking the clay as this will cause it to stretch and break; the clay should be sliding through your hand like it does on the wheel.

Pro Tip: Keep your pressure even all the way down the length, and keep pulling past the end. If you stop near the bottom, you'll likely get a nub that you'll be tugging on and over stretch the clay.

11. You'll need to repeat this pulling motion dozens of times, rewetting your hand in between pulls to avoid any stickiness. This repetitive downward stroke encourages the clay to become longer and thinner.

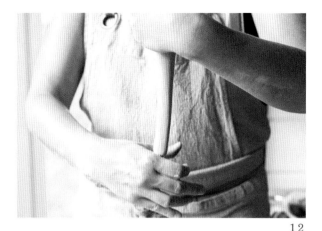

12

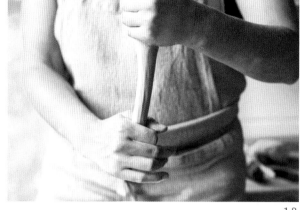

13

14

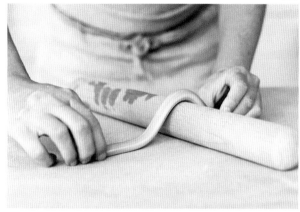

15

12 . Depending on the shape you'd like, you'll need to pivot your wrist, so you are pulling the clay through a slightly different part of your hand. For example, if you'd like a flatter shaped handle, pivot your wrist 90 degrees after every third stroke. If you want your handle to be more rounded in shape, pivot your wrist 90 degrees after every stroke.

13 . Continue to pull the clay like this. You are aiming for the length of clay to be approximately 7 inches (18 cm) long, thicker at the top than the bottom. The diameter you're aiming for is between 1 and 1 ½ inches (2.5 to 4 cm) thick at the top and ½ inch (1.3 cm) at the bottom.

14 . Lay the length of handle onto your wooden board and, from the thinnest end, measure out approximately 5 inches (13 cm) in length and cut the clay using your needle tool.

15 . Drape the soon-to-be handle over a wooden rolling pin; this will help to give you the curve of your handle. Leave it to dry until the handle is a tad wetter than leather-hard; cover it with plastic if you need to stop it from drying out too quickly. Because it is smaller and has more air circulating around it, a handle is likely to dry much faster than the mug body. In order to have the best chance of drying evenly with the mug body, add the handle when it is slightly wetter than leather-hard. Keep a close eye on it while it's drying.

16

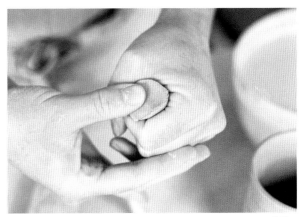

17 A

17 B

Constructing Your Mug

16 . When your handle is just before leather-hard you are
ready to attach it to the mug. Using your serrated
kidney, score a 1-inch (2.5-cm) square about 1 inch
(2.5 cm) down from the rim of the mug and in a
second spot near the base. It's best to place the mug
on a table for this and use a straight object like a ruler
or wooden chopstick to guide where you are scoring to
ensure the handle will sit straight.

17 . Take your handle and grip the thick end with your
left hand, with only a small section of about $1/16$ inch
(2 mm) sticking out of the top. With your right thumb,
gently push the damp clay to splay it out; this gives
more surface area from which your handle can attach
to the mug body. Score the flattened-out part of
handle.

18 A

18 B

19 A

19 B

18. Using a paintbrush, apply some water to the scored sections of your mug and your handle. Hold the handle in your right hand and use your left hand inside the mug to support the wall. Push the top of the handle onto the scored area, being careful not to warp the mug in the process.

19. Using your fingertip, work the two pieces of clay together, smoothing the edges of the handle into the body of the mug. You can also use your wooden sculpting tool to help you do this. Once it's attached all the way around, wet your finger and rub over the clay, smoothing the join together to make sure both pieces of clay are well combined.

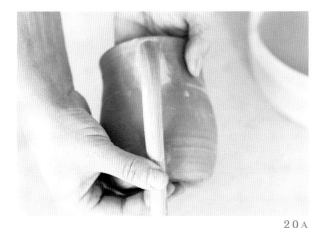

20A

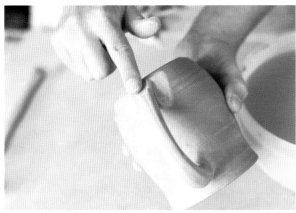

20B

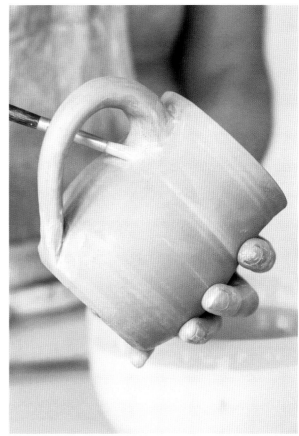

21

20. Now that the top part of the handle is joined, align the bottom of the handle with the top. It is important to check that the handle is straight from a few different angles before committing to attaching it. Only once you are sure the handle is in the correct place should you gently but firmly squish the bottom of the handle into the bottom scored area of your mug. Trim off any excess clay at the bottom of the handle using your needle tool. Once again, wet your finger and work over the join smoothing the two pieces of clay together, making sure both pieces of clay are well combined. If you accidentally squash the rim of your mug while attaching your handle, use the wine glass trick to make it circular again (page 111).

21. Using a soft bristle brush, wet the brush and with gentle strokes brush out any finger marks or gnarly bits to give the joins a really professional looking finish.

Pro Tip: Brush on wax emulsion resist around the joins of the handle; this slows down the drying in this area and helps to eliminate cracks at the join. The wax burns out in the firing.

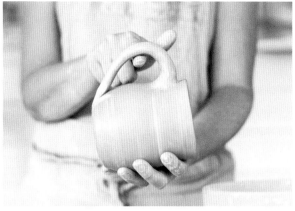

22 A

22 B

23

24

22. Refine the final shape of your handle before leaving your mug to dry away from direct heat sources or drafts. Turning your mug upside down helps the bottom of the mug to dry at the same rate as the walls, minimizing the chances of warping or cracking.

Once the mug is bone dry, bisque fire to 1940°F (1060°C), cone 04.

23. Once cooled and out of the kiln, prepare your mug for glazing by wet sanding any sharp edges or gnarly bits. Wipe the surface of the mug with a clean, damp sponge to get rid of any dust.

24. Choose a glazing technique from pages 143 to 157 and follow the steps. I used a clear glossy stoneware on the interior. I poured the glaze into the mug, holding for a few seconds and then pouring it out. I used a brush-on lavender blue to glaze the bottom two-thirds of the body of the mug and a pink matte brush-on on the top. Where the two glazes merged, it created a third unexpected indigo color (see picture 9 on page 112).

25. Fire the mug to the recommended temperature as instructed by the glaze manufacturer. My glazes are fired to 2231°F (1222°C), cone 6.

CERAMIC CITRUS JUICER

Skill Level: Adventurous Beginner

A truly useful, beautiful and—when your friends know you made it—impressive object to have on your kitchen worktop. This hand thrown citrus juicer makes a great gift for the baker or cocktail maker in your life, if you can bear to part with it that is!

The joy of being able to make things out of clay, instead of buying it, is that you can make it your own (if you don't mind a bit of a wait). A few years ago, I was making a lemon drizzle cake and the lemon juicer I was using was truly useless. So, I thought to myself, I can make a better one out of clay—so I did! Now, I am sharing how I did it with you. You can adjust the size of the juicer so you can juice larger fruits such as oranges and grapefruits by simply increasing the amount of clay you use, along with the final dimensions.

Tools

Your Essential Pottery Tool Kit (page 21)

Throwing Tool Kit (page 22)

1 lb 2 oz (500 g) stoneware clay

Calipers or ruler

Chuck

Optional Extras

Sponge on a stick

Spirit level

Throwing Your Juicer

1. Weigh out 1 pound 2 ounces (500 g) of stoneware clay. I am using a speckled stoneware for this project. Prepare your clay as described in the wedging section (page 28), choosing either the Spiral or Ram's Head method.

2. Follow the steps in the Three Cs section (page 78) to center and cone up your clay twice, ensuring it has no air bubbles and is nicely homogenized. Your citrus squeezer is simply two cylinders, one inside another. So, first you need to create a disk of clay approximately 3½ to 4 inches (9 to 10 cm) in diameter and 1 to 1½ inches (3 cm) deep (measure this with calipers or a ruler).

1

2

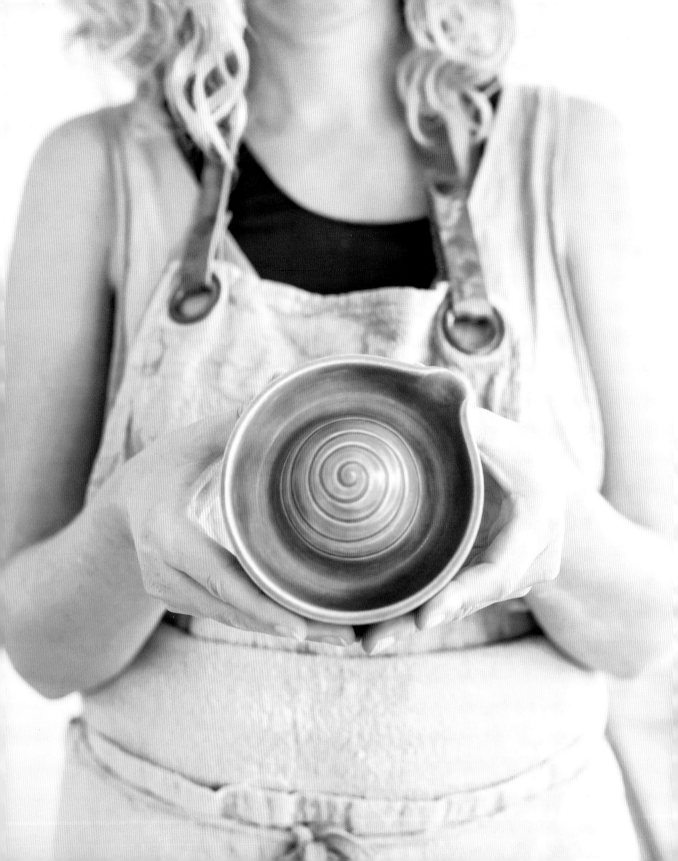

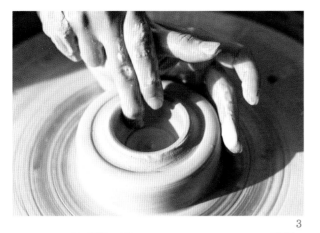

3

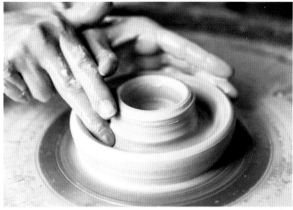

4 A

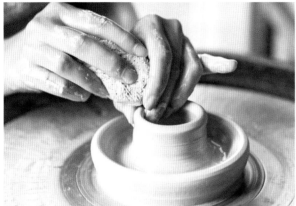

4 B

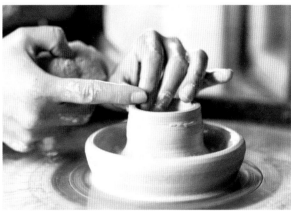

4 C

3 . Set your wheel at two-thirds speed. You're going to create your internal cylinder first—this will be closed in on itself to create the dome part of the juicer. Make sure the clay is glossy with water so there is no friction. Locate the center of the disk of clay with your middle finger, then push straight down into the clay until you have approximately ¼ inch (6 mm) of clay left between your finger and the wheel head (use the needle trick on page 86 to check if you're not sure). Now, slowly open out the clay to create the beginnings of the inner cylinder, approximately 2 inches (5 cm) in diameter. Compress the base with your thumb.

4 . Move over to 4 o'clock on your form. Working at approximately ½ inch (1.5 cm) from the outside edge, push your middle finger through the clay, stopping roughly ¼ inch (6 mm) from the wheel head (this will eventually create the bowl to catch the juice). Move back to the interior cylinder and using the thumb pull, pull up the interior cylinder walls. Aim to get the wall to be 2 to 2½ inches (5 to 6 cm) within three pulls. Set the rim in between each pull to give it strength.

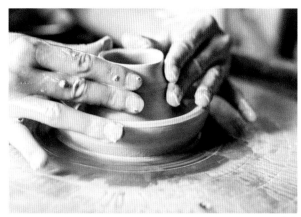

5 A

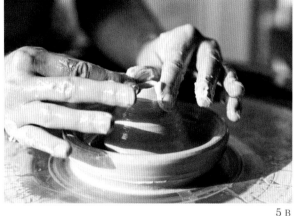

5 B

6

5 . Take out any excess water from the internal cylinder with your sponge or sponge on a stick. Now, you are going to close the dome of the juicer (the bit that squishes into the fruit). Make sure only the outer wall of the internal cylinder is glossy with water (be careful not to get any water inside the cylinder, as once we close it up this water will be trapped in and will cause the base to crack during drying or even explode during firing). Start toward the middle of the cylinder using the fingertips of your index and middle fingers and thumb on both hands to move slowly up, collaring the cylinder in. Gently squeeze the opening of the cylinder closed. Repeat this action two to three times to close the top of the cylinder over completely to form the dome part of the juicer. In between collaring in the cylinder walls, you might want to thin the walls out slightly, increasing the height of the dome to make it a more effective squeezer. I find that leaving the tip of the dome pointed rather than rounded makes it a more effective juicer.

6 . Now, you will pull up the outer cylinder to create the bowl that catches the juice. With the wheel moving at half speed and working at 4 o'clock, use the thumb pull to pull up the wall of the outer cylinder. Use your sponge as a reservoir to ensure the clay is glossy and there's no friction. Pull it up to a height of 1½ to 2 inches (4 to 5 cm). Set the rim.

7 A

7 B

7 C

8

7. Angle your bamboo knife at about 45 degrees and cut away any excess clay thickness toward the base of the juicer. Now, you are going to create the pouring lip. With the wheel stationary, wet your fingertips and hold your thumb and index finger of your left hand against the rim, spaced at approximately 2 inches (5 cm) apart. With your index finger of your right hand, do a small side-to-side motion to stretch the clay out between your thumb and finger. Shape the lip with your fingertip.

8. Use your wire to cut the citrus juicer off the wheel. If you are throwing directly on the wheel head (i.e., not on batts), use your sponge to soak the wheel head and use your wire again to drag through the water underneath the pot. Place your fingers toward the base of the form and slide it carefully toward the edge of the wheel and onto a shelf to dry to leather-hard.

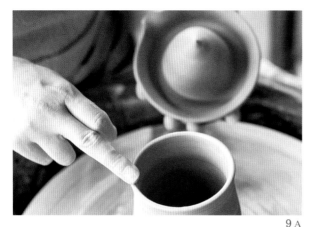

9 A

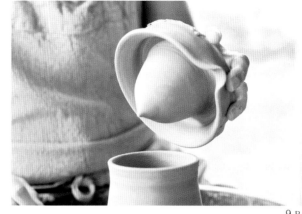

9 B

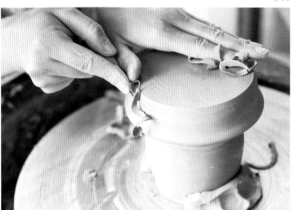

10

11

Trimming Your Juicer

9. Once your citrus squeezer is at the leather-hard stage of dryness, it's time to trim it. For this you are going to need a trimming chuck. This is essentially a cylinder made of the same clay as your citrus squeezer, dried out to leather-hard. (Here, I used a mug I threw earlier.) You want the rim of your chuck to be able to sit in between the bowl and dome of your citrus squeezer. Center the chuck on the wheel with the opening facing upward. Dampen the wheel head to stick it to the wheel, then use sausages of clay to secure it down. Wet the rim of the mug a little with your finger and place your citrus squeezer upside down in the chuck (the dome of the juicer should sit snuggly inside the mug with the bowl on the outside). You can use a spirit level to ensure the bottom is straight. The tacky leather-hard clay should hold the pot in place while you trim, but if it is slipping, use clay sausages to help secure the lemon squeezer into the chuck.

10. Lightly rest the fingers of your left hand on the base of the squeezer. Hold the trimming tool in the palm of your hand with your index finger extending toward the loop for maximum control. With the wheel turning at three-quarters speed, working at 3 o'clock, angle the trimming tool at 45 degrees and carefully trim away any unwanted uneven clay on the external edge of your squeezer. The clay should come away in thin ribbons. Be careful not to cut into the pouring lip.

11. Using your triangle loop tool angled flat against the base, work from the center over to 3 o'clock and trim off any unevenness on the base, creating a smooth bottom. Once you've trimmed your squeezer, use the metal rib to burnish the base; this will give it a really professional finish. Be careful, metal ribs are sharp. Add a small hole in the middle of the bottom of the citrus squeezer using your needle tool to let out any steam during firing. This is very important; if you skip this step your pot may explode!

12

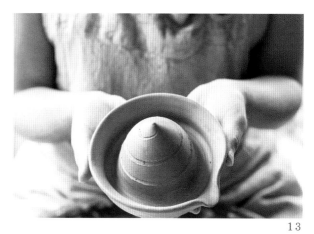

13

14

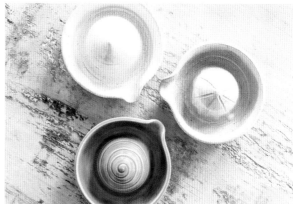

15

12. Now you are going to incise ridges in the clay, which will help the juice to flow. Remove the chuck from the wheel head. Turn the lemon squeezer back the right way up and center it on the wheel. Use clay sausages to secure it to the wheel head. Using a bamboo knife, begin at the very top of the dome, start the wheel turning very slowly and follow the curve of the dome downward with the tip of the knife creating a spiral. Alternatively, using the point of your loop tool you can carve straight lines down the curve of the dome finishing at the bowl which work just as well.

13. Put your leather-hard pot somewhere safe to dry. Upside down in a mug is a great way to ensure the base dries evenly.

Once your squeezer is bone dry, bisque fire to 1940°F (1060°C), cone 04.

14. After the bisque firing you will want to prepare your lemon juicer for glazing by wet sanding any sharp edges or gnarly bits. Wipe all the surfaces of the pot with a clean, damp sponge to get rid of any dust. Choose a glazing technique from pages 143 to 157 and decorate your pot following the steps. I used a dipping glaze for my lemon squeezer (page 148). I painted wax resist on the base, waited for it to dry, then dipped it into a bucket of well-stirred glaze using tongs. Fire the juicer to the recommended temperature as instructed by the glaze manufacturer.

15. Ensuring the base was free from glaze, I fired it to 2231°F (1222°C), cone 6.

THROWING PLATES

Throwing plates on the wheel isn't as hard as you may think, but what is tricky is getting them off the wheel and drying them so they don't warp or crack! If you are patient and heed the tips I share with you in this book, you can make stunning dinner plates to wow your family and friends.

Tips for Making Plates

1. When you're making plates, you want to make sure you work with enough clay. The following project uses about 4 pounds (1.8 kg) per plate. One of the biggest mistakes that I used to make was not throwing with enough clay, which meant that my plate ended up being really thin and I couldn't trim the base of it very well without it warping or bending. I'd also find that I wouldn't be able to get the diameter that I'd like. The average dinner plate in the UK is between 9 and 10 inches (23 to 25 cm). I find that if they are any bigger, they don't fit in a dishwasher.

2. Another important factor to consider when making plates is what you're going to throw them onto; it is very difficult to cut a plate off if you're throwing directly onto the wheel head.

3. Throwing batts (see page 23 for more details) are a really crucial tool when throwing dinner plates. There are varying types of batts that you can use: MDF, plywood or plastic. Throwing your plates onto plaster batts is a great option because you don't need to throw them as thickly and you don't need to wire them off; they simply pop off the plaster once they are leather-hard. This means there is also less trimming. Ready-made batts are widely available from pottery supply stores or online (search "pottery batts").

4. A lot of wheels don't have batt pins to which batts attach. If you're a bit scared of drilling holes into your wheel head to make batt pins, I understand why. Probably the simplest batt is just a round MDF piece of flat wood which you attach to your wheel head using clay. In this next section, I'm going to show you how.

HOW TO ATTACH A WOODEN BATT TO YOUR WHEEL HEAD (WITHOUT BATT PINS)

1. Weigh out 1 pound 3 ounces (450 to 550 g) of clay. You want to use the same clay that you're making your plates with because when you recycle it all together, you're not going to have any issues with mixing up the clays.

2. Pat it into a ball and whack it down into the middle of your wheel—you don't have to wedge it because it's not going to be anything.

3. Center it and cone it up once or twice. Then, you are going to flatten it out into a pad. Form a fist with your dominant hand and push down onto the center of the clay with the underside of your fist (use your other hand on top to provide additional strength if needed). Keep a wet sponge in your dominant hand—the trickle of water helps to keep the clay lubricated. Flatten the clay out to about two-thirds or three-quarters of the diameter of your wheel head.

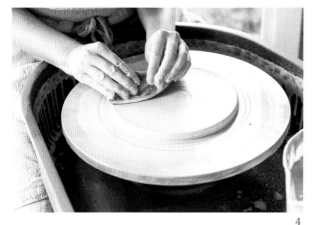

4

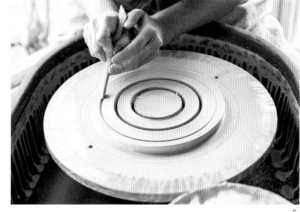

5

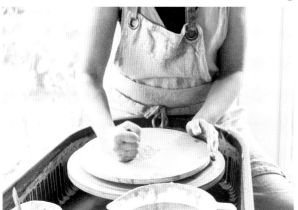

6

7

4 . You want the pad to be level, so use the curved edge of your wooden kidney to flatten it. Hold the kidney at an angle so the clay can skim past while the wheel is spinning and, with firm pressure, hold the kidney against the clay moving it from the center over to 3 o'clock. The hardness of the wooden kidney really helps to give you a level surface to attach your batt.

5 . With the wheel still turning, cut down through the clay with your bamboo knife to make three equally spaced circular grooves into the clay pad. These grooves will increase suction and help to suck your batt onto the wheel.

6 . Stop the wheel. Take your wooden batt and lightly place it on top of the clay, lining it up to make sure it is central. With the side of your fist, give it a bash in the middle. Then, bash around the edges. Your batt should be pretty well stuck down, but give it a little wiggle to check it will stay on the wheel and won't go flying off when making your plate.

7 . When it comes to taking the batt off the wheel head, use your metal potter's knife. Place the end tip between the wheel and the batt, and lever it off—this will break the air lock and the batt will pop off. You can keep reusing the same pad of clay for your subsequent batts.

WHIRLPOOL DINNER PLATE

Skill Level: Advanced Beginner

Nothing is quite as satisfying as serving food to family or friends from a plate you have made. One of the most important factors in plate making is choosing the right clay.

The clay that I used here is called Earthstone Extra Smooth. This clay is really lovely to use; it's really white, almost like a semi-porcelain, which means that glaze colors come out looking really vibrant. It also has good thermal shock resistance, which is why I chose it for my dinnerware. It is quite a soft clay so it isn't as great for throwing taller pieces, as it has a tendency to flop, but it works great for plates. If you can't find this clay, then ask your local pottery supply store what clay is good for wheel-thrown flatware, and they'll be able to point you in the right direction. This project is great practice for throwing with larger amounts of clay. It will test your trimming skills as well as your patience. Plates make a wonderful canvas on which to explore different decorating techniques.

Tools

Your Essential Pottery Tool Kit (page 21)

Throwing Tool Kit (page 22)

4 lbs (1.8 kg) white stoneware clay

Throwing batts

Optional Extras

Calipers

Throwing Your Plate

1. Weigh out 4 pounds (1.8 kg) of stoneware clay. Next, wedge your clay really well using the Spiral wedging method. The important thing with plates is that there are no air bubbles, the clay is beautifully homogenized, there are no dry bits and no wet bits, because that's what's likely to cause warping and cracking. Wedge your ball of clay at least 100 times—no need to go to the gym this week!

1

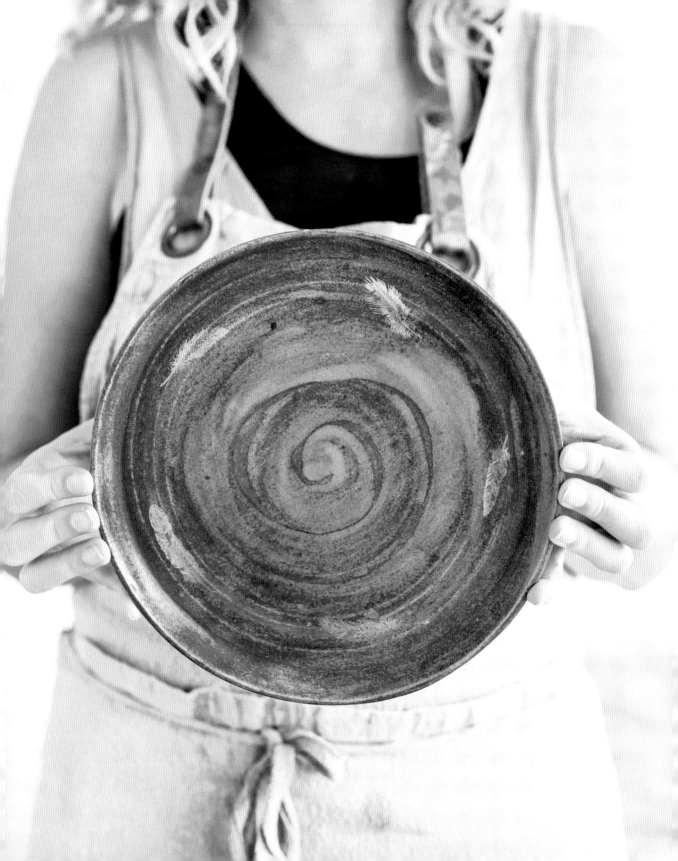

2 A

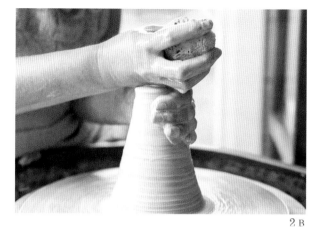

2 B

3 A

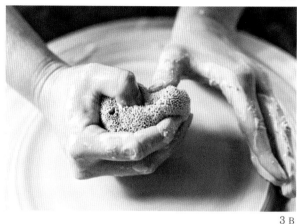

3 B

2. Form the clay into a round ball. Whack it down into the center of your wheel. Make sure the elbow of your foundation arm is securely in the crook of your hip. Brace against the side of the clay using the heel of your hand. Set your wheel going at full speed and ensure the clay is glossy with water. Have your waterlogged sponge in your dominant hand and keep your foundation arm solid; that's going to keep your clay centered. Cone up and down twice, making sure that there are no air bubbles in the clay and that it is perfectly centered.

3. With the wheel going at three-quarters speed, push down with your right hand in the center of the disk, hold your hand there and let that clay spread slowly outward. Keep your hand in that center point until the clay has created a wide and thick disk. If you feel like you need additional force you can put your left hand on top of your right and increase the downward pressure.

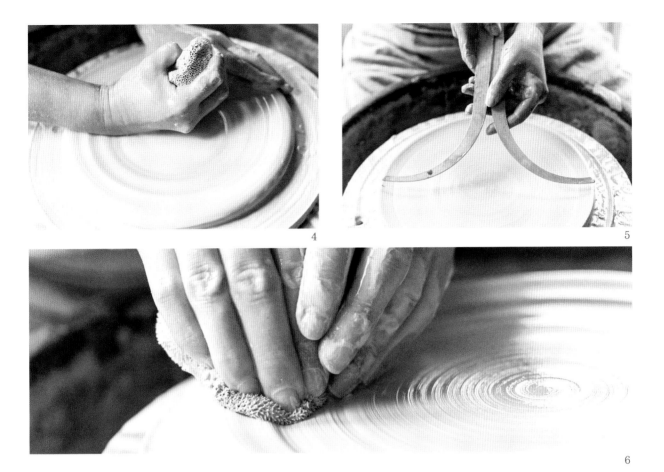

4

5

6

4 . While continuing to push downward, encourage the clay to spread outward by moving your hand from the center to the outside of the wheel toward 4 o'clock (remember, you've got to be moving slower than the wheel). Repeat this action two or three times, flattening out your clay into a disk approximately 1 inch (2.5 cm) thick.

5 . Use a ruler or calipers to measure the diameter that you've achieved. Don't forget about shrinkage—the clay I used shrunk about 15 percent. You need to make sure that's accounted for in the diameter of your plate. If you want a 9-inch (23-cm) dinner plate, then you're going to have to ensure the plate measures approximately 10½ inches (27 cm). If it's not quite wide enough, repeat step 4.

6 . To make sure your plate is flat and even, grasp your sponge between your thumb and three fingers with a little sponge overlapping the edge of your fingertips. Move from the center and, applying firm pressure to the clay, gradually move out toward 3 o'clock with your wheel going at about one-third speed. This action does two things: it flattens your plate (you don't want your plate to be all kinds of wavy) and it also compresses the particles together. This is really important to avoid "S" cracks (see "S" cracks on page 186) and to make your plate strong. Do this three times, always going from the center out toward 3 o'clock.

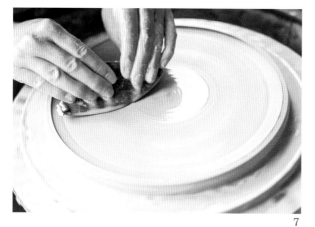

7

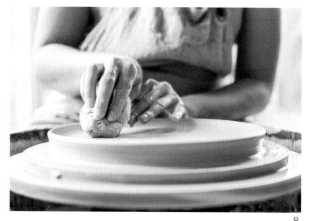

8

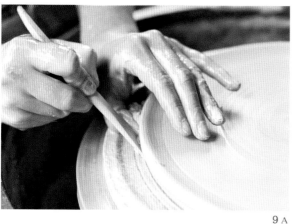

9 A

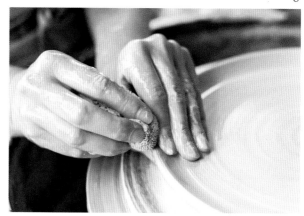

9 B

7 . You can also compress the base using the curved side of a wooden kidney. Take your wooden rib and repeat the same action, starting at the center and making your way over to 3 o'clock. Make sure the rib is wet so there is no friction. Angle the curved side of the rib at about 45 degrees so that the clay can slide underneath it and it doesn't dig into the surface. Hold the rib in the center for a few rotations before starting to move it over toward 3 o'clock. Do this three times. This also helps compress those clay particles down, making your plate really strong, and it's also going to give you a beautiful flat surface from which to eat.

8 . Get rid of any excess water on the surface of your plate with your sponge. Using enough clay means your plate will seem pretty thick at this stage; don't worry, that's okay because this means it's going to be easier to pull the wire through and there will be less of a chance of cutting through the base. We will trim the excess weight off later.

9 . To create the rim of your plate, with the wheel spinning, use the wooden knife to cut away a bevel of clay under the edge of your plate at a 45-degree angle. Making sure that the clay is glossy so there's no drag, position the thumb of your left hand at 4 o'clock in the bevel. Using gentle, even pressure, push your thumb in toward the center of the wheel; this will lift up the clay above the bevel and cause a rim to form. You can then pull the rim to thin it out using your fingertips.

10 A

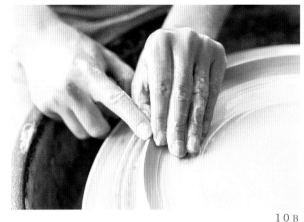

10 B

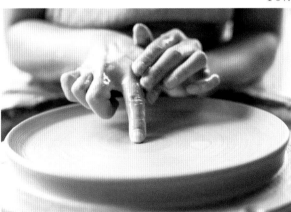

11 A

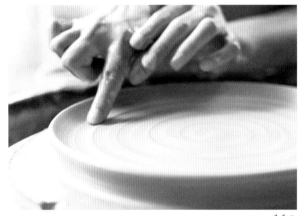

11 B

10. Check the diameter again using your ruler or calipers to make sure you have the diameter you need. Make sure you've got no standing water on your plate. You don't want the clay to absorb any additional water that could cause cracks and uneven drying. Set the rim.

11. Now add the optional whirlpool detail; this will catch glaze and create interest on the flat surface. Start the wheel turning slowly, and using your wet index finger to apply light pressure, move your finger at an even speed (which is the only time you'll move faster than the wheel) from the center to 3 o'clock, continuing toward the edge of the plate. This will create the whirlpool pattern.

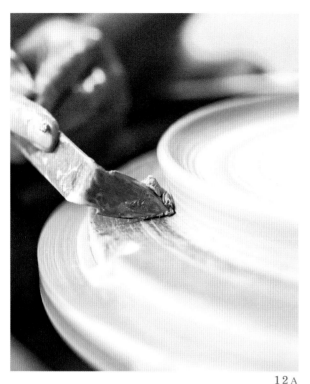

12 A

12 . Now you're ready to wire through the plate. With the wheel spinning at half speed, take your metal potter's knife and place it at the point where the clay and the batt meet. Carefully trim away some of the extra clay underneath the rim. It's best to get rid of that now rather than having to trim loads more later on in the trimming stages.

Stop the wheel. Take your wire tool and stretch it out—you are going to need it to be extremely taught to make sure it doesn't lift up in the middle and cut into your plate. Place your thumbs on top of the wire to help keep it taught. With the wire as tight as possible, pull it through the clay toward you and as close to the batt as possible. This will take a little bit of effort. Turning the wheel very slowly as you cut will help. You are going to leave the plate on the batt to dry to leather-hard.

When it comes to taking the batt off the wheel head, sponge any excess clay, slip or water off the batt, then use your metal potter's knife and the method described on page 127 to pop the batt off.

Set your plate to one side to dry until it's leather-hard. Now this is a really critical stage of the process: you want to dry your plate slowly and evenly. Don't be tempted to put it out in the sunshine to speed up the drying—this can cause cracking and warping. If the edges start to dry out quicker than the middle, then cover the edges with some plastic (a strip of a carrier bag is good). Once your plate has stiffened, it should pop off the batt with a little wiggle. Place a second batt on top of it and flip it over so it is upside down; this means the base gets exposed to more air and will help to dry the plate more evenly.

Potter's Patience: Good work has never emerged from a rushed potter. Western culture is focused on immediacy, speed and getting from A to B in the quickest way—pottery is an antidote to rush culture. Leave your impatience at the studio door; it will not help you here. Clay does not like being rushed. Pottery is a wonderful lesson in patience and patience is a key skill for any potter. As a potter, I always seem to be waiting for something, whether that is waiting for the piece to dry to the next stage so it can be worked on again or waiting for the kiln to cool so it can be opened.

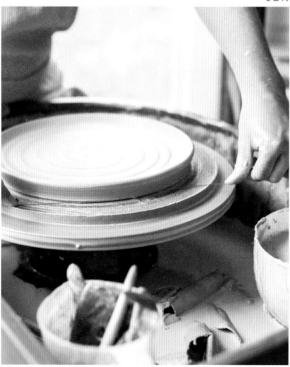

12 B

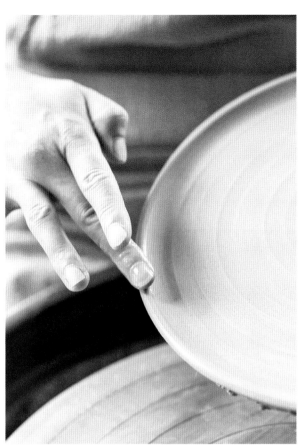

13 B

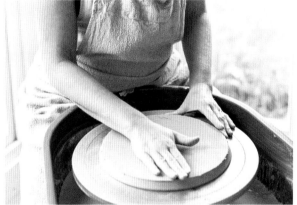

13 A

13 C

Trimming Your Plate

1 3 . As soon as the plate is leather-hard, you are ready to trim. Wet the rim of the plate with a little water and place your plate upside down in the center of your wheel. Gently tap it around the edge of the base (not the middle as you may warp your plate) to secure it to the wheel head; the water will cause an air lock. You can't really use clay sausages to secure the plate for trimming plates, as we need to access the edge of the rim and they will get in the way. Check that your plate is secure before you begin trimming by giving it a little wiggle.

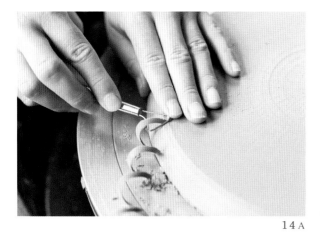

14 A

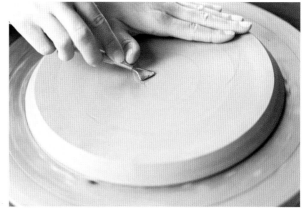

14 B

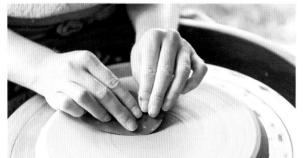

15

16

14 . Rest the fingers of your left hand on top of the plate mirroring where you are trimming; this will help stabilize the plate. With the wheel turning at half speed, hold the trimming tool in the palm of your hand with your index finger extending toward the loop for maximum control. Trim the outer edge of the plate where the rim starts to rise—you want to achieve a nice curved edge and get rid of any excess weight. Then, working from the center over to 3 o'clock, angle the trimming tool flat and carefully trim away the excess clay on the base of your plate. Because you had to throw it quite thickly, you may have to trim away a lot of clay. Be careful not to put too much pressure on the middle of the base, otherwise the plate may bow.

15 . When the base is flat, use the metal rib to burnish it. Hold the metal rib flat against the clay. With the wheel spinning three-quarters speed, move the metal kidney along the clay on all the areas you trimmed between the center and 3 o'clock (you'll see the clay beneath become super smooth). This will give it a really professional finish and also help to avoid "S" cracks. Be careful, metal ribs are sharp. If your plate gets slightly bowed during trimming, turn it right side up, place on a flat surface, then push the middle back down to flatten it again.

16 . Once you're happy, pop your plate off the wheel by gently holding the plate on either side and slowly turning the wheel to release the air lock. Tidy up the rim with a damp sponge, if needed. Leave your plate upside down somewhere out of direct sun, drafts or heat sources to dry slowly. You may need to cover the edges again if they are drying quicker than the middle.

17

18 A

18 B

18 C

17. Now that the plate is bone dry, bisque fire to 1940°F (1060°C), cone 04. I fire my plates standing on their side with the rims resting against the wall of the kiln rather than flat. This saves room in the kiln and I also find it reduces the occurrence of cracking.

18. When your plate is cooled and out of the kiln, prepare your plate for glazing by wet sanding any sharp edges or gnarly bits. Wipe the surface of the plate with a clean, damp sponge to get rid of any dust.

Choose a glazing technique from pages 143 to 157 and follow the steps. I used two different brush-on glazes for my plate, layering them one over the other to help emphasize the whirlpool pattern. Plates take up quite a lot of room in the kiln—when you glaze fire them, they each need their own shelf. Fire the plate to the temperature as instructed on your glaze packaging. The glazes I used were fired to 2231°F (1222°C), cone 6. I added the gold decal as a final flourish to my plate. It was fired one final time to 1261°F (683°C), cone 019. (I show you how to do this decal technique on page 165.)

GLAZING

Bring Your Pottery to Life with Color

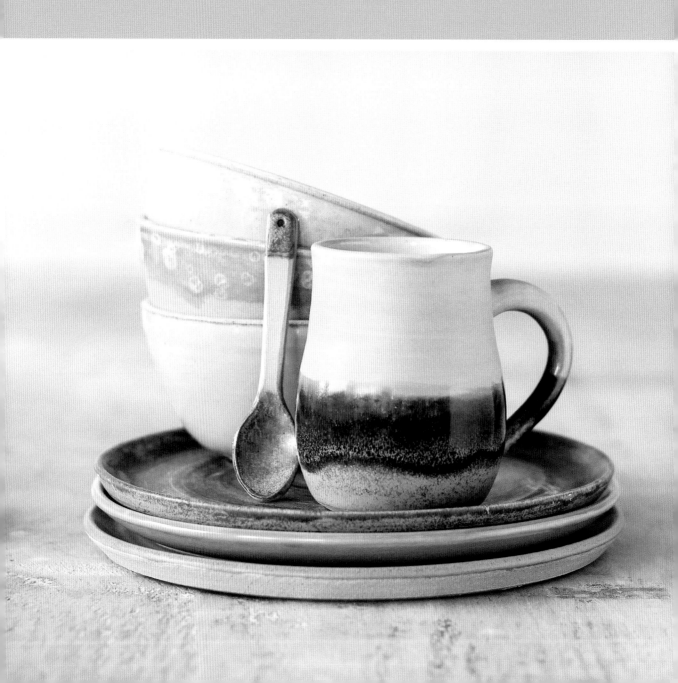

If clay is the body, then glazes are the clothes. Glaze gives your pottery its unique personality via color and texture. Glaze also makes your pots functional, watertight and robust. In combination with heat, glaze turns chalky, absorbent, fragile bisqueware into glossy (or matte), vitrified and sturdy pieces of utilitarian dinnerware or beautiful bright, colorful pieces of art. Ceramics only come into being with the magic of glaze.

It is important that the clothes (glaze) fit the body (clay). We all know how uncomfortable a tight pair of jeans is! You may hear potters talk about glaze fit; this simply refers to the glaze being the correct formula to work well with the clay body. All clays and glazes are formulated to vitrify at a specific temperature range. You must always match your glaze to your clay firing temperatures.

If you are firing your work in a community studio, find out at what temperature they fire their kilns before buying glazes. Ask your pottery supply store if you're not sure about compatibility. It is possible to mix your own glazes from scratch, but as this is a beginners book I focus on ready-made commercial glazes. You can of course go on to learn about the more advanced techniques of making glazes from recipes once you've mastered the basics.

I use a combination of all the glazing techniques mentioned in this book in my studio. It took me a long time of experimentation to find my own rhythm and get comfortable with glazing and discovering the processes that work for me. It might take you a while to get into your own rhythm too. Don't be afraid to experiment. Find the colors, textures and effects that you really like and practice the techniques to become confident in applying them.

SIX THINGS YOU NEED TO KNOW ABOUT GLAZE

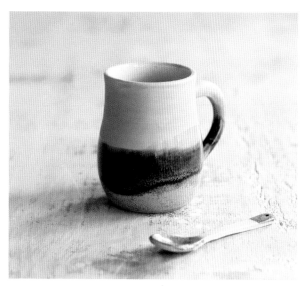

These glazes looked very pale in the bottle in comparison to how they looked after they were fired.

1. Glaze is not like paint; it's not made from pigment. The color of the liquid glaze rarely resembles that of the final fired piece. Instead, it's made from raw ceramic materials like clay that stiffens the glaze, silica that forms the glass-like surface, fluxes that help melt the glaze in the kiln and oxides that provide the color. These are all suspended in a liquid, normally water. Sometimes a thickener is added to make them brush-on glazes. The glaze is formed in the kiln via a chemical reaction through the exposure to intense heat over a period of time. Potters call this *heat work*. In its unfired state, glaze can be thick and gel-like or thin and quite watery. After being applied to a pot, before it's fired, glaze has a powdery finish. Once dried it can be easily chipped or scratched, so freshly glazed pots need to be handled with care. Glazes dry very quickly; you'll see them go from glossy and wet to matte and powdery before your eyes.

2. Glazes can be found in a few different forms: ready-mixed liquid, powder to which you add water or mixed from raw materials following a recipe.

3. Glaze textures come in glossy or matte, opaque, transparent, semi-transparent and sometimes with crystals. The color of the clay you choose will have an impact on the final color and effect, as will the opacity of the glaze and how thickly it is applied.

4. Glaze can be applied by brushing, dipping, pouring or even spraying. (I don't cover spraying in this book, as it requires special equipment and is a little more advanced.)

5. You need to stir your glazes really well. Many of the solid elements in glazes are not water-soluble and, being heavier than the water, they will sink to the bottom of the container. If you don't have enough of the right components mixed well and evenly throughout your glaze, you will face problems such as pinholes, craters, crazing or poor color when applying it to your pottery. So, stir those glazes folks! Stir them for longer than you think is necessary.

6. You will need to test them. Before using a new glaze or a new technique on a whole batch of work, test it. It's really disappointing if it doesn't turn out the way you expect. This is where your potter's patience is put to the test; it can be so tempting to just go ahead and glaze everything with a new untested glaze.

"The only failure is one from which we learn nothing." —Henry Ford (no relation)

Prepare to fail—a lot! Pottery is the world's best teacher in letting go. You can think you've done everything right—prepared the clay well, thrown the best mug you've ever thrown, taken care during trimming, applied a handle without cracks appearing, judiciously prepped the pot for glazing and taken your time applying glaze—and yet it can still come out of the kiln not how you were expecting. Sometimes, your pot will just look different to how you imagined—you need to accept that as part of this enigmatic process.

Most of the time there will be a reason why our pot "failed," and it is all part of the learning process to try and figure out what caused it so as to ensure the next pot you make will be better. Sometimes you'll just never know, and that's when you have to turn that mug into a planter and just let it go.

PREPPING YOUR POTS FOR THE BEST GLAZING RESULTS

It is important to inspect your bisque for faults or cracks that may have occurred during the firing. Check handle joins and bases, since these are the areas where faults most regularly occur. There's not much point in spending lots of time prepping and glazing pots that aren't going to be usable in the end. It's tempting to try and cover a crack with glaze, but in my experience, this rarely works and, most of the time, cracks become even more pronounced in the glaze firing and the piece becomes weaker. It may sound harsh to reject something you have already spent so much time on, but firings use precious resources, so it is best to save kiln space for pots you can be really proud of instead of ones that are likely to just end up as a crock in the bottom of a flowerpot.

Pro Tip: Testing glazes is a great way to use up dud bisque pots. Whenever you find a new glaze, use a dud pot to test the color.

1

2 A

2 B

3

Wet Sand Your Pots

Before applying glaze to pottery, take the time to wet sand your pots. Any rough edges will show through the glaze, so do this for a professional finish. I use a diamond sanding pad and an abrasive sanding stick, but sandpaper works just fine too. It is important to always wet sand pottery due to the dust that is caused during dry sanding (remember to always keep dust to a minimum). As well as being bad for your health, dust deposits on the pot will prevent the glaze from adhering properly because it creates a barrier between the glaze and the ceramic surface (see Troubleshooting on page 186). Using a respirator with fine particle filtration is essential if creating dust. Plan to prep your pots the day before glazing them.

1 . Submerge your bisque pot and sanding pad into a bucket of clean water.

2 . Use the sanding pad or sandpaper to gently buff over any sharp edges, rough bits you may have missed during trimming or bits of debris picked up from the kiln shelves. Use an abrasive sanding stick to get into tight corners, taking extra care around handle and foot areas.

3 . Use a clean, damp sponge to wipe the surface of your pots to ensure all dust created during the sanding process is removed; you need them to be completely dust-free before glazing them.

Allow your pots to dry completely before glazing. I normally leave them overnight. Glaze will not be absorbed into an already waterlogged pot—this can lead to a problem called crawling (see Troubleshooting on page 186).

Always test your glazes before applying them to your work. It's really frustrating to glaze a big batch of work for it to not turn out the way you'd expect. I make test tiles to use with all new glazes.

Remember any areas which come in contact with the kiln shelf need to be free of glaze. This plate was made without a foot so the base remains unglazed.

Ensure each coat dries throughly before applying the next.

BASIC GLAZING TECHNIQUES

Brush-On Glazes

Brush-on glazes are probably the easiest to work with, but they tend to be the most expensive. However, they are a great place to start. The ceramic manufacturers have done all the hard work for you, concocting elements to create wondrous colors in a myriad of textures and finishes. From matte to glossy, from crystals to celadon, you can find it all. Brush-on glazes are a brilliant way to become confident with glazing. Brands such as Mayco®, Amaco®, Terracolor®, Spectrum® and Botz® all have fantastic ranges of glazes.

How to Use Brush-On Glazes

1. Use a soft bristled wide or fan brush. Wet your brush before putting it in the glaze.

2. Stir your glaze really well, for at least a minute. Remember glaze is made of particles that settle on the bottom of the container, so it's really important to distribute them evenly throughout the glaze for it to fire properly. Sometimes you'll need to add a little water to the glaze to thin it and make it easier to brush.

3. Always fully load the brush with enough glaze; your paintbrush may drag off the already applied glaze if you don't have enough on the bristles.

4. Follow the instructions on the glaze packaging to check how many layers you will need to apply (normally it's two or three).

5. Use smooth strokes all in the same direction.

6. Use a different brush for each color. Always wash your brushes after glazing to minimize dust.

A foot ring was trimmed into the base of this plate, so the underside can be glazed, as the foot elevates it off the kiln shelf.

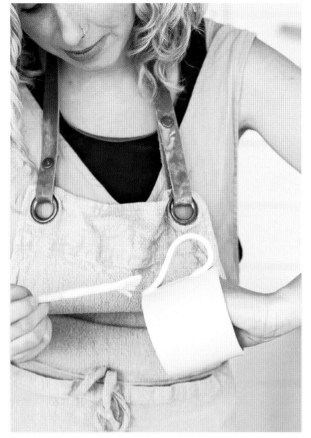

See Pro Tip below.

7. Wait for each layer to completely dry before you paint the next.

8. The thickness of glaze you are aiming for averages at about 2 millimeters.

9. Wait for the glaze to completely dry before firing it.

10. Make sure no glaze is in contact with the kiln shelf or it will stick your pot to the shelf. Wipe the bases or foot rings of your pots with a damp sponge to get rid of any stray drips or splashes of glaze.

11. Double-check the firing temperature of the glaze (cone 01 and cone 1 are completely different!).

12. Always use pyrometric cones in your glaze firings (see page 179 for an explanation of pyrometric cones).

Pro Tip: An easy way to glaze a cylindrical pot such as a mug while using a brush-on glaze is to put your fist into it, gripping the walls by expanding your fingers. Turn it upside down and glaze the outside first—this way you can get easy access to all sides of the pot and you can glaze the handle, avoiding finger marks. Once you've done one layer of the outside, pop the pot on a table and then glaze the inside. Alternate between outside and inside until you have completed all layers.

Making glazes from ready-made powders is the first step towards creating your own glaze using a recipe.

Keep the glaze bag low in the bucket whilst pouring to reduce dust.

Dipping and Pouring Glazes

Health & Safety: Protect your lungs and always wear a respirator when dealing with dry ceramic powders.

Glazes also come in a powdered form ready to mix with water. You tend to get more even coverage using these glazes than with brush-on glazes. Mixing powdered glaze can be cheaper than buying brush-on. They tend to go further, and you aren't paying to ship water weight. With these glazes, you need to add the correct amount of water according to the manufacturer's instructions.

How to Mix Powdered Glazes

Remember to wear a respirator and work in a well-ventilated area.

1. Powdered glazes are best made in a big bucket.

2. Pour in the required amount of water to the bucket according to the manufacturer's instructions. Always add the glaze powder to water and not the other way round; this minimizes dust in the air.

3. Let the glaze slake down into the water for 20 minutes before mixing.

4. Mix using a drill paddle attachment or a stick hand blender. Mix for a minimum of 1 minute.

Pour a little into the sieve at a time and work through using your spatula or brush.

Ensure you get all the lumps from the bottom of the bucket as these will contain vital elements to be distributed throughout the glaze.

5 . Pass the mixture through a 100-mesh pottery sieve a couple of times. This is the best way to make sure all the particles are evenly distributed and that any lumps are removed. Use a stiff bristled brush or a silicone spatula to help you pass the glaze through the sieve.

6 . Mix your glaze well before each use. I always whizz my glazes with a stick blender for at least 1 minute before each glazing session and give them a really good stir in between every pot I glaze.

Using Wax Resist

Potters use something called wax emulsion resist. Wax resist acts as a barrier between the pottery and the glaze; glaze is not absorbed on the areas that the wax is applied. When using dipping or pouring glazes, you'll likely want to apply the wax on the area that will be in contact with the kiln shelf—this is most likely the bottom of your pot. Pot bottoms will need to be completely glaze free so your pot does not stick to the kiln shelf, so give the waxed area a wipe with a damp sponge after glazing. The wax will burn off in the kiln.

You have to be careful with wax—if you get it on any area of the pot that you do want to glaze, it's going to create an instant barrier. The only real way to get that off is to bisque fire your pot again, which is a real pain. To make sure that you don't get the wax anywhere that you don't want, move all of your bisque to one side of your workbench and only have the pot you are currently waxing in front of you; this lowers the risk of splashes going on to your other pots.

Wax normally comes in 1-pint (473-ml) tubs from your pottery supply store.

Use a really soft, small paintbrush to apply the wax in a single layer. You can water the wax down to make it easier to apply. Wet your brush before using the wax.

Pro Tip: Wax is normally a clear or off-white color and can look very similar to your bisque clay once dried. Put food coloring into your wax; this helps you to see where it has and hasn't been applied, and it also helps you to identify any stray drips.

Wax can be a fun way of creating unique designs on your pottery by deliberately masking off areas of bisque using the wax. Paint the wax on freehand with a paintbrush or use stencils cut out of paper or card. Anywhere the wax is painted on, the glaze will not adhere to, allowing the clay to show through and offering another way to create a variety of color and texture on your work.

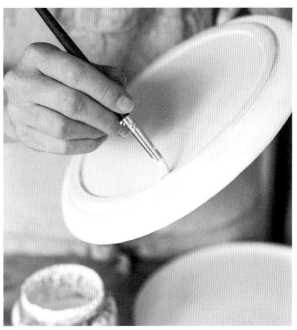

I am waxing the foot ring of a plate so the glaze will not be absorbed. After glazing I will wipe the foot to ensure it is completely glaze free.

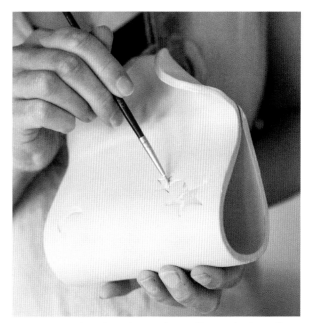

Painting wax in the embossed stamped area will mean the glaze will not stick here. The clay showing through will further emphasize the star motif.

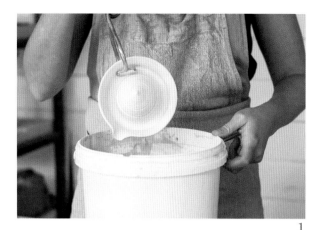

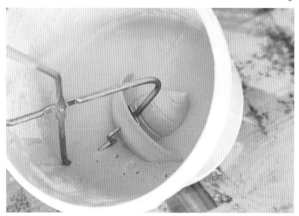

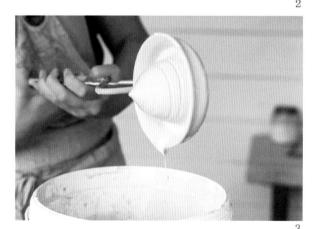

How to Dip Glaze

This is probably the easiest and quickest way to glaze your pots. It's great for when you are using just one glaze color on the entire pot. You can glaze many pots in a much shorter space of time than brushing. The best way to get good results from using dipping glazes is to ensure you have a big enough bucket of glaze. It can be awkward and frustrating to try and glaze a pot if it doesn't fit into your glaze container or you don't have enough glaze in your bucket to submerge your pot fully.

Dipping isn't a great method if you make smaller batches of glaze or when you're trying out new glazes. However, it is really great if you've got a favorite glaze color that you know you'll use all the time, and you can make a really big batch of it. If you try and dip a form into a half-empty bucket of glaze, you're only going to be able to glaze half of it. If you take it out and then put it back in the other way, you'll get a noticeable line where the glaze is double thick (some potters choose to use this as a design feature).

Pro Tip: Remember, it's really important to keep stirring your glaze, especially with dipping glazes. They are thinner than brush-on glazes and the glaze particles are heavier than water, so the sediment sinks much quicker. I normally use my stick blender to give my glaze a quick stir in between every single pot.

1. Prepare your pottery by wet sanding (page 142). Using your stick blender or drill paddle, whisk the glaze for at least a minute before you start glazing and then stir it well in between each pot.

 Grip your pot using your tongs; the grip must be firm enough so the pot doesn't slip out but gentle enough so that you do not crush the pot. Remember bisque is still delicate at this stage. If you are glazing a mug, bowl or plate, the best way to grip it is to have the wall between the tongs.

2. Dip your pot into the glaze, ensuring it's fully submerged for approximately 3 seconds. Carefully lift the pot out and pour out any glaze.

3. Hold the pot rim side down over the bucket of glaze to allow for any drips. Gently shake any drips off in an up-down motion. Keep the pot upside down until the glaze has turned from glossy to powdery—this may take several seconds, but it will help avoid any unsightly drips.

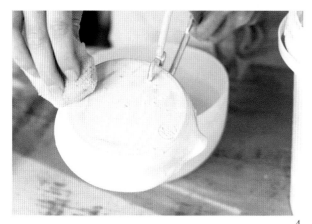

4

5

6

PT

4 . When the glaze is dry, it can be carefully handled. Use a sponge to wipe away any glaze on unwanted areas of your pot or any areas that will be in contact with the kiln shelf.

5 . The tongs have likely left a mark where they were holding the pot, but you can normally smooth this over by gently rubbing the glaze with your fingertip, or using a paintbrush to take a small amount of glaze and fill it in.

6 . Leave freshly glazed pots to dry completely before putting them in your kiln to fire. I normally leave mine overnight. Check the bottoms to ensure they are completely free of glaze before loading your kiln.

Pro Tip: Any glaze drips will likely be visible after firing. Before you fire your glazed pot, you can use a little scraping tool to get rid of them. Hold your pot over your glaze bucket and gently scrape back the drip until it is flush with the rest of the surface. Be really careful doing this because you don't want to scratch through the layer of glaze. Use your finger just to smooth it out. Remember to wear a respirator when working with dry glaze.

How to Pour Glaze

Pouring a glaze is a great way to glaze larger, flat pieces like plates, platters or other pieces that don't easily fit into a bucket or if you don't have enough glaze in which to submerge a pot.

To begin, you'll need a larger bucket underneath to catch the glaze as you pour it over your pot, a jug big enough to hold enough glaze and tongs to grasp your pot. It's always best to glaze a pot all in one go, otherwise you'll get noticeable lines or streaks.

1. Stir the glaze thoroughly. Wax any areas that will be in contact with the kiln shelf.

2. Hold the pot firmly with tongs over a large bucket.

3. Use a large 2-quart (2-L) jug and fill it with enough glaze so you don't run out halfway through the pour.

4. Angle the pot facing up at 45 degrees so the glaze will run over the surface before running into the bucket.

5. Start from one edge of the pot and begin pouring the glaze with a smooth, slow pour, ensuring all parts of the bisque are covered in glaze. Work from one end to the other. Allow the glaze to drip off into the bucket.

6. Once dry, turn the pot over and glaze the reverse, if required (for example, if your pot has a foot).

7. Allow it to dry before cleaning up any drips and filling in holes left by the tongs with a paintbrush.

1

2 A

2 B

How to Use Pouring Glazes with Props

Using props over a bucket when glazing is a good method to use if you only have a small amount of glaze or not enough for dipping. It's also handy if you want to glaze a pot a different color on the inside than on the outside.

1. Wax any area of the pot you do not want to glaze and leave to dry.

2. Get your glaze into a suitably sized jug. Holding the pot in one hand, pour in the glaze as quickly as possible all the way up to the top, being careful not to spill. After approximately 2 to 3 seconds, pour it back out into the bucket. Keep the form upside down until the glaze is dry to avoid unwanted drips.

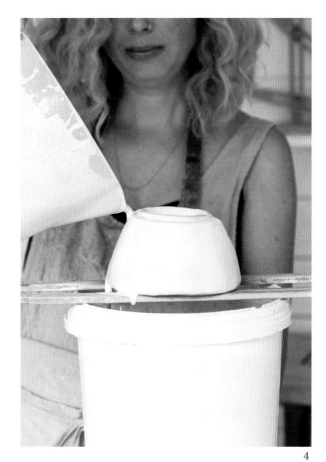

3

4

3. Have the jug of glaze already mixed and stirred well. Putting the bucket on a turn table can be useful to get easy access to all sides. Place some props such as thickness gauges or chopsticks on the bucket to rest the rim of your pot. Put the pot upside down as near to the center of the bucket as you can. Make sure that it's resting evenly on the supports, so it doesn't fall into the bucket.

4. Pour the glaze around the outside of the form with one hand and if using, slowly turn the turntable at the same time with the other hand. It doesn't matter if the glaze goes on the base (it's not going to be absorbed because of the wax).

Wait for the outside to dry before touching it. Lift the pot off the supports and pour off the excess glaze that may have gathered on the waxed base back into the bucket.

Wipe the bottom or foot ring with a damp sponge to ensure it is free of glaze.

Using a paintbrush, fill in any bit of missing glaze around the rim.

Sometimes some of the glaze will splash up inside the pot. You can remove dry glaze splashes by using a little scraper tool as described in the Pro Tip on page 149.

COMBINING GLAZES

Layering Brush-On Glazes

Layering two or even three glazes together is a great way to create an entirely unique look on your pottery. It's super fun to experiment with color combinations—the possibilities are truly endless. You can end up with super professional and distinctive looking pottery with minimum experience.

As discussed earlier in this chapter, glazes are not like paints, and traditional mixing of glaze colors will often not produce predictable results (e.g., mixing a blue and red glaze won't necessarily create purple, as you would expect with paints). That's because you are adding oxides and heat into the mix. However, this unpredictability is all part of the fun. The only way to know what your layered glazes are going to look like is to test them.

Glaze brands such as Mayco create glazes that are specifically designed to be layered together to create fantastic effects on your pots. You can layer two dipping glazes easily by dipping one over the other after the first is dry. Thickly layered glaze like this can produce drips and running. This can be great for unique effects, but it may be dangerous for the kiln shelves.

When layering two or more glazes together, only do so on the top two-thirds of your pot.

Brush-on glazes are a really good way to layer your glazes, as it gives you the most control over where to put the colors and it means you can apply thinner layers than you could if you were dipping.

Start out by testing a few different combinations using different techniques on test tiles.

You can even combine brush-on glazes and dipping glazes together. I find applying the brush-on glaze first easier, then dipping the pot in the dipping glaze second. Always do a test to avoid disasters.

1

2

3

4

Here is an example of how to layer your glazes using brush-on glazes. You can make test tiles like these by throwing a cylinder without a base on a throwing batt. Once leather hard, cut it into 1-inch (2.5-cm) sections and bisque fire when dry.

1. Choose two glazes you like.

 Using a soft bristle or fan brush with the brush fully loaded with glaze, paint a single layer of one color on the top two-thirds of a test pot or test tile. Wait for it to dry.

2. Apply a coat of the second color on the bottom two-thirds of the pot. Wait for it to dry.

3. Then apply a second coat of the first color to the top two-thirds and wait for it to dry. You want the glazes to overlap in the middle section.

4. Repeat steps 1 through 3.

Pro Tip: Make a note in your glaze notebook of what you did. This is important as it's the only way you'll remember the method you used when you want to recreate it later. The portion of the pot that has the overlapping glazes will hopefully give you some really interesting, unique effects that you can replicate on your future pottery.

There are so many different combinations to try. Two layers of glaze I with one layer of glaze II will give you a completely different result than one layer of glaze I with two layers of glaze II. Some glazes look great with two layers of each glaze. Remember, glazes melt in the kiln at a specific temperature. Thus, mixing glazes can often mean they get runnier, so do bear this in mind when using them.

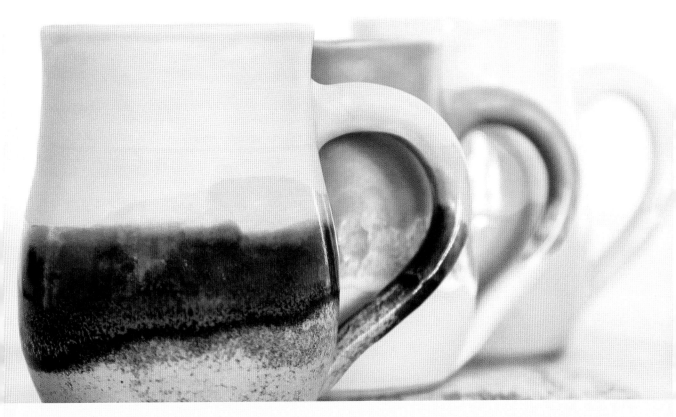

Pro Tip: Glazing Notes

Using a simple diagram such as the one below will help you make accurate notes about how you glazed your pots and be able to replicate it next time.

Pot Design	Glaze I	Glaze II	No. of coats			
	e.g., Mayco SW-201					
		e.g., Spectrum 1180				

1

2

3

Layering Dipping Glazes

Pro Tip: It's easier to work through your batch of pottery using one glaze color at a time rather than flipping from one glaze to another between every pot.

Sometimes you might want to use two or three different color dipping glazes. For example: It is common to use clear or liner glaze on the interior of a mug and two colored glazes on the outside.

I will now describe how to glaze a pot using three different dipping glazes: a clear glaze on the interior, a white glaze on the top half and a colored glaze on the bottom half. Always do the liner (interior) glaze first because if you get any drips on the outside, you can just use a sponge to wipe them away.

1. Prep your pot as described on page 141. Wax the bottom of the pot with wax emulsion resist and leave to dry. Use a stick blender to mix the glaze for at least a minute.

2. You want as thin a layer of liner glaze as possible (this helps reduce issues such as crazing). Pour the clear liner glaze into a suitably sized jug, making sure you've got enough of it, because it's much easier to be quick when you can just fill the form right up to the top. Holding the pot in one hand, pour in the glaze as quickly as possible all the way up to the top, being careful not to spill. After approximately 2 seconds, pour it back out into the bucket. Keep the form upside down until most of that glaze is dry to avoid drips.

3. Holding the pot firmly at the base, dip the top of the pot into the white glaze up to just past the middle and hold it for 3 seconds. Pull it out and hold it upside down until dry to avoid drips. Wipe away any unwanted drips with a damp sponge. Then, leave to dry.

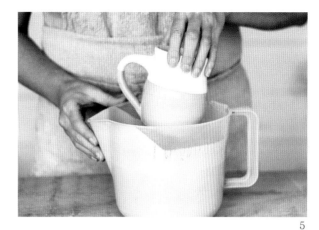

5

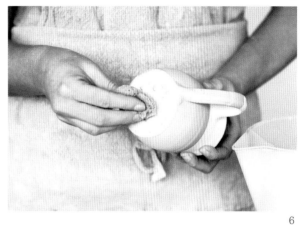

6

4 . Once the top is dry, you're ready to glaze the bottom. Check you don't have any debris on the bottom of your pot; you don't want it to go in your glaze. Use the stick blender to mix the third glaze for at least 1 minute.

5 . Hold the pot carefully at the rim. Dunk the bottom of the pot into the glaze up to just past the middle. The overlapping glazes will create an interesting effect. Hold it there for 3 seconds and then pull it out slowly and let all the drips run off the bottom. Wait until the glaze turns powdery before touching it.

6 . Wipe the waxed area on the bottom of the pot with your sponge to get rid of any excess glaze. Then leave it to dry before firing your pot to the correct glaze temperature.

DECORATIVE TECHNIQUES

Creating Texture & Pattern on Your Pots

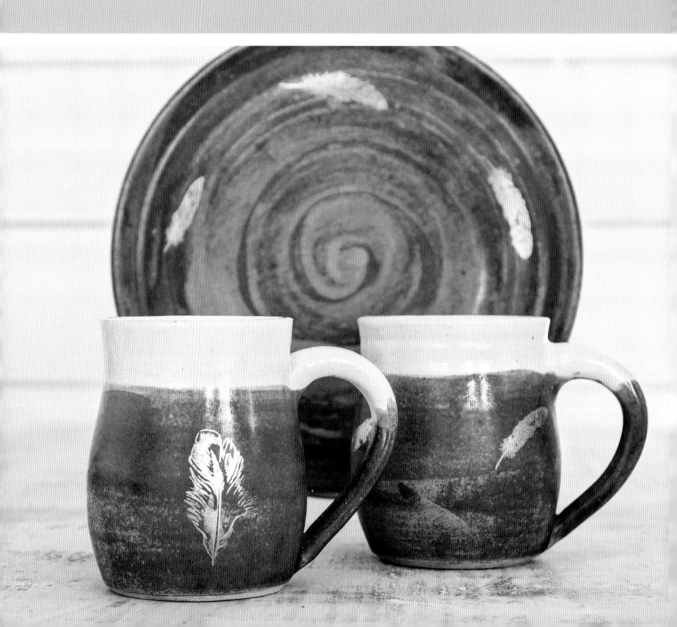

This next chapter describes various other fun decorative techniques you can mix and match with the pottery projects and the glazing techniques to create truly unique and beautiful pottery.

All the decorating techniques can be used across hand-built as well as the wheel-thrown forms.

How about trying out the sgraffito technique (page 161) to add an illustration to a barrel bellied mug or carving pattern into a plate? Or adding colorful overglaze decals (page 165) to a set of comforting soup bowls? Try adding stamps (page 172) to a slab-built mug or underglaze decals to the soap dish project.

The projects included in this book are a great starting point, but there are hundreds of other techniques you can use to decorate your pottery—the possibilities are endless. When you get started you're not going to want to stop trying new ideas for how you can bring your pottery surfaces to life.

I encourage you to explore, have fun, experiment and find your own style.

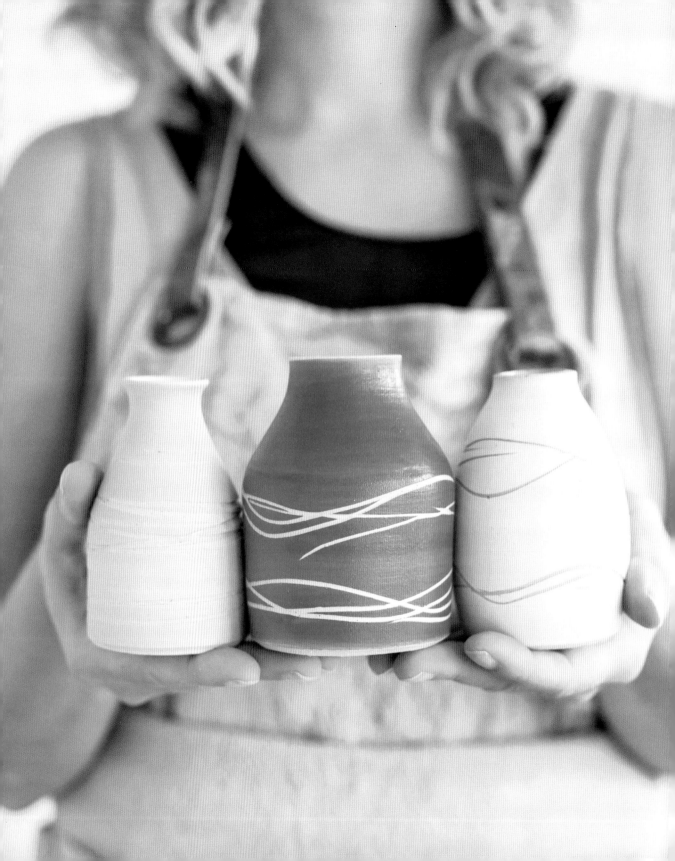

SGRAFFITO:
CARVING COLORED SLIPS

Sgraffito means "scratched" in Italian. This is a fun, easy and super effective way of adding patterned, geometric or organic design elements to your pottery. Often the simplest design techniques have the most impact.

Sgraffito involves applying colored liquid clay known as slip to a leather-hard pot surface and then scratching through to reveal the original clay color beneath. Sgraffito techniques are easier to apply to leather-hard clay, but it can also be done on bisqueware. This simple technique combines contrast and texture, which can be impactful or subtle depending on the clay and slip combination you choose. The most vibrant designs are created using two highly contrasting colors (think of a color wheel): black slip over porcelain clay, turquoise slip over terracotta clay or porcelain slip over a black or dark brown clay—all of these will produce striking results. Subtlety can produce beautiful results, too. I am drawn mostly to coastal colors in my work, which tend to be softer and have a more tonal quality, so I will show you how to use paler slips on a white clay.

If you want to try more detailed, structured or graphic designs, you can draw out patterns or illustrations beforehand and transfer them to your clay by tracing them onto the surface using carbon paper before carving the clay. I find simple freehand patterns can often be extremely effective.

In this project I will show you how to sgraffito on leather-hard clay, using the bud vase form from page 101. I use the wheel to help me apply the slip and carve the pattern, but it would work equally as well on hand-built forms. Sgraffito techniques work best with finer clays with less grog in them because you can achieve a sharper line. The sandy particles in groggy clay tend to rip through the clay as you carve the surface, leaving jagged edges. You can buy ready-made colored slip in little pots, which is normally referred to as underglaze, or you can make your own by whizzing up dry offcuts of your chosen clay with water—this can be any type of clay. You can also color it with ceramic stains, but white clay is better for this. For beginners, I recommend you use a ready-made underglaze. It comes in a huge variety of colors.

Tools

Underglaze color of your choice

Soft fan brush

Sanding pad/fine sandpaper

Trimming/fettling tool

1. Start off by throwing your bud vase form by following the instructions on page 101. Cut it off the wheel and leave it somewhere safe to dry until it gets to a leather-hard consistency. The length of drying time will vary depending on weather, humidity and how warm your creative space is, so keep checking on it. The perfect time to sgraffito the clay is when it is just a little harder than leather-hard; this is because your tool won't cut through the clay too easily and make mistakes. The clay should feel firm enough so when you push your tool onto it, it doesn't distort, but soft enough that when you gently press your fingernail into it, it will make a mark.

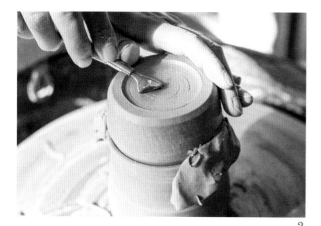

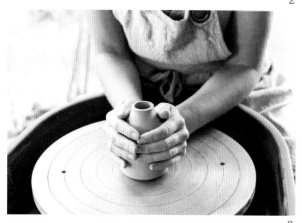

2

3

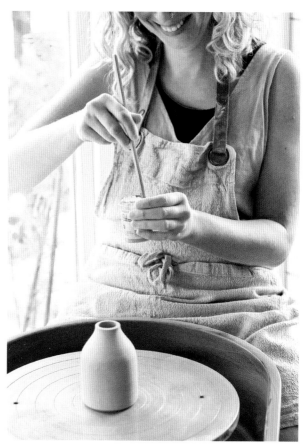

4

2 . Trim your pot so the bottom is neat and the form has the final desired profile. It will be difficult to trim the pot after the sgraffito, as you will mess up the design.

3 . Attach the vase to the center of the wheel by dampening the wheel with a sponge, making sure the vase is perfectly centered, and gently press it onto the wheel head.

4 . Stir your chosen underglaze thoroughly using a brush or stick. You may find that you'll need to add a little water to the underglaze if it's too thick. The consistency needs to be a little like heavy cream. Using a soft fan brush for this project allows you to apply the slip generously without leaving behind bristle marks.

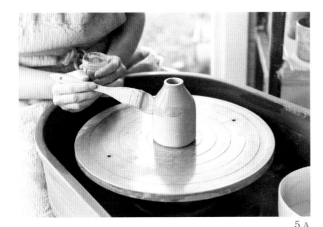

5 A

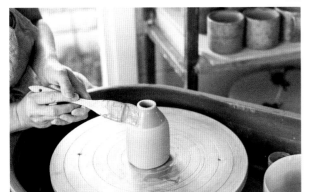

5 B

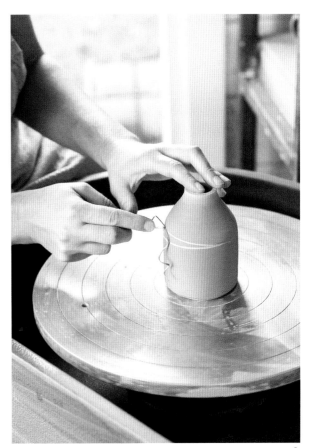

6

5 . Start the wheel turning slowly. Load the brush full of underglaze, and starting at the top of your form, hold the brush next to the surface—the rotation of the wheel will help you apply it evenly. Work your way down the form until you reach the bottom. You will need to keep applying more underglaze to your brush regularly. Wait for the first layer to dry before applying the next, starting back at the top each time. Apply three layers. If you can still see the color of the clay beneath, then apply another layer.

6 . You need to wait for the last layer of underglaze to dry and until it is no longer glossy before you can start carving. Ensure the vase is still secure on the wheel head between applications and re-attach it to the wheel, if necessary. Work out roughly where you'd like the flowing pattern to be on your vase. (I find that the shoulder and near the base are good places for a pattern.) Hold the trimming tool steady in your hand like you would when trimming. (If you're carving an illustration or a pattern off the wheel, you'd hold the tool more like you would a pencil.) You need to angle it so only the very tip is going to cut through the top 1/16 inch (2 mm) of underglaze, revealing the clay beneath. You shouldn't need to press into the clay very hard. The slow rotation of the wheel will pull the tool through the surface. Do this all in one motion to get the best results. While the vase is steadily rotating, you can undulate your hand, moving up and down slowly to create a wave-like ripple. Brush away the carvings using a clean, dry soft brush; try not to use your hands or you may smudge the underglaze. Look at your vase from different angles and add more waves if you wish.

Once you're happy, release your vase from the wheel suction by gently rocking it with two hands. Set it to dry upside down to help avoid cracks on the base. Once bone dry, bisque fire your vase to 1940°F (1060°C), cone 04.

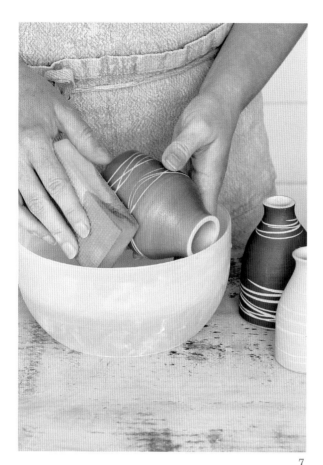

7

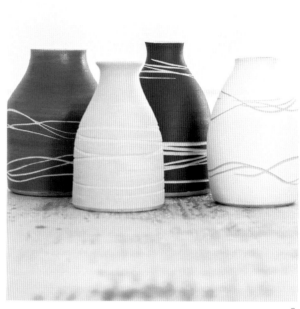

8

7 . Once cool and out of the kiln, gently wet sand your vase around the sgraffito design with fine sandpaper or a sanding pad; this will get rid of any sharp edges created when carving. Make sure you wipe away any dust created during sanding with a wet sponge. Don't forget to use a respirator when creating dust.

8 . Choose the glaze you'd like to use for the exterior. A clear transparent glaze will intensify the color of the underglaze and retain the carving texture. You can also just leave the outside unglazed to retain a matte finish like I have here. Pour transparent glaze into the vase right to the top and then quickly pour it out; this will make the vase watertight and usable for flowers. Fire to the temperature according to the clay and glaze manufacturer's instructions.

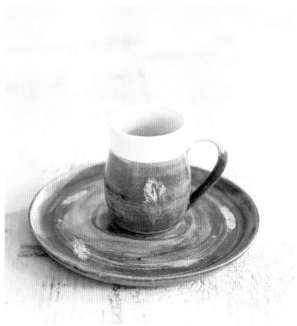

DECALS:
PRINTING ON CLAY

Decals are a way of printing onto the surface of your pottery, decorating your pots with often delicate or repeating patterns that would be very difficult to achieve freehand with standard glazes. A design is created and printed by a manufacturer onto decal transfer paper by using special inks containing oxides. This paper can then be wetted and applied to your bisque, leather-hard or greenware pottery or glaze-ware, transferring the pattern or motif onto the clay. It's then fired in the kiln, which permanently adheres the design onto your pottery.

There are two main types of decals:

1. *Underglaze decals:* These are applied to your pot when it is in its leather-hard or bisqueware state. The pot can then be glazed as normal and fired to glaze temperatures. Underglaze decals tend to be made up of a single color such as blue, black, red or green, but as the pattern is under the glaze and fired to a higher temperature, it is more robust than overglaze decals.

2. *Overglaze decals:* These are only applied to the surface of pottery that has already been glazed and gone through a glaze firing. The pottery is then fired for a third time at a much lower temperature, adhering the design to the surface of the glaze. Overglaze decals can be much more colorful and varied; you can even get them in real gold. The only downside to these types of decals is that because they are on the surface of the glaze, they tend to be less scratch resistant and can be subject to fading over time, especially in a dishwasher.

You can source decals in many places online:

https://elantransfers.com

https://chinaclayart.com

https://baileydecal.co.uk

In the following projects I'm going to show you how to use both types of decals on your pottery.

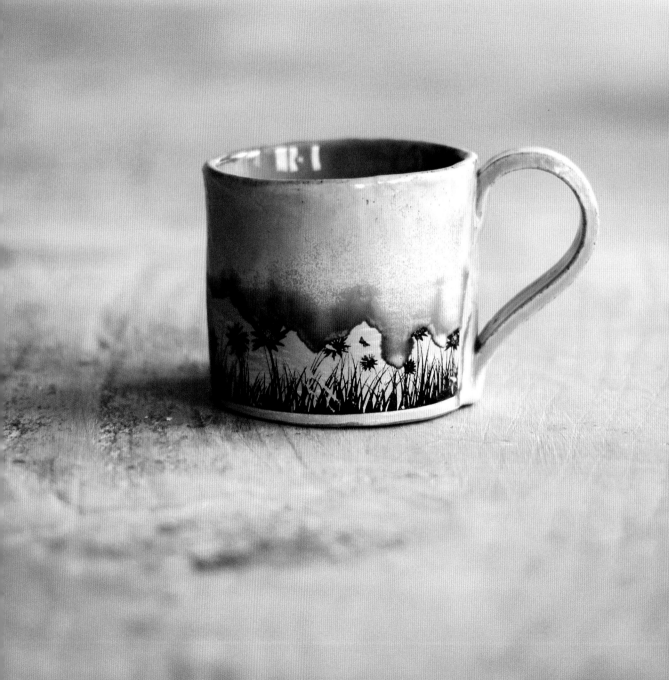

UNDERGLAZE DECAL PROJECT

Underglaze decals work really well when mixed with colorful or plain glazes. They work best with paler clay bodies; white and speckled clays give especially attractive results. However, I used a buff stoneware body here with a pink underglaze slip to change the background color. I chose a black decal to work with a blue glaze, but you can choose any color combination you like. I applied my underglaze decal to bisque in this project because it is easier to handle than greenware and less likely to get damaged. Remember to read the manufacturer instructions that come with each decal as each may come with specific instructions.

Tools

Scissors

Pencil

Ruler

2 paintbrushes

Bowl of clean water

Dipping or brush-on glaze

Sponge

1. Prepare your bisque like you would for regular glazing as described on page 141.

 Think about where you'd like the transfer to be positioned on your form and where you'd like the glaze to be. For my project, I wanted the decal to be around the bottom third of my mug. I glazed the inside in a clear transparent glaze, the top third of the mug in a glossy blue glaze and left the bottom third unglazed. Place the decal paper on the area you want to feature the decal pattern to check it fits.

2. Cut away any excess paper to make it easier to handle. Using a pencil, mark on the paper roughly where you need to cut, place the decal paper onto a flat surface and use a ruler to draw a pencil line. Cut along this line. Set aside any spare pieces of decal; you can use this on another project.

1

2

3 A

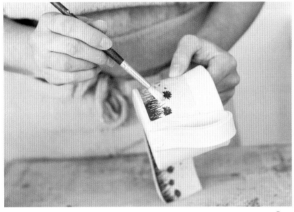

3 B

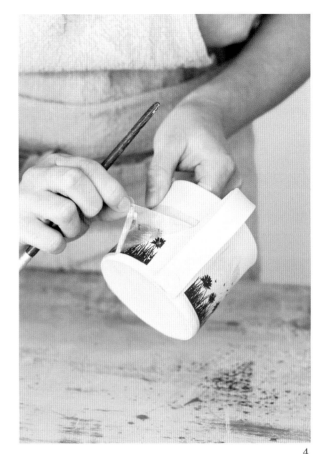

4

3 . Position the decal on the form. Then, using a soft, wet paintbrush, lightly stroke the decal starting from the center and moving outward, being careful that the entire decal has been brushed and becomes damp; this ensures all parts of the colored underglaze ink transfer well. If the paper wrinkles, gently pull at the edges to straighten it out. Try and aim for any wrinkles to be in the negative space between the design.

4 . Peel a small section at the corner to check the design has transferred well. If not, go over the area again with your wet paintbrush. Once you are happy (the transfer ink is now on the bisque surface), gently peel away the decal. Discard the paper. The underglaze is a bit like ink at this stage and will smudge, so be careful to only handle the part of the pot without the underglaze pattern. Leave the form to dry out completely.

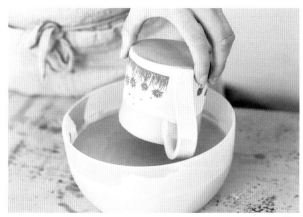

5 A

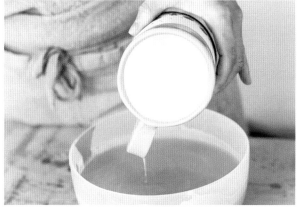

5 B

6

5 . After a few hours of drying, you can add glaze to your pot. Start with the interior pouring glaze; stir the glaze for at least a minute. Holding the mug by the handle and using a jug, pour in the glaze to the inside of the mug right to the top. Pour it out back into the bucket straight away. Wipe away any drips you may have created on the outside, being careful not to smudge the decal.

Now, use a glossy blue dipping glaze on the exterior. Stir the glaze well for at least a minute. Dip the top third of the mug into the glaze and hold for 3 seconds. Now dip the handle into the glaze and hold for 3 seconds. After each dip hold the pot over the container to allow for the drips. It doesn't matter if the blue glaze goes over the underglaze pattern slightly.

6 . Wipe away any glaze drips on the base. Leave to dry before firing to the temperature recommended on the glaze packaging. Most underglaze decals can be fired between cone 04 and cone 11.

Pro Tip: You can of course glaze over the top of the underglaze decal (hence the name). It's best to use a transparent rather than an opaque glaze to show off the design beneath.

OVERGLAZE DECAL PROJECT

With overglaze decals, you are going to be working with pottery that has already been glazed and fired. For this project, I used a mug I made following the Barrel Bellied Mug project on page 108 and glazed it in a cobalt blue and white glaze combo with a real 22 karat gold overglaze decal.

Tools

Sponge

Bowl of clean water

Scissors

Soft rubber kidney

1. Make sure your pottery is free from dirt and dust. Wipe it with a clean sponge and dry it thoroughly with a clean tea towel or paper towel.

 Decide how many and where you'd like to position your decals on the surface of the pot. Cut out the decals using scissors.

2. Dip the decal into the water. It only takes a few seconds for the decal to begin loosening from the backing paper. Peel the decal from the backing paper. Only handle the decal around the edges with care.

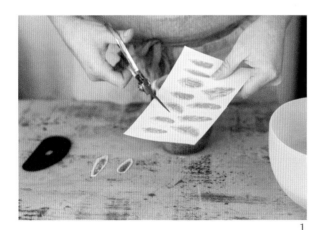

1

2

3 A

3 B

3 C

3 . While the decal is still wet, apply it to the surface of the pot. Using your sponge, remove any excess water. With the rubber kidney, gently smooth out any air bubbles, starting from the middle and making your way toward the edges. Be very careful as the decal is delicate and can rip easily. Leave to dry for at least 10 hours.

4 . Put it back in the kiln and fire between cone 018 to 017 at 1301 to 1353°F (705 to 733°C) for regular color decals and cone 019 at 1252°F (678°C) for gold decals. Always refer to the maufacturers instructions for firing temperatures.

See final examples on page 158 and 165.

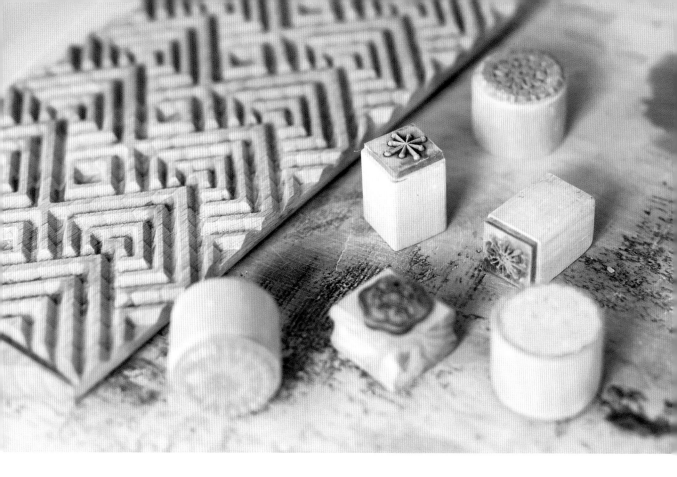

STAMPS: TEXTURE AND
PATTERN ON POTS

Another way to get beautiful texture or repeated patterns on your pottery is to use stamps. Stamps can be made from rubber, wood, plaster, metal or plastic. You can buy stamps relatively cheap from pottery supply stores, craft shops, online or even make your own. There are lots of items you can pick up in thrift shops that can be used to make stamps or even find things around your house and garden such as old buttons mounted onto wine corks, textured wallpaper, lace,

fabric, leaves, flowers, even bark from trees. Glazes will flow over texture and pool into pockets in the surface of the clay, creating unique effects. You need to make sure the texture is deep enough, otherwise the glaze may obscure it; 1/16 inch (2 mm) is ideal.

You can freehand individual stamps onto trimmed leather-hard thrown pottery, but remember to support the inside of the form with your hand to make sure you don't warp it.

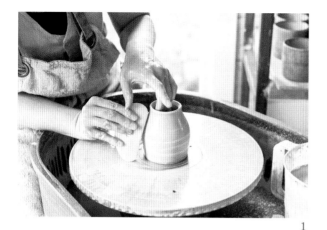

1

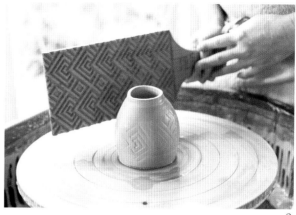

2

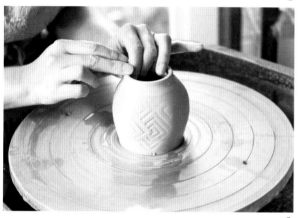

3

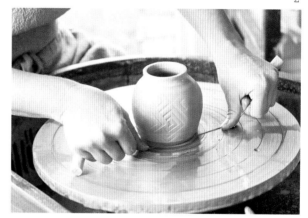

4

Using a Paddle Stamp

A paddle stamp is made from wood with a repeating pattern carved into the surface. Striking a wet form with the paddle will emboss the pattern into the clay.

1. I used 14 ounces (400 g) of white stoneware clay for this pot. Prep your clay by wedging it thoroughly with the Spiral or Ram's Head method. The most effective shape to use a paddle stamp on is a barrel bellied pot. Once thrown, don't cut the pot off the wheel.

2. Allow the form to firm up a little; you want it to still be soft enough so you can set the rim on the wheel again to reshape after it gets warped following the stamping.

Soak the wooden paddle in water for a few minutes before using to prevent it from sticking to the clay.

In one swift movement, firmly pat the side of the pot once with the textured paddle and pull it away quickly. This will deform the pot slightly, but don't worry.

3. Reshape the rim of the pot by using the setting the rim action as described on page 87. Re-wet the rim to avoid friction. The barrel of the pot will remain a little flattened, but this only adds to the charm.

4. Be sure to get rid of any standing water from the interior (a sponge on a stick would come in handy here). Finally, cut the pot off the wheel and set aside to dry and trim normally.

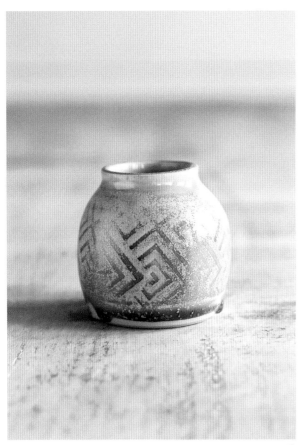
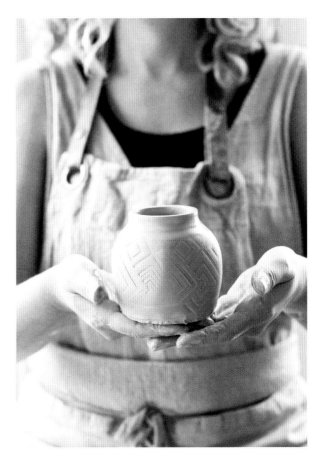

5

5 . Bisque fire to 1940°F (1060°C)

Glaze in your choice of glaze. Fire to cone 6. Glazes will flow over texture and pool into pockets in the surface of the clay creating unique effects, so semi-transparent glazes are best.

Stamps work great on slabs of clay too, which can then be used to make hand-built forms. Roll out large slabs of clay for your project, leave them to dry until they are just a little bit wetter than leather-hard and then place your texture (e.g., lace or textured wallpaper) on the surface. Use a brayer tool or a rolling pin and gently roll over the entire surface to emboss the pattern. Use your needle tool to cut the slabs into the size you need for your project.

Pro Tip: Practice your texture on a spare piece of clay before committing to your project. Plastic, metal or rubber stamps can be painted with a little vegetable oil or sprinkle it with cornstarch to prevent them from sticking to the clay.

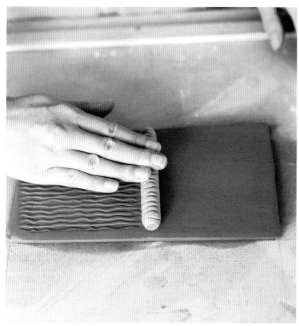

1

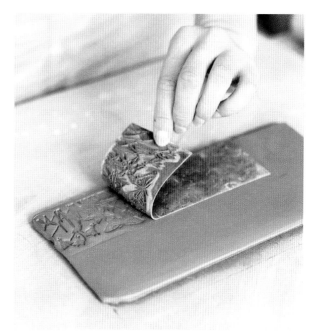

2

Here are some other ideas for using stamps in combination with projects from this book:

1. Make a slab-built Rustic Soap Dish from page 57. Instead of carving the surface, use a wooden texture roller to create pattern and interest.

2. Make a Simple Slab-Built Mug (page 70) and use a rubber stamp sheet to create texture on your mug. Glaze your mug using the dip-glaze technique on page 148.

3. Make an Adorable Bud Vase (page 101) and use stamps to create unique textures on the surface. Combine with a brush-on glaze technique on page 143.

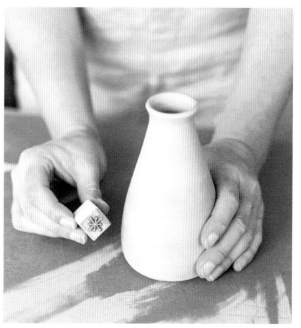

3

FIRING YOUR POTTERY

The Magic & Drama of Heat

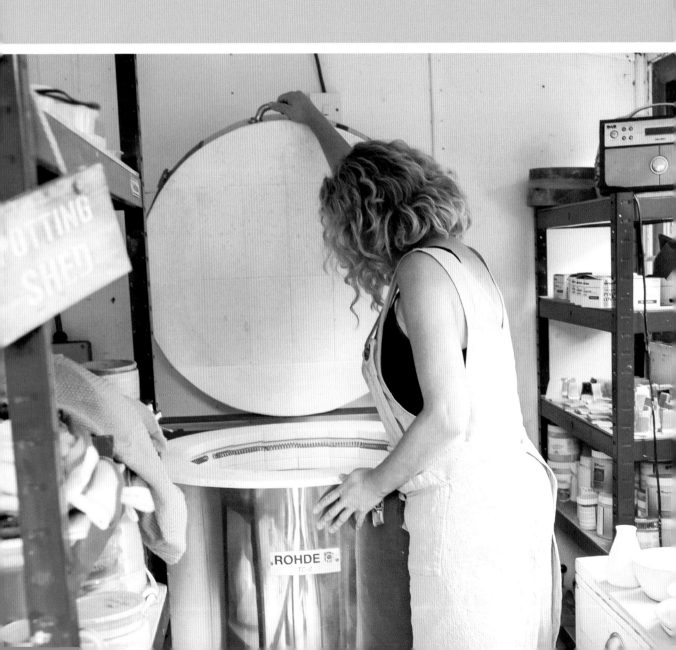

Opening a kiln full of beautiful, shiny, vibrant pottery is a special moment.

For clay to turn into ceramics, it will need to be fired. You can't do this in your home oven; you need a kiln. You can just use air-dry clay when you are practicing, but these pieces would be for decoration only and wouldn't be watertight. When you get more confident in your craft you will want to use clay, which needs firing.

You likely won't have your own kiln to begin with and will be reliant on a community studio to fire your pieces for you. Make sure you know what temperature your local studios fire their kilns at since some only fire at one specific temperature. You'll need to match your clay and glaze to their specifications. Most pottery supply stores also offer a firing service where you take them your clay and they will fire it in their kilns for you for a charge. Some charge by weight, others charge by shelf space. You may also have a friendly local potter who can offer a firing service for a small fee.

Even if you are not doing the firing yourself, it is important to understand a few of the terms involved in firing pottery, because this will help improve your work and allow you to efficiently communicate with the kiln technician/person firing the kiln about how you need your pottery fired. You may decide you'd like to invest in your own kiln one day.

Some firing terms you will need to know:

Top temperature: This is the temperature the kiln will reach.

Schedule: The temperature you want your kiln to get to and how fast you want it to get there. This may be slow, medium or fast on a manual kiln, or it may be done in ramps (see below for explanation of *ramp*) on a digital controller.

Ramp: This refers to how many degrees per hour your kiln will heat up as programmed into a kiln's digital controller (e.g., 212°F [100°C]) per hour. Slow = 176°F (80°C) per hour, Medium = 212°F (100°C) per hour, Fast = 302°F (150°C) per hour.

Soak: This refers to holding the top temperature for a period of time (normally in 15 minute increments) to help even out the heatwork throughout the kiln. You may want to add a soak to a glaze firing to even out the temperature in the kiln, making sure the bottom shelves reach the same cone as the top shelves.

Heat work: Heat work is what we potters refer to when describing the combined effect of heat over a period of time. A slow firing schedule at a lower top temperature may result in the same effect on a piece of pottery as a fast schedule at a higher top temperature. Which works best for you will depend on the kiln you use, the glaze and the effects you are looking for.

FIRING TEMPERATURES

Bisque firings are normally slow and at a lower temperature. A typical bisque firing schedule is 176°F (80°C) per hour until 1112°F (600°C), then 300°F (150°C) an hour until 1940°F (1060°C), or until cone 04. No soak.

Glaze firings are often quicker and done at a higher temperature. A typical stoneware firing schedule could be 300°F (150°C) an hour until 570°F (300°C), then 392°F (200°C) an hour to 2231°F (1222°C), cone 6, with a 15-minute soak.

Most firings take between 8 to 11 hours. Then, it will take at least another 24 hours for the kiln to cool down to room temperature before you can open it.

My small 45 L kiln is called Little Derek.

CONES: WHAT ARE THEY AND WHY DO WE NEED THEM?

We all know that cooking something at one temperature over 10 minutes will have a much different outcome than cooking something at the same temperature for several hours—the same is true in a kiln.

You can't open a kiln during a firing to check everything is firing correctly. It isn't advisable to look into a kiln through the peep hole either due to the risk of cataracts. Most of our learning about what happens during a firing is retrospective (after the firing took place), by studying the outcome on the work itself. But this kind of expertise takes experience and trial and error.

Luckily potters can also implement a useful a little tool called a pyrometric cone to understand the heat-work patterns that happen inside a kiln. Cones are small pieces of ceramic material that have been carefully formulated to melt and bend at very specific temperatures. A perfectly melted cone 6 bends at 2231°F (1222°C).

We use a cone chart (see the next page) to determine which cones we need to use in our kiln for the temperature we are aiming for.

Cone 6 cone pack before a firing. From left to right: cone 5, cone 6 and cone 7.

Temperature Equivalents (°F) For Orton Pyrometric Cones

	Self-supporting cones		Large Regular Cones	
Heating Rate used	108°F/hr	270°F/hr	108°F/hr	270°F/hr
How fast was your firing rate	*Medium*	*Fast*	*Medium*	*Fast*
Cone Number				
022	1087	1094	N/A	N/A
021	1112	1143	N/A	N/A
020	1159	1180	N/A	N/A
019	1252	1283	1249	1279
018	1319	1353	1314	1350
017	1360	1405	1357	1402
016	1422	1465	1416	1461
015	1456	1504	1450	1501
014	1485	1540	1485	1537
013	1539	1582	1539	1578
012	1582	1620	1576	1616
011	1607	1641	1603	1638
010	1657	1679	1648	1675
09	1688	1706	1683	1702
08	1728	1753	1728	1749
07	1789	1809	1783	1805
06	1828	1855	1823	1852
05½	1859	1877	1854	1873
05	1888	1911	1886	1915
04	1945	1971	1940	1958
03	1987	2019	1987	2014
02	2016	2052	2014	2048
01	2046	2080	2043	2079
1	2079	2109	2077	2109
2	2088	2127	2088	2124
3	2106	2138	2106	2134
4	2124	2161	2120	2158
5	2167	2205	2163	2201
5½	2197	2237	N/A	N/A
6	2231	2269	2228	2266
7	2262	2295	2259	2291
8	2280	2320	2277	2316
9	2300	2336	2295	2332
10	2345	2381	2340	2377
11	2361	2399	2359	2394
12	2383	2419	2379	2415
13	2428	2458	2410	2455
14	2489	2523	2530	2491

Temperature Equivalents (°C) For Orton Pyrometric Cones

	Self-supporting cones		Large Regular Cones	
Heating Rate used	60°C/hr	150°C/hr	60°C/hr	150°C/hr
How fast was your firing rate	*Medium*	*Fast*	*Medium*	*Fast*
Cone Number				
022	586	590	N/A	N/A
021	600	617	N/A	N/A
020	626	638	N/A	N/A
019	678	695	676	693
018	715	734	712	732
017	738	763	736	761
016	772	796	769	794
015	791	818	788	816
014	807	838	807	836
013	837	861	837	859
012	861	882	858	880
011	875	894	873	892
010	903	915	898	913
09	920	930	917	928
08	942	956	942	954
07	976	987	973	985
06	998	1013	995	1011
05½	1015	1025	1012	1023
05	1031	1044	1030	1046
04	1063	1077	1060	1070
03	1086	1104	1086	1101
02	1102	1122	1101	1120
01	1119	1138	1117	1137
1	1137	1154	1136	1154
2	1142	1164	1142	1162
3	1152	1170	1152	1168
4	1162	1183	1160	1181
5	1186	1207	1184	1205
5½	1203	1225	N/A	N/A
6	1222	1243	1220	1241
7	1239	1257	1237	1255
8	1249	1271	1247	1269
9	1260	1280	1257	1278
10	1285	1305	1282	1303
11	1294	1315	1293	1312
12	1306	1326	1304	1324
13	1331	1348	1321	1346
14	1365	1384	1388	1366

After a firing, we can refer to the cones to determine whether the kiln reached the ideal temperature. Cones change color to white during a firing, so even if the cone hasn't bent you know it has been used.

It is important to register the difference between cone 06 and cone 6! They are at completely opposite ends of the firing temperature range.

We normally put three cones on each kiln shelf in a cone pack—the middle cone will be rated at the temperature you want to achieve. For example: at 2231°F (1222°C) the middle cone would be a cone 6. The cone to the right will be cone 7 which bends at 2262°F (1240°C) and the one to the left will be cone 5 which bends at 2183°F (1195°C). We are aiming for the middle cone to bend over in an elegant arc to indicate the perfect temperature has been reached. If it has melted completely, the kiln got too hot, if it didn't bend as much or at all, then the kiln was too cool. Because heat rises, taller kilns will often be hotter at the top than at the bottom. We can adjust the placement of our shelves, the work and make changes to firing schedules to accommodate for these temperature fluctuations. Even though we generally trust that the controller is accurate, it can only read temperature at one point in the kiln and it has no ability to record or represent the effect of temperature over time (or heatwork). I suggest using cones in every single firing and on every shelf. You can use self supporting cones or press large cones at a slight angle (determined by their base) into a small coil of clay as I have done on page 178. The Orton Cones website explains cones in more detail. You can provide a cone pack to your community studio and ask for it to sit near your work in the kiln.

Keep a Firing Notebook

It might be several weeks, even months, between firings. There are so many different variables and combinations involved: what cone was reached, what glazes you used and on which shelf the work sat, that you are not going to remember everything. So, it is really helpful to keep a firing notebook.

Important things to include in your firing notebook:

1. The date

2. What clay you used

3. What glazes were used

4. The firing schedule you used (e.g., top temperature, ramp per hour/speed)

5. Number each firing. This helps you keep track of the age of the elements and when they might need replacing. Start at 1 for the first firing or when the elements were last changed. Elements normally last on average 100 firings, but this does depend on the temperature you fire at. Firing a kiln to higher cones tends to wear out elements quicker.

6. The cone achieved and shelf number (e.g., shelf 1 at the bottom, shelf 2 in the middle, shelf 3 at the top)

7. How tightly the kiln was packed; was the work tightly or loosely packed? This will have an effect on the heatwork.

8. General notes about the results: Were they as you expected? How did the color result? Were there any issues? Any recommendations for the next time you fire these glazes (e.g., include a soak or reduce top temperature by 10 degrees)?

GETTING A KILN

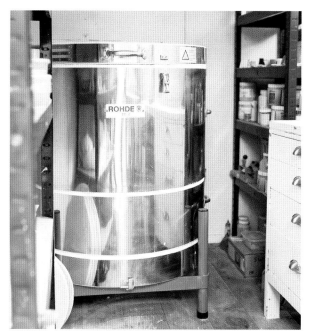

My kiln, a ROHDE 117 L Top Loading Kiln, is called Big Derek.

If you are considering making pottery a side hustle or a career, or you just want to take your hobby to the next level, then you will need a kiln of your own.

Most kilns are powered by electricity or gas. As a newbie to pottery, I'd recommend an electric kiln; they are the best place to start, as they are relatively easy to use, very economical to fire, more environmentally friendly and come in a range of sizes that make them more affordable and easier to locate in your creative space.

Modern kilns are extremely safe if used correctly and many are small enough to fit into a corner of a garage or shed. Newer kilns have super-duper insulation, meaning they can get up to stoneware temperatures using surprisingly little electricity.

Most kilns need to be hardwired by an electrician; they will also need to check your breaker box to make sure the kiln won't cause it to trip.

You'll need to run a "ghost firing" with a new kiln before putting any work in it. This simply means firing your kiln with just the furniture, shelves and stilts without any work inside. This will oxidize the elements and protect them from fumes and water vapor damage, and it cures the furniture, making it ready for use.

Kilns have vents that can be open and closed, allowing gases and water to escape and help extend the life of the elements. I normally keep my top vent in my kilns open for bisque firings and closed after reaching 1112°F (600°C) for glaze firings. Most kilns have a padlock on them to prevent accidental openings while hot.

Like any pieces of working machinery, parts of the kiln will wear over time and will need replacing—this is normal and to be expected. Pottery supply stores can normally recommend a good kiln engineer, but the more experienced you get, you'll be able to learn to replace the parts yourself. It is important to only do this if you are confident and experienced—if you're in any doubt, always get a professional to do it!

It is super important to keep your kiln in a safe location. Kilns should be in a well-ventilated area away from where you work and live; if this isn't possible then a kiln will need to have a ventilation system installed to take the gases away and safely outside. Having a kiln in a wooden shed is fine, but it needs to be at least 18 inches (46 cm) away from the walls, floor or anything else combustible while firing. The outside of the kiln will get hot! My little Rohde kiln is on wheels, so I wheel it into the middle of my shed when firing it, then store it away when cooled. It's important to always supervise a kiln when it is firing. Always follow the safety instructions of the manufacturers. See the Health and Safety section on page 27 for further information on firing kilns.

HOW TO PACK A KILN

Firing a full kiln rather than a half full kiln is more economical. Only fire work that you think is good enough. Don't fire any greenware whose integrity is in doubt hoping you can save it later: cracks = reclaim. Pick only the best pieces you have made to be fired; recycle the rest.

New kilns will come with recommended firing schedules, but these can be adjusted to suit the glazes and clays you are using. It is only by testing that you will determine the best firing schedules for your desired results. You will need to adjust these depending on your kiln, how much work is in the kiln and the type of glaze you are using. The age of your elements can also affect how your kiln fires (the older the elements are, the less efficient they are and they may need a slower schedule).

Stacking a Kiln for a Bisque Firing

Stacking a kiln is an art form in itself. It is like a big, complex jigsaw puzzle. It is important to move slowly as you stack the kiln; don't rush—it is all too easy to damage pots or the kiln when carrying works or heavy kiln shelves from one place to another. It's not uncommon to pack a kiln only to have to unload and repack it to fit everything in, so allow yourself enough time for this process. It is important that the work is completely dry before firing. Don't be tempted to put damp or cold-feeling work in the kiln, as it will likely explode. The most efficient and space-saving way to load a bisque kiln is to use a method called "tumble stacking" as described below.

1. Ensure your kiln has nothing around it or stacked against it.

2. Vacuum your kiln before each use—this will keep elements free of dust and debris. This is a good point to inspect the elements for damage or signs of wear.

3. Use three ½-inch (1.3-cm) stilts evenly spaced on the kiln floor; I use three because it gives maximum stability. Place your kiln shelf on top of the stilts. Be careful to load the shelf into the kiln at an angle; this helps to avoid chipping the soft walls of the kiln or hitting the thermocouple on the way down. The thermocouple is the delicate piece of wire covered in a ceramic sheath which detects the temperature in your kiln. Position the shelf in the middle with even space all the way around the edge. Never place work directly onto the kiln floor.

4. During a bisque firing there is no glaze, so the work can touch each other and can be stacked rim to rim. Begin stacking or nesting works inside each other. It can lean against the kiln wall but avoid the elements.

5. Stack mugs and bowls rim to rim. Plates and large flat items can lean on their sides against the kiln wall. Filling a kiln completely will increase efficiency. However, it is important to make sure pots are not too tightly stacked because the work will expand and contract with the heat. So, be sure to give each piece a little room to move and ensure it is stable enough that it does not displace and fall during the firing.

6. Stack smaller pieces of work inside bigger pieces to make better use of the space, but they must fit easily inside, as there's a risk of them getting stuck or one cracking the other if one of the pots shrinks more than expected or warps during the firing.

7. I begin stacking my kiln from the furthest outer edge of the kiln shelf, stacking the pots one on top of another, rim to rim at the back until they reach 1 inch (2.5 cm) from the top, and working my way forward. This helps to avoid knocking any pots while stacking. You need to be mindful of leaving a 2-inch (5-cm) clearance around the thermocouple, or this could skew the temperature reading.

8. If your kiln has a vent, leave it open for the duration of the bisque firing to allow for gasses to escape.

9. It's really important to ensure all the pots are completely dry. If a pot at the bottom of the stack exploded, then it would likely cause an avalanche of pots.

10. I always try and wait to fire my bisque kiln until it is completely full of work, which is much more energy efficient.

11. Always leave 1 inch (2.5 cm) of space at the top of the kiln to the allow the work to expand while it's heated.

12. Supervise your kiln throughout the firing. Always check that the kiln reaches the top temperature and then switches itself off.

13. Allow your kiln to cool naturally; never open the lid before it is at room temperature.

Stacking a Kiln for a Glaze Firing

Prepare the shelves of your kiln by using something called "kiln wash" (you can find this at your pottery supply store). It comes in powdered form that you mix with water to create a thick solution (like melted ice cream) that you paint onto the top side of your kiln shelves. This helps to protect the shelves from stray drips of glaze. If some glaze does get on the shelf, it will be able to be scraped off relatively easy without doing too much damage to the shelf. Without kiln wash, if glaze dripped onto your shelf, you will need to chisel it off or use an angle grinder that may damage your expensive shelves.

Work that has been glazed cannot touch each other during the firing. No part of the work with glaze on it can touch the kiln shelf, walls or other pieces of work; otherwise the glaze will permanently fuse it together.

1. Ensure your kiln has nothing around it or leaning against it.

2. Vacuum your kiln before each use. This will keep elements free of dust and debris. This is a good point to inspect the elements for damage or signs of wear.

A digital controller enables you to program your kiln firing schedules. Some controllers even have a function which records how much electricity was used during the firing.

6. The kiln posts will need to be at least ⅛ inch (3 mm) taller than the tallest pot on the shelf; this will ensure the work will not touch the kiln shelf above.

7. Ensure you stack the kiln posts of each subsequent shelf directly above the one below; aligning them like this ensures there is no undue stress on the shelves which could be at risk of fracturing under a heavy load. Feel for the lower post under the kiln shelf with your fingers; once located, that's where you put the next post.

8. There needs to be at least ¼ inch (6 mm) of space between the tops of the final layer of pots and the lid of the kiln.

9. Put a cone pack on every shelf so you can see what cone each shelf of work reached. Make sure they are far enough away from pots; you want them to avoid touching your work as they melt and cause them to fuse together.

10. The bottom of the kiln tends to be cooler than the top (heat rises), so lightly stack the kiln at the bottom. As you get accustomed to your glazes, you might find that some perform better when they get slightly hotter and some are just fine a little cooler. Stack your work in your kiln to make the most out of any temperature variation.

11. If your kiln has a vent, leave it open until 1112°F (600°C). Leaving a vent open will help to protect your elements against excessive corrosion from the fumes given off during the firing. You can then close them for the remainder of the firing to save electricity.

12. Supervise your kiln throughout the firing. Always check that the kiln reaches the top temperature and then switches itself off.

13. Allow your kiln to cool naturally; never open the lid before it is at room temperature.

3. Start with three ½-inch (1.3-cm) stilts placed evenly spaced on the kiln floor; three provides the most stability. As with a bisque firing, place the kiln shelf on the stilts, being careful to load the shelf into the kiln at an angle (this helps to avoid chipping the soft walls of the kiln or hitting the thermocouple on the way down).

4. Position the shelf in the middle of the floor with even space all the way around the edge.

5. Position similar-sized pots on the same shelf to save space and maximize the number of pots that can fit in a kiln. You'll need a finger width of space in between each pot.

TROUBLESHOOTING

All potters will experience these problems at some point in their pottery journey—I know I have. There is absolutely no shame in problem pots while learning; in fact, there is still no shame in experiencing problem pots at *any* stage—it is to be expected. As long as we try to understand what went wrong and how we can fix it next time, no failure is wasted. Often, you can spend more energy trying to rescue a failing pot than you would just making a new one. In my experience, if a pot still at the greenware stage develops a problem, it's best to recycle the piece, learn from it and start again.

There can be many and varying reasons why your pot has not turned out how you expected. Here are just some of the possible explanations:

Greenware Issues

Wobbly pots: Unevenness while throwing can be due to a few factors.

1. You may have had uneven moisture in your clay. Make sure you prepare your clay well by wedging, especially if the clay has been out of the bag for any length of time or it has been recycled.

2. Your clay may not have been completely centered. You can check if your clay is totally centered before moving on to the next step by slowly taking your hands away, and if you can see the clay wobbling from side to side, even if just the tiniest bit, your clay isn't totally centered and you will end up with an uneven pot.

3. Get your foundation arm strong. Cone up the clay one more time to get it truly centered.

4. Often a wobbly pot can be caused by the thrower moving faster than the wheel is spinning, which will cause a spiral effect and mean the walls will be uneven in thickness or height. You must always move slower than the wheel is turning; if you are finding that difficult, speed up the wheel.

5. Uneven bottoms. Practice your trimming technique to achieve a level base.

Air bubbles: The reason you want to avoid air bubbles is because they cause a weakness in the form; if clay has been displaced by an air pocket, then this part of your form is weaker and more vulnerable to breakages and cracks.

1. Air bubbles lead to uneven walls during throwing and will cause wonky pots.

2. Spend more time wedging your clay; use the Slam and Cut method and be careful during wedging so that you are not driving more air into the clay.

3. You can sometimes pop small air bubbles using your needle tool and smooth it back over with your finger.

"S" cracks: an "S"-shaped crack that forms on the base of greenware and normally appears while the clay is drying.

1. This is due to the walls drying quicker than the base—as the drying clay shrinks it contracts and pulls the still soft clay in the base apart.

2. Try and make the walls and the base even thickness.

3. Always compress the base of your pots while throwing.

4. Get rid of any standing water in your pot while you are throwing and when a pot is complete.

5. As soon as pots have been trimmed, flip them over to dry to increase air flow and even out drying between the walls and the base.

Join cracks: cracks appearing around the joins where two separate pieces of clay have been joined together; these often happen where a handle joins the body of the mug.

1. This often occurs because the two pieces of clay are drying at different rates and pulling away from each other or the handle or mug was too dry when attached.

2. Slow the drying process by covering the work with plastic and drying work away from heat sources or drafts.

3. Use wax resist on handle joins to slow down the drying in this area.

4. Make sure the clay is well blended around the join.

Warping: Warping occurs if the clay has been one shape for a long time and then (via the making process) becomes another. The clay can want to get back to an earlier shape.

1. Warping can also occur if a pot is nudged out of shape at any point during making or drying.

2. Clay will remember any stresses it goes under, so handle your freshly made pots with care.

3. Warping is made worse by unevenness, including if your pot has a thick bit and a thin bit and experiences uneven drying via heat sources or drafts.

4. Try and keep the base and walls of your pots the same thickness and dry work slowly. If you roll out some clay for hand building, roll it on both sides to even out the stresses.

5. Use a batt system to throw work on to help prevent warping as you are taking your work off the wheel.

Cracking: Cracking can occur at any point during the making process: at the greenware stage or during a bisque or glaze firing.

1. Cracking occurs when there are stresses in the clay.

2. This could be because of uneven drying or an air bubble in the clay.

Explosions: Most people think that air bubbles cause explosions in the kiln. Air bubbles are undesirable for many reasons, but explosions are not one of them. It's actually residual water turning into steam that causes explosions. Air and water expand when heated. Air particles are small enough to escape through the microscopic pores between the clay particles. Water particles, however, are larger and will expand too quickly to be able to escape through the pores, causing a dramatic kiln explosion. Make sure your work is completely bone dry before it goes anywhere near a kiln.

Glaze Issues

Pin-holing: tiny pits or holes in the glaze surface that go right down to the body of the clay.

1. This may be caused by impurities left in the clay after the bisque firing. Fire your bisque slightly hotter.

2. Leave the vents in your kiln open during the bisque firing.

3. Slow down your glaze firing when nearing peak temperature or add a soak on to the end of the firing.

Crazing: Crazing is the formation of tiny cracks in the glaze surface. This can sometimes be a deliberate decorative effect but if it's unwanted then it's a fault. This is caused by the clay and glaze not quite fitting properly.

1. The glaze might not be fully vitrified or some of the materials in the glaze not fully melting.

2. Slow down your glaze firing when nearing peak temperature or add a soak at the end of the firing.

3. If this has occurred in a transparent glaze, it could be because it has been applied too thickly. Thin the glaze down with water or be quicker with your application.

Crawling: The glaze contracts away from the clay body leaving bare spots on the pot.

1. This could be caused due to dirty or dusty bisqueware; make sure you wipe any bisque with a damp sponge before glazing.

2. After wet sanding, let the pottery dry completely before attempting to glaze it.

3. This can also happen if the glaze has been applied too thickly. Thin the glaze with water and if dripping or pouring, reduce the time the bisque comes in contact with the liquid glaze, reducing the dip from 3 seconds to 1 second.

Blisters: tiny little bumps on the surface of the pot; looks a little like pottery acne.

1. This may be due to a mismatch of the firing temperature.

2. Check the glaze manufacturer instructions.

3. Always use cones in your kiln.

4. Add a soak to the end of your glaze firing.

Drips: glaze has dripped off the pot onto the kiln shelf.

1. Apply the glaze more thinly. If using a dipping glaze, thin the glaze out with water.

2. The glaze may have also been overfired. Always use cones in your firings.

3. Reduce the top temperature of the kiln and/or reduce any soak time (See 'Soak' at the bottom of page 177).

4. Apply the glaze to the top half of the pot only.

SUPPLIER LIST

USA & Canada

Bailey Pottery
baileypottery.com

Clay King
clay-king.com

Clay Planet
shop.clay-planet.com

Georgies
georgies.com

Greenbarn Potter's Supplies
greenbarn.com

Laguna Clay
lagunaclay.com

Mudworks
mudworkspotterypa.com

Plainsman Pottery
plainsmanpotterysupply.com

Sheffield Pottery
sheffield-pottery.com

Sial
sial-canada.com

Tucker's Pottery Supplies
tuckerspotteryeshop.com

UK

Bath Potters
bathpotters.co.uk

Cromartie
cromartiehobbycraft.co.uk

CTM Potters Supplies
ctmpotterssupplies.co.uk

Hobbyceramicraft
hobbyceramicraft.co.uk

Potclays
potclays.co.uk

Pottery Craft
potterycrafts.co.uk

Scarva
scarva.com

Germany

Ceramic Magstadt
ceramicashop.de

Keramik
keramik-kraft.com

Spain

Anper
anper.net

Marphil
marphil.com

Netherlands

Keramikos
keramikos.nl

Australia

Clayworks
clayworkspotters.com

Keane Ceramics
keaneceramics.com.au

The Potter's Market
thepottersmarket.com.au

Walker Ceramics
walkerceramics.com.au

New Zealand

CCG
ccg.co.nz/craft

Nelson Pottery Supplies
nelsonpotterysupplies.co.nz

ACKNOWLEDGMENTS

Patreons—My beautiful Pottery Club members, without your support in the form of monthly pledges and enthusiasm for my work this book would not have been written. You enable me to fulfill my dreams of being an artist, bring my pottery into the world and share my knowledge. I am eternally grateful.

To everyone who has ever bought a piece of pottery, supporting an artist is a very special thing—thank you.

To my Instagram community—I appreciate every like, comment and share. Thank you for cheering me on.

Thank you to Kate Southall of Copper and Blossom for the beautiful photography and being such a dream to work with.

Thank you to all my friends who are like family to me, for believing in me and telling me to follow my heart: Verity, Kate, Jayde, Roanna, Hannah, Stacey, Megan, Janine, Caroline, Soph and Naomi—love you girls.

Special thank you to Becky, Layla and Verity for helping to proofread.

To David Kelly, I don't think I could make you enough bowls to pay back the generosity of knowledge and encouragement you gave me when I started my business—how about a book dedication?

To Megan, for the counseling and encouragement.

To Cait Flanders, for your books and your guidance. You gave me the courage to advocate for myself.

Page Street Publishing—thank you for asking me to write this book and taking a chance on me. It came at just the right time. Thank you to my editor, Rebecca, for her patience answering all my questions.

Nanny—I wish you could have seen this.

To the village of Carlingcott, thank you for your warm embrace.

To Alex—thank you for giving me the courage to follow my dreams. I miss you bud.

My family—Mum, Dad and Zoë (Dode), thank you for always being there. Even though we are miles apart, we are always by each other's sides. "Despite the rocky start, you don't need to worry about that one—she'll do okay."

To Thomas—my adventure buddy. Thank you for giving me everything I've ever dreamed of.

ABOUT THE AUTHOR

Kara lives in a tiny cottage in a village just outside of Bath, UK, with her husband, Tom, and two rescue kitties, Luna and Flora. You will often find her hiking the South West Coast Path of Britain with her husband, gathering inspiration for her work. Kara's work is enjoyed by buyers all over the world. She has been stocked in many shops including the prestigious Fortnum & Mason. Kara also teaches other potters how to sell their work via shops and galleries via her online course 'The Smart Maker's Guide to Wholesale.'

To learn more from Kara, join her at her online Pottery Club at patreon.com/karaleighceramics, where she shares detailed tutorial videos, projects, tips and tricks and heaps of pottery advice. Follow Kara on Instagram @karaleighceramics. Share your clay creations tagging @karaleighceramics or using the hashtag #curiosityandclay. You can also find her at karaleighfordceramics.com.

INDEX